Twentieth Century American Drawings

From the Arkansas Arts Center Foundation Collection

Twentieth Century American Drawings

From the Arkansas Arts Center Foundation Collection

EXHIBITION CURATOR GERALD NORDLAND

CATALOGUE ENTRIES BY GERALD NORDLAND

WITH CONTRIBUTIONS BY RUTH PASQUINE, BRIAN YOUNG AND MICHAEL PREBLE

CATALOGUE FUNDED BY

Stephens Inc. NationsBank

Grassfield Press, Miami Beach, Florida

In Association with The Arkansas Arts Center Foundation Collection

First published in the United States of America in 1998
Grassfield Press, Inc.
P.O. Box 19-799
Miami Beach, FL 33119

Copyright ©1998, Grassfield Press, Inc.
Editors: Bonnie and James Clearwater
Copy editor: Sue Henger
Design: Fullerton/McBride Design, Coral Gables, Fl

Printed and bound in Hong Kong

Library of Congress Catalog Card Number: 97-78049
ISBN 1-886438-00-5

Cover: Roy Lichtenstein, *Study For Aviation*, 1967. Pencil, crayon and collage on paper. 22 x 26 inches. The Arkansas Arts Center Foundation Collection: The Museum Purchase plan of the NEA and the Tabriz Fund, 1976. 76.19

TOUR SCHEDULE

The Arkansas Arts Center, Little Rock, Arkansas
February 13 - March 15, 1998

Sunrise Museums, Charleston, West Virginia
September 6 - November 8, 1998

Philharmonic Center for the Arts, Naples, Florida
December 11, 1998 - January 30, 1999

Fort Wayne Museum of Art, Fort Wayne, Indiana
February 21 - April 18, 1999

Knoxville Museum of Art, Knoxville, Tennessee
May 16 - July 11, 1999

Boise Art Museum, Boise, Idaho
August 8 - October 17, 1999

Mobile Museum of Art, Mobile, Alabama
November 7, 1999 - January 9, 2000

Art Museum of Southeast Texas, Beaumont, Texas
January 30 - March 26, 2000

Art Museum of South Texas, Corpus Christi, Texas
April 23 - June 19, 2000

Joslyn Art Museum, Omaha, Nebraska
July 16 - September 10, 2000

Kalamazoo Institute of Arts, Kalamazoo, Michigan
October 15 - December 31, 2000

INTRODUCTION

Since the early 1970s, Director and Chief Curator Townsend Wolfe has been acquiring drawings in all media, styles and periods for The Arkansas Arts Center. Through its collecting activity, related exhibitions and publications, the Center has become an advocate for drawing and has gained international attention for its accomplishments. This selection of twentieth-century American drawings from the Center's collection represents the breadth and diversity of its holdings as well as the directions and themes that characterize the period.

Presenting a survey of American twentieth-century art with drawings provides an intimate, thoughtful approach through the mediums of pencil, pen and ink, charcoal, pastel, watercolor and silverpoint. Examining them in groupings by subject and approach provides a structure for looking that transcends style and period. It enables the viewer to compare and contrast like images and to gain an appreciation of the differences between the various styles characteristic in the twentieth century.

SCENES OF NEW YORK

The group of works inspired directly by the architecture and people of New York confirms the importance of this city for artists and the art world. Drawings by John Marin, Lyonel Feininger, Stuart Davis and Charles Sheeler represent the excitement and activity of the city through its buildings and skyline without any reference to its inhabitants. The people of New York are depicted at leisure in beach scenes by William Glackens and Reginald Marsh, while Edward Hopper offers a psychological comment on the difficulties of personal relationships in the city. Fairfield Porter's New York street scene, executed in 1968, integrates cars, people and buildings in a more literal, dispassionate, almost photographic view. Robert Cottingham's street scene, though in Los Angeles, has its focus on commercial signage combining Pop and photorealist sensibilities.

PORTRAITS

Probing the human personality through the portrait is a time-honored tradition that has survived the tumultuous changes in art historical style. The three silverpoint portrait drawings—by Bernard Perlin, Joseph Stella and John Storrs—are perhaps the most beautiful and elegant, due to the precision of execution required by this most exacting of mediums.

The portraits of women are moody and mysterious. Youth in its quieter moments is presented in two meticulously rendered pencil studies: William Bailey's *Portrait Head*, 1977, and Paul Otero's *Her Waiting: Edda's Voice*, 1991. Philip Evergood's more mature woman rests her head on her hand in the traditional melancholic pose while John Graham's line drawing of a woman with a rip in her breast and a dog in her arms suggests the darker side of femininity. Jim Dine evokes the mystery of womanhood with dark pastel tones and abrasions to the surface of the sheet. The portraits of men are particularly intense. Ivan Albright's stoic farmer and Richmond Barthé's dreamy Mexican are both compassionate evocations of specific personalities. Pavel Tchelitchew's dark, painterly approach to his subject and James Valerio's photorealist portrait are probing and insightful. Self-portraits by John Wilde and Jared French take self-examination to new aesthetic heights. A lighter approach to the portrait is presented in Romare Bearden's impression of a jazz pianist and

Larry Rivers's *De Kooning in My Texas Hat*, c. 1963. Comic relief is provided by Federico Castellon's surrealist portrait and by the insolence of Robert Arneson's self-portrait.

The most unsettling treatments of the human head are by Alfonso Ossorio, Arnold Bittleman, Lee Bontecou and Nancy Grossman. Ossorio's *Breath of Life*, 1940, and Bittleman's *Death, Christ and the Artist*, 1970-74, imbue the portrait with disturbing religious overtones. Bontecou's *Untitled*, 1974-75, a distorted face from the realm of fantasy, and Grossman's super-real strapped, buckled and bound heads evoke horror and confinement.

NATURE

The role of landscape with its range of emotion is key to the understanding of abstraction. Abraham Walkowitz's *Abstraction*, 1912, shows this tendency early in the century and bears comparison to the more contemporary drawing by Peter Takal. Much more intense feelings for the landscape are expressed by Charles Burchfield in his pessimistic *Burning Muckland*, 1929, and by Arthur Dove in the spirituality of his color studies. Edwin Dickinson's beach scene evokes loneliness, while Milton Avery's *Black Goat, White Goat*, 1958, displays an element of humor. More recent drawings by William Baziotes (*Desert*, 1954), Richard Diebenkorn (*Ocean Park Series*, 1972) and James Brooks (*Untitled*, 1984) evoke a transcendence similar to Dove's.

Within landscapes, close-up studies of plant life have also been a point of departure for artists concerned with shape and form. Drawings by Georgia O'Keeffe (*Banana Flower*, 1933) and Ellsworth Kelly (*Asiatic Day Flower*, 1969) show the importance of close observation, while drawings by Sam Francis and Jack Youngerman are more abstracted.

THE FIGURE

Study of the human figure has remained vital during the twentieth century despite a decreased interest in history and genre subjects where mastery of the figure is critical. Studies of individual figures by Max Weber, Elie Nadelman, Paul Cadmus, Elmer Bischoff and Jack Beal, while exhibiting drastically different approaches, typify the practice of working in the studio from a live model. The very different *Ax Man*, 1908, by Marsden Hartley aims to achieve a consistent style and feeling. The sheet of figure studies by Thomas Hart Benton illustrates part of the painstaking methods necessary to prepare a large mural composition.

Multifigured compositions have always presented a significant challenge to artists. George Bellows's *Tennis at Newport*, c. 1918, John Steuart Curry's *The Flying Codonas*, c. 1933, and Kent Bellows's *Four Figure Set Piece*, 1988, succeed in locating figures in a coherent pictorial space. Maurice Prendergast's *Bathers*, c. 1919-20, is more concerned with design and color. Drawings by George Grosz and R. B. Kitaj carry political messages, those of Jacob Lawrence and Robert Gwathmey carry social messages, and Bob Thompson's reflects personal despair. In the lighter mood of Pop art, Roy Lichtenstein contextualizes the figure into an allover design of objects and shapes in his 1967 *Study for Aviation*. Humor is provided by Jim Nutt's *If Only I Could*, 1975, and H. C. Westermann's *Falling Man*, 1973.

PAINTERLY ABSTRACTION

Concurrent with World War II, painterly abstraction, otherwise known as Abstract Expressionism, derived in large part from distortions of the human figure placed in a symbolic or shadowy setting. Dorothy Dehner, Emerson Woelffer and Adolph Gottlieb utilize a surrealist distortion of the figure, surrounded by signs and symbols, to construct their primitive worlds. Arshile Gorky, Willem de Kooning and Morris Louis utilize shadowy figures in blurred environments to express the flow of conflicting unconscious emotions and feelings. In the same vein, the drawing by Jackson Pollock is a powerful eruption of aggressive forces. Raymond Saunders, in his work from 1987, adds collage to his figural drawing to evoke a similar feeling of chaos.

Complete suppression of recognizable forms, with an emphasis on color, gesture and painterly strategies, removes subject matter from the aesthetic equation, focuses attention on the formal qualities of the picture and demands an emotional reaction to the work of art. The drawings by Theodoros Stamos, Philip Guston and Hans Burkhardt show a primary interest in the effects of color, while those by Mark Tobey, Lee Krasner and Helen Frankenthaler are more concerned with the energy of line, and those by Robert Motherwell and Richard Stankiewicz express a concern for shape. David Smith's and Seymour Lipton's studies for sculpture express the energy and totemic qualities inherent in solid forms.

GEOMETRIC ABSTRACTION

Abstraction derived from geometrical forms may have its origins in the work of the Dutch artist Piet Mondrian. Burgoyne Diller's *Third Theme*, 1948, and Ilya Bolotowsky's *Blue Ellipse*, 1977, are firmly planted within Mondrian's late aesthetic ideology. The more recent drawings by Al Held, Sol Lewitt, and Henry Pearson show the renewed interest in this approach by the minimalists, who reformulated the style for their own ends. More recently, geometric abstraction has been reinvigorated by a group of artists interested in applying painterly strategies to geometric forms. This approach is shown by Joel Shapiro, Rodney Carswell, Sean Scully and Elizabeth Murray.

STILL LIFE

Drawings by Morton Schamberg and Theodore Roszak show still life in the context of the early modernist interest in the machine aesthetic, while those by Hans Hofmann and Michael Goldberg show it within the abstract expressionist movement. Pop art elevated the ordinary object to the status of icon, as shown in drawings by Claes Oldenburg and Wayne Thiebaud. Drawings by Neil Welliver, Carolyn Brady and David Parrish illustrate the importance of still life to the photorealist movement.

RUTH PASQUINE
Curator of Art
The Arkansas Art Center
1997

JOHN MARIN

American, 1870-1953
Untitled (Woolworth Building), c. 1913-15
pencil on paper
9 ½ x 7 ⅜ inches
Arkansas Arts Center Foundation Purchase, 1979.
79.6.a

John Marin belongs to a core group of American modernists in the Alfred Stieglitz circle celebrated for their approach toward abstraction. While Marin is known best for his watercolors, he stated, "Drawing is the part of all movement great and small. The path made visible." (See note.) He was born in New Jersey and raised, in part, on a peach farm, where he began to sketch the land, buildings and nature. He was educated at the Pennsylvania Academy of the Fine Arts, Philadelphia, and the Art Students League, New York. From 1905 to 1911, he lived in Paris, where he met Albert Steichen and, through him, Alfred Stieglitz. In 1912 Marin exhibited at Stieglitz's 291 gallery; this was followed by inclusion in the Armory Show in 1913. In 1922 Marin showed at the Montross Gallery, New York, where collector A.E. Gallatin praised the artist as one of America's best. In 1936 The Museum of Modern Art accorded him a retrospective.

Marin looked at the city and the sea as systems of interpenetrating dynamisms—buildings, bridges, highways versus land and sky; upthrusting towers and skyscrapers tilting against gravity; tides, waves, currents and winds interacting with endless and independent rhythms of great ferocity; mountains suggesting a seismic power of explosive rearrangement beyond understanding. This style was accessible and personal, energetic and independent, rooted in the achievements of the late nineteenth century but conversant with the experiment of his contemporaries.

The drawing *Untitled (Woolworth Building)* is a small but quintessential formulation of Marin's expressive response to the experience of New York City, his avoidance of the photographic, and his need to convey an impression of the forces at work in the universe of nature and the man-made. Along with his depictions of the Brooklyn Bridge, this drawing is among his earliest mature evocations of the rapture he sensed in great works of modern architecture and engineering. The twisting, surging energy of the geometry captures the vitality in the city that corresponds to the "pushing, pulling, sideways, downwards, upwards" sensations he sought.

Sources:
Curry, Larry. *John Marin: 1870-1953*. Los Angeles: Los Angeles County Museum of Art, 1970.
Marin, John. *Drawings and Watercolors*. New York: The Twin Editions, 1950.
McBride, H. and E.M. Benson. *John Marin: Watercolors, Oil Paintings, Etchings*. New York: The Museum of Modern Art, 1936. Reprint, New York: Arno Press, 1966.
Reich, Sheldon. *John Marin: Drawings 1886-1951*. Salt Lake City: University of Utah, 1969.

Note:
John Marin: *Drawings and Watercolors, n.p.*

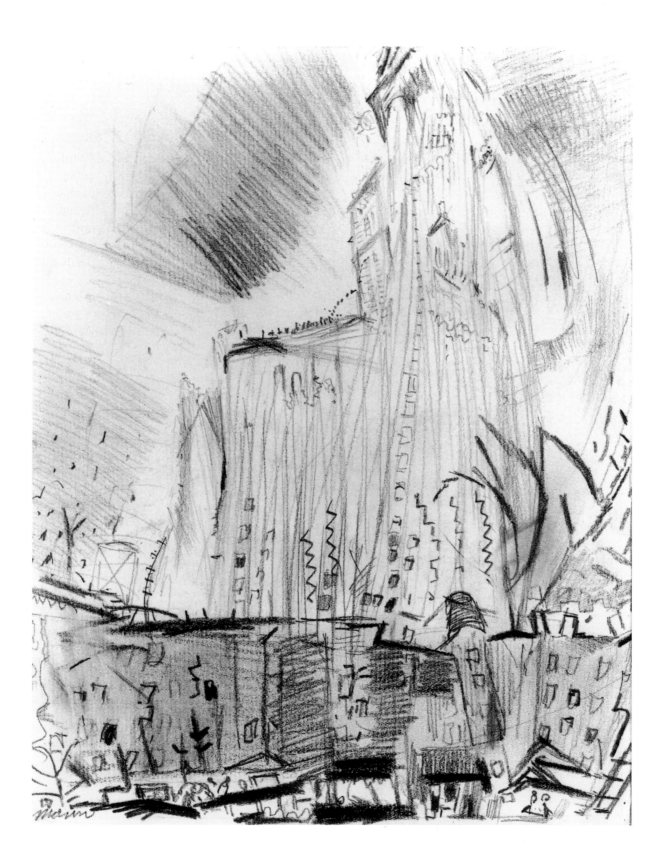

Lyonel Feininger

American, 1871-1956
Bridge with Underpath between Buildings,
Manhattan, 1937
charcoal on paper
12 ⅜ x 9 ½ inches
The Barrett Hamilton Acquisition Fund, 1981.
82.32.1

Lyonel Feininger's early dedication to music—his father was a violinist of international reputation and a composer and his mother a singer and pianist — was the cause for his move from New York to Germany at the age of 16. There, his studies switched to painting and drawing, which he undertook in Hamburg, Berlin and Paris. Referring to drawing, for which he was largely self-taught, he stated, "I am prouder of that fact, and take more pleasure in pen drawing than anything else." (See note.) Feininger's career flourished in Germany; he would not make the United States his home until 1937. In Berlin in 1917, he was invited to show with *Der Blau Reiter* group and held a solo exhibition at *Der Sturm*. From 1919 to 1924, he taught painting and graphics at the Bauhaus, Weimar. In the U.S. he exhibited in Galka Scheyer's *Blue Four* exhibition along with Kandinsky, Klee and Jawlensky. The National Gallery, Berlin, presented a retrospective (1931). This early success was tempered in 1937 when his work was put in the Nazi exhibition *Degenerate Art*. Not long after his return to the U.S. retrospectives followed: Museum of Modern Art, New York (1944) and Cleveland Museum of Art (1951).

Feininger found permission in the work of the French Cubists to explore the rhythms and interactions of nature and the proportions of the man-made world—architecture, bridges, seagoing vessels, and locomotives. His work paralleled that of his friend Robert Delaunay, who invented color systems which he imposed on church architecture, the Eiffel Tower, and the city of Paris. Feininger intuitively extended Cubist line and plane into his observations. He once joked that his work could be called "prism-ism." No doubt shaped by his early musical training, he pushed to incorporate a multiplicity of interacting building forms and styles and to fuse them into an orchestral unity.

Upon returning to New York City, he saw the city of his childhood through the lens of his separation and said, "New York is the most amazing city in its atmosphere, color and contrasts, in the whole world." (See note.) He did not paint for two years after returning to New York, but drew incessantly, seeking unusual viewpoints, both high and low, to better reflect the crowded juxtaposition of many-layered living in the great city. Once ready to paint, the drawings provided themes and compositional ideas which brought forth an astonishing body of new work in the artist's late sixties.

In *Bridge with Underpath between Buildings, Manhattan*, one senses his capture of the compression of many structural styles interpenetrating the thrust of the bridge, which almost dematerializes as it rushes upward, while the isolated elevation of the tower in the distant upper right serves to balance the darkness of the lower-central underpass.

Sources:
Schardt, Alois and Alfred H. Barr, Jr. *Lyonel Feininger*. New York: Museum of Modern Art, 1944.
Hess, Hans. *Lyonel Feininger*. New York: Harry N. Abrams, 1961.
Scheyer, Galka. *Lyonel Feininger, Caricature and Fantasy*, 1964.

Note:
In Galka Scheyer, *Lyonel Feininger, Caricature and Fantasy*, p.36.

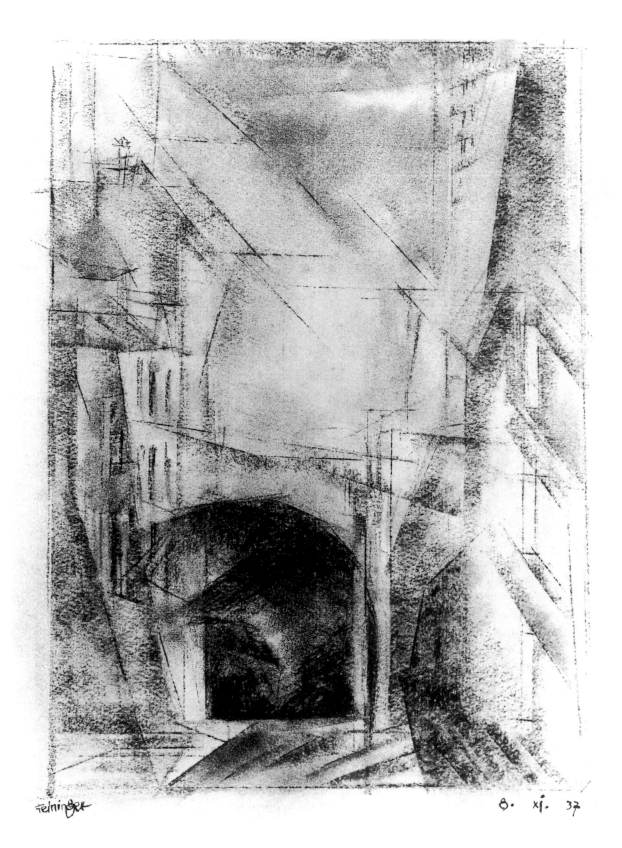

Feininger 8. xi. 37

Stuart Davis

American, 1894-1964
Untitled, 1923
ink on paper
25 x 19 inches
The Barrett Hamilton Acquisition Fund, 1984
84.1

Stuart Davis committed to modern art through the experience of The Armory Show (1913) and his association with Robert Henri, which he referred to as "the two greatest single forces in my early education." (See note.) This declaration came despite his family environment—Davis's mother was a sculptor and his father an illustrator and art director for the *Philadelphia Press*. In 1909 Davis studied with Robert Henri at the artist/teacher's school. Davis's first solo show came in 1917 at the Sheridan Square Gallery. In 1925 he had another solo exhibition at the Newark Art Museum, New Jersey. Three years later he traveled to Paris, where he studied the Cubists' work in depth. Throughout his long career, Davis had many important exhibitions including retrospectives at the Cincinnati Art Museum (1941), The Museum of Modern Art, New York (1945) and the Walker Art Center, Minneapolis (1957-58). A posthumous retrospective was held at the National Collection of Fine Arts, Washington, D.C., and the Musée d'Art Moderne, Paris (1965-66).

During his brief period in Paris, Davis saw the city as a stage set. *Untitled*, 1923, could easily have been given a title related to New York City. It was constructed in that city, executed first in pencil and inked for emphasis. It reflects the tall buildings, with windows seen straight on; planes of one building interrupt the vista; shifting Cubist planes suggest collage; and arches relate it to cathedral architecture. Just as Davis selected the

schooner as a central subject when he lived and worked in Gloucester, Massachusetts (for many summers between 1915 and 1934), he found that the skyline, like a multimasted sailing ship, defined the empty expanse of sky and offered the artist a theme upon which to work variations. Like Georgia O'Keeffe, Fairfield Porter, Charles Sheeler and Alfred Stieglitz, Davis was entranced by the metropolis and the multiplicity of lifestyles that it offered. He was deeply influenced by jazz musicians, whose virtuosity and aesthetic invention impressed him. Davis loved the city's unpredictability, its brash populism, and he sought to encompass it all in his creative work.

Sources:

Arneson, Harvard. *Stuart Davis Memorial Exhibition (1894-1964)*. Washington, D.C.: National Collection of Fine Arts, Smithsonian Institution, 1965.

Davis, Stuart. "How to Construct a Modern Easel Picture," a lecture Davis developed at the New School of Social Research, New York, December 17, 1941. Published in *Documentary Monographs in Modern Art*. Paul Cummings, ed. London: Praeger Publishers, 1971.

Sweeney, James Johnson. *Stuart Davis*. New York: The Museum of Modern Art, 1945.

Wilkin, Karen. *Stuart Davis*. New York: Abbeville Press, 1987.

Wilkin, Karen and Louis Kachur. *The Drawings of Stuart Davis: The Amazing Continuity*. New York: American Federation of Arts in association with Harry N. Abrams, 1992.

Note:
In *Documentary Monographs in Modern Art*, p. 3, fn 1.

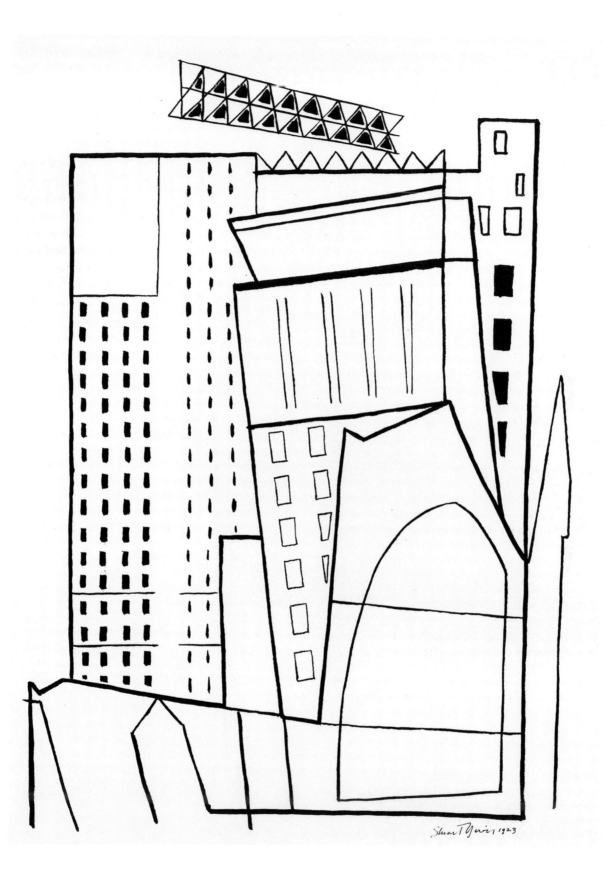

CHARLES SHEELER

American, 1883-1965
Study for Canyons I, 1951
tempera on paper
8 ¼ x 5 ⅞ inches
The Stephens Inc. City Trust Grant, 1986.
86.51

Charles Sheeler's artistic vision was shaped by his surroundings — Bucks County barns, Shaker furniture, patterns of floorboards, Indian rugs, early American furniture, the skyline of New York. From 1900 to 1903, Sheeler formally studied applied design at the Philadelphia School of Industrial Art, and drawing and painting at the Pennsylvania Academy of the Fine Arts under William Merritt Chase. He soon abandoned the bravura brushwork learned as a student of Chase and developed a sharp-focus view of realism that may be related to his camera work. In 1912 he adopted photography as a means of a livelihood; yet he exhibited six paintings at the Armory Show a year later. From 1915 to 1927, he was invited to exhibit in various prominent galleries throughout New York City. He and Charles Burchfield were given a two-person show at the Society of Arts and Crafts, Detroit, in 1935. He was afforded a major museum retrospective by The Museum of Modern Art, New York, in 1939. Important exhibitions followed at the Dayton Art Institute, Ohio (1944) and the Walker Art Center, Minneapolis (1952), and a retrospective at the Cedar Rapids Art Center, Iowa (1967), to name only a few.

Sheeler's tempera on paper work, *Study for Canyons I*, is a preparatory work for the widely exhibited painting *Canyons* which belonged to the artist's longtime dealer, Edith Halpert, whose Downtown Gallery was a pioneering modern art showcase for nearly forty years.

It is important to realize that many of Sheeler's early oil paintings were executed in a format only slightly larger than this study, and that he was comfortable conceiving great themes and vistas within a small scale, as he did in his photographs. This tempera suggests vast space, indeed all of New York, in its large, simple planes and careful juxtaposition of well-dispersed buildings that give scale to the whole. It is a study that invites comparison with Marin's *Untitled (Woolworth Building)*, c. 1913-15, or Feininger's *Bridge with Underpath between Buildings, Manhattan,* c. 1937, works that share the modernist wonder in the excitement of the great city and its stimulating life and art.

Sources:

Driscoll, John P. *Charles Sheeler, The Works on Paper.* University Park, PA: Museum of Art, Pennsylvania State University, 1974.

Friedman, Martin. *Charles Sheeler.* New York: Watson-Guptill Publications, 1975.

Friedman, Martin, Bartlett Hayes and Charles Millard. *Charles Sheeler.* Washington, D.C.: Smithsonian Institution Press, 1968.

Rourke, Constance. *Charles Sheeler, Artist in the American Tradition.* New York: Harcourt, Brace and Company, 1938.

Troyen, Carol and Erica D. Hirshler. *Charles Sheeler: Paintings and Drawings.* Boston: Museum of Fine Arts, 1987.

Williams, William Carlos. *Charles Sheeler, Paintings, Drawings, Photographs.* New York: Museum of Modern Art, 1939.

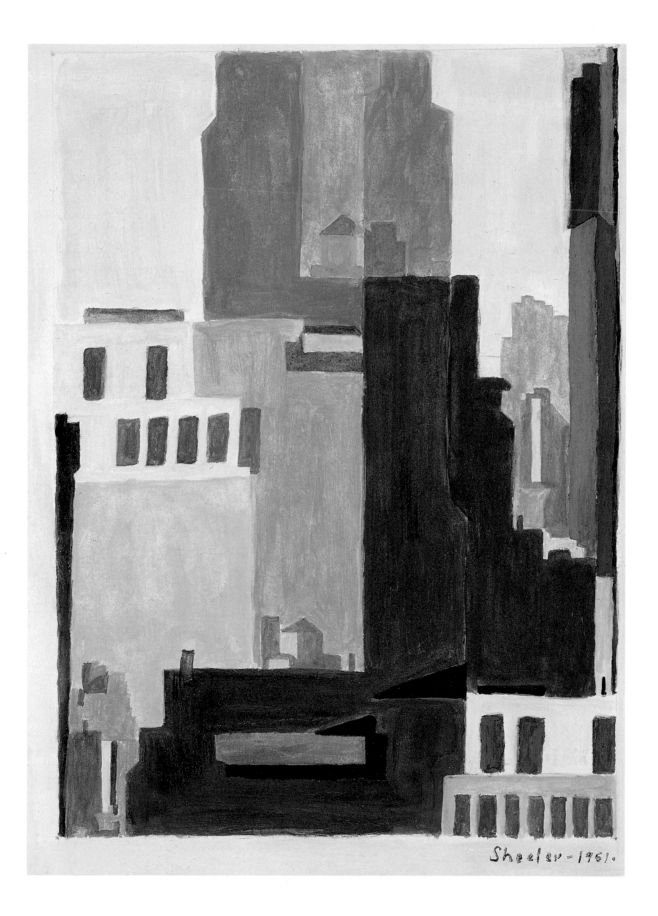

Sheeler — 1951.

WILLIAM GLACKENS

American, 1870-1938
Beach, Coney Island, c. 1907
illustration crayon, wash and Chinese white on paper
22 ¼ x 29 inches
The Mrs. Frank Tillar Fund, 1995,
95.40.2

William Glackens's associations as a young man would serve him well in later years: he attended high school with John Sloan (1871-1951) and Albert C. Barnes (1872-1951). The latter would be recognized as one of the great collectors of nineteenth- and twentieth-century art. Later Glackens attended the Philadelphia Academy of the Fine Arts, where he fell in again with Sloan, studied under Thomas Anshutz, and met fellow students George Luks and Everett Shinn. Frequently, the students met in the studio of painter Robert Henri, beginning an association that would further develop their national recognition. In 1897, Glackens began work as an illustrator for the *New York Herald*, the *New York World* and *Scribners*. Others from the Philadelphia group under Henri resettled in New York, where they were joined by Arthur B. Davies, Ernest Lawson, and Maurice Prendergast. Their association included a show at MacBeth Gallery (1908) through which they called themselves "The Eight" and were tagged by others as "The Ash Can School." In 1912 Glackens traveled to Paris on behalf of Barnes and returned with pieces by Renoir, Cézanne, Matisse, Van Gogh and others. These works would help form the core of the collection bearing Barnes's name. Shortly after Glackens returned, Davies, Walt Kuhn and Walter Pack were organizing and raising funds for the art exhibition that would be known as The Armory Show. Davies put Glackens in charge of the American entries. Despite the success of the Armory, Henri always advocated independent exhibitions and Glackens served as the first President of the Society of the Independent Artists in 1916 and 1917. Glackens received serious recognition in his lifetime, but only a minimum of larger, solo exhibitions. He was accorded a major retrospective by the Carnegie Institute, Pittsburgh, in 1939, the year following his death.

Glackens's aesthetic vision was shaped by his work as an illustrator for the *New York Herald* and the *New York World*, in which he recorded the news—fires, the Spanish-American War, and court trials—striving to capture the drama of a public event. He enjoyed the challenge of imposing an understandable or rational unity on his observations. He drew upon his carefully sharpened, news-trained shorthand to frame and capture a picturesque story.

Ira Glackens, the artist's son, and a previous owner of *Beach, Coney Island*, remarked of his father's sketchbooks, "They were more valued by him than his paintings, for they contained the material for his many beach and crowd scenes, and were the records of a lifetime of observing humanity." (See note.) The drawing *Beach, Coney Island* is a tangle of figures walking in groups, standing or sitting in the sand, conversing, primping and attending to children. The activity is suggestive of the chaos seen during his journalistic work combined with the bathing and leisure scenes from the paintings of the French Impressionists he came to admire. Not to be confused with his earlier French counterparts, Glackens portrays nearby cabanas and the fisherman's pier, which are Coney Island landmarks. This complex panorama offered Glackens precisely the challenge which he best enjoyed: to find the order in the spontaneity of ordinary life and to give it a permanence that would be meaningful for later viewers. G.N. and B.Y.

Sources:

DeGregorio, Vincent. *The Life and Art of William Glackens.* Doctoral dissertation, Ohio State University, 1955. Ann Arbor, MI: University Micro Films International.

Du Bois, Guy Pène. *Memorial Exhibition of Works by William Glackens.* Pittsburgh: Carnegie Institute, 1939.

Flint, Janet A. *Drawings by William Glackens.* Washington, D.C.: Smithsonian Institution Press, 1972.

Gerdts, William H. and Jorge H. Santis. *William Glackens.* New York: Abbeville Press for Fort Lauderdale Museum of Art, 1996.

Glackens, Ira. *William Glackens and the Ash Can School.* New York: Crown Publishers, Inc., 1957.

Note:
In Janet A. Flint, *Drawing by William Glackens,* n.p.

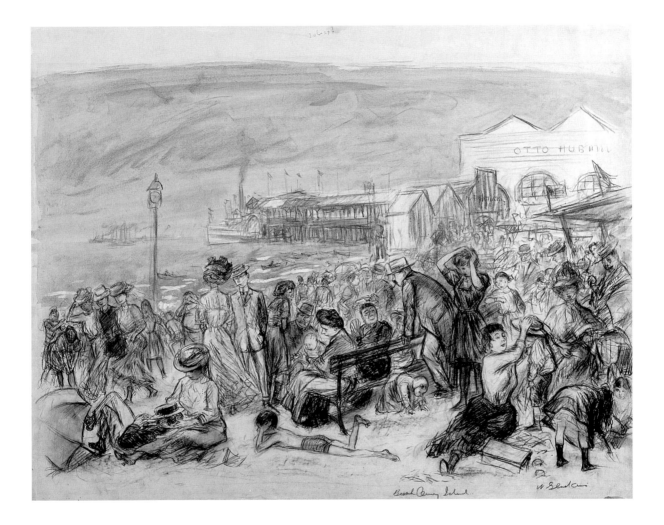

Beach Coney Island. W. Glackens

REGINALD MARSH

American, 1898-1954
Fat Lady on the Beach, 1954
egg and ink on panel
7 ½ x 10 ½ inches
The Tabriz Fund, 1982.
82.15

Reginald Marsh was born in Paris to American parents, but moved with his family to New Jersey in 1900. He attended Yale University, working as an artist for the *Yale Record*. This served him well for a move to New York City, where he found employment as an illustrator for the *New York Evening Post*, the *New York Herald, Vanity Fair* and *Harper's Bazaar* (1920-22). From 1920 to 1924, Marsh studied at the Art Students League with John Sloan, Kenneth Hayes Miller and George Luks. In the late twenties, he contributed to the *New Yorker, Esquire, Life* and other popular magazines. In 1930 he joined Frank K.M. Rehn Gallery, New York where he exhibited annually from 1930 to 1953. In 1935 he painted murals for the Post Office Building, Washington, D.C. Yale University Art Gallery honored him with a solo show in 1937, as did the Berkshire Museum, Pittsfield, Massachusetts in 1944. His book *Anatomy for Artists* was published in 1945. He was given a retrospective exhibition at Carnegie Institute in 1946-47 and a Memorial Exhibition at the Whitney Museum of American Art, New York, in 1955.

Marsh was enchanted with New York City and its people. He prowled its streets with a sketchbook seeking his subjects, loving the crowds, the Bowery, Fifth Avenue, and the theater district. Marsh had a responsive feeling for the lower classes, the vulgar and seamy aspects of New York. He found his Venuses striding under the elevated tracks, at the Burlesque houses, sunning on a Harlem street corner, or flirting with a lifeguard at Coney Island. As an illustrator, Marsh approached his urban subjects with a journalist's sharp eye. He drew in pencil, in China ink and with a burin, engraver and etching needle. He emphasized watercolor so that he could preserve his drawing traces in color, which he also did in the egg yolk medium. In his use of drawing and color and the overlay of glazes, he sought to achieve the transparency and depth of the old masters.

Marsh's *Fat Lady on the Beach*, done the year of his death, is a jewel-like sheet onto which the artist has concentrated a trio of monumental figures and conveyed the life experience of summer at Coney Island. Marsh specifically remarked on this place, "I like to go there because of the sea, the open air, and the crowds—crowds of people in all directions, in all positions, without clothing, moving—like the compositions of Michelangelo and Rubens." (See note.) Marsh died prematurely, and this small work epitomizes the aspects which affected him: journalism, suggested by *New York Post* in left foreground; the concentration on unidealized female anatomy; his debt to Rubens; and the lure of the indigenous reality of New York. G.N and B.Y.

Sources:

Cohen, Marilyn. *Reginald Marsh's New York (Paintings, Drawings, Prints, and Photographs)*. New York: Whitney Museum of American Art in association with Dover Publishers, 1983.

Garver, Thomas H. *Reginald Marsh: A Retrospective Exhibition*. Newport Beach, CA: Newport Harbor Art Museum, 1972.

Goodrich, Lloyd. *Reginald Marsh*. New York: Whitney Museum of American Art, 1955.

Laning, Edward. *East Side, West Side / All Around the Town*. Tucson, AZ: University of Arizona Museum of Art, 1969.

————.*The Sketchbooks of Reginald Marsh*. Greenwich, CT: New York Graphic Society, Ltd., 1973.

Note:
In Edward Laning, *The Sketchbooks of Reginald Marsh*, p. 58.

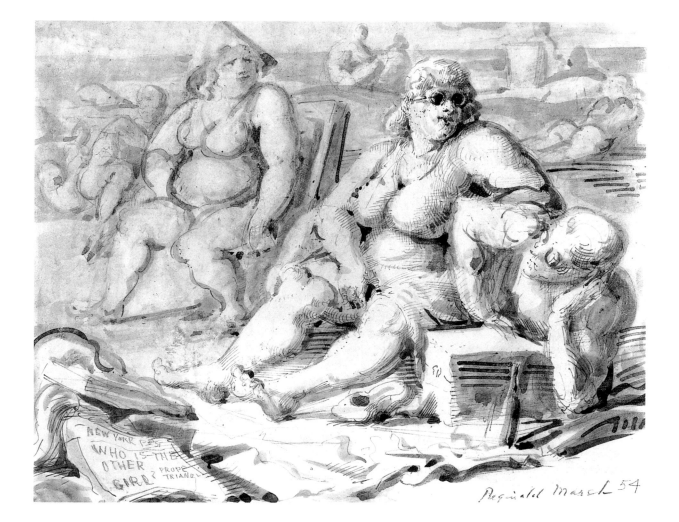

NEW YORK POST
WHO IS THE
OTHER
GIRL? PROPE
TRIANO

Reginald Marsh 54

EDWARD HOPPER

American, 1882-1967
Couple at Window, c. 1962
sanguine crayon on beige paper
8 ½ x 11 inches
The Barrett Hamilton Acquisition Fund, 1988.
88.4

From 1900 to 1906, Edward Hopper studied at the New York School of Art with Robert Henri, William Merritt Chase and Kenneth Hayes Miller and counted among his classmates Rockwell Kent, George Bellows and Guy Pène du Bois. Following brief travel throughout Europe in 1906 and 1910, Hopper established a Washington Square home in Manhattan, where he settled permanently for the next fifty years, except for summers in New England, including Maine and Massachusetts. In 1913 Hopper exhibited one of his paintings in the Armory Show. Awards and exhibitions were numerous for Hopper. Among the highlights: He sold a painting to the Brooklyn Museum in 1923 (for $100); inclusion in *Nineteen Living Americans* at the newly opened Museum of Modern Art, New York (1932); and acceptance in the first Whitney Biennial of American Art, also 1932. A year later he had a retrospective at The Museum of Modern Art. The Whitney Museum of American Art hosted a retrospective in 1950, which traveled to the Museum of Fine Arts, Boston, and the Detroit Institute of Arts. Fourteen years later, the Whitney hosted another retrospective. Large exhibitions of his work continued to follow.

Hopper was a successful illustrator, but he turned away from that practice as soon as it was economically feasible to concentrate on painting. His subject matter leaned toward isolated buildings—lighthouses; a house by the railroad; a lighted drug store at night; lone women in urban interiors, often at a window, looking out; a few isolated figures in a cafe late at night; or a solitary man—at a gas pump at dusk, raking leaves in the side yard, or sitting dejectedly on a stoop. Hopper captured the inner life of modern urban times with a simplicity and clarity that gave dramatic urgency to his images, making the mundane resonate with human significance.

Couple at Window is a small drawing with a bold rendering of the building's exterior and two figures who are drawn forward to follow an unseen development outside. The size of the sheet and the roughness of the drawing suggest that the artist would develop the theme further in a second and larger drawing, perhaps giving greater attention to the posture of the figures, the angle of light falling on them, the social tension between the woman and man, and the implicit impact of some event. Hopper's drawings could ultimately lead to a design for a painting, or like the Arts Center's, they may have served as a jumping point to rework a similar subject or theme.

Sources:

Barr, A.H., Jr. and Charles Burchfield. *Edward Hopper, Retrospective Exhibition.* New York: The Museum of Modern Art, 1933.

Goodrich, Lloyd. *Edward Hopper: Retrospective Exhibition.* New York: Whitney Museum of American Art, 1950.

Levin, Gail. *Edward Hopper: The Art and the Artist.* New York: W.W. Norton and the Whitney Museum of American Art, 1980.

Hobbs, Robert C. *Edward Hopper.* New York: Harry N. Abrams, in association with the National Museum of American Art, 1987.

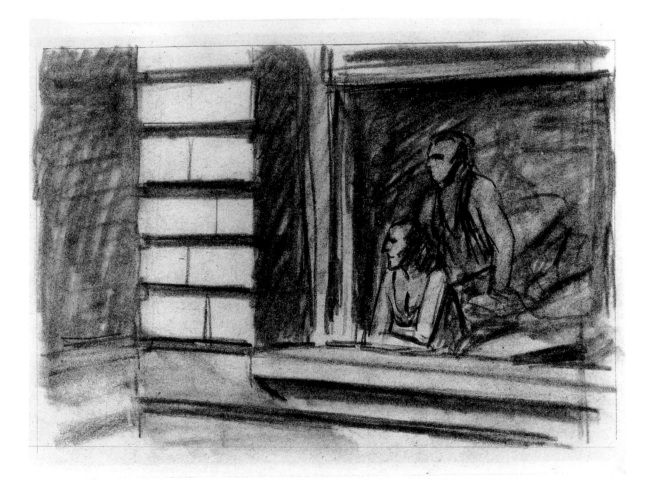

FAIRFIELD PORTER

American, 1907-1975
Untitled, 1968
pencil on paper
22 x 30 inches
The Tabriz Fund, 1992.
92.11

The son of an architect, Fairfield Porter was born Hubbard Woods in Winnetka, Illinois. Following completion of a BA in Art History from Harvard, in 1928 he moved to the Art Students League, New York, to work with Thomas Hart Benton and Boardman Robinson. After a stint traveling in Europe in 1931-32, he settled in New York. He felt an early admiration for the watercolors of John Marin, who lived not far from the family's summer home in Maine. Also during the early thirties, he met Alfred Stieglitz and became aware of the work of Arthur Dove, Yasuo Kuniyoshi and Oscar Bluemner. By 1934 he had met Willem de Kooning and bought an early work of his. Following a return to Winnetka, he came back to New York, where during the war, he worked on classified drafting projects. He practiced as an art critic from 1951-61, writing and serving as Associate Editor for *Art News* and later for *The Nation*. During the fifties, he befriended a new generation of figurative artists including Alex Katz, Larry Rivers and others. In 1959 he wrote *Thomas Eakins*, published by George Braziller. After 1960 he devoted a portion of his career to teaching at Yale University, the University of Alabama, the Skowhegan School of Art, Maine, and the Maryland Institute. As an artist he exhibited at Tibor de Nagy from 1951 to 1970 and thereafter at M. Knoedler until his death in 1975. His work has been exhibited in six Whitney Annuals. Other museums that showed his work include the Rhode Island School of Design (1959), the Cleveland Museum of Art (1966), the U.S. Pavilion, Venice Biennale (1968), and the Parrish Art Museum, Southampton, (1971).

Porter's subjects are the most normal and bland of daily life: views through the bedroom window or the backporch door; a still life; a self-portrait in the studio; his wife or son; a painter friend. Inside or out, Porter's light is undramatic, without deep shadows, always even and clear.

Untitled is an urban scene, perhaps from the window of a café, looking out on a busy street, with cars and buses waiting for their signals to change. Lampposts establish the curb plane; a traffic light hangs abstractly in the crossing; parking signs have their place, but commercial signs are missing, as are hydrants, mailboxes, dumpsters and police barriers. The massing of buildings is the scenic backdrop for vehicles and pedestrians and serves as the subject. Trees soften macadamized nature with mini-parks. Porter did not consider himself to be an outstanding draftsman. He drew complex works like this sheet with the belief that there was a finished work lurking from the idea in pencil. Paul Cummings asserted *Untitled* was a study for a lithograph and added, "Here the outlines are used simply to enclose panels of strong hatching which indicate shifting degrees of light and dark or brittle textural differences." (See note.)

G.N. and B.Y.

Sources:

Agee, William C. *Fairfield Porter.* Southampton, NY: Parrish Art Museum, 1993.

Ashbery, John, Kenworth Moffett, John Bernard Myers, et al. *Fairfield Porter 1907-1975: Realist Painter in an Age of Abstraction.* Boston: Museum of Fine Arts, 1982.

Cummings, Paul. *American Drawings: The 20th Century.* New York: Viking Press, 1976.

Ludman, Joan. *Fairfield Porter: An American Classic.* New York: Harry N. Abrams, 1960.

Porter, Eliot. *Fairfield Porter.* Chicago: The Arts Club of Chicago, 1984.

Note:
Paul Cummings, *American Drawings: The 20th Century*, p. 129.

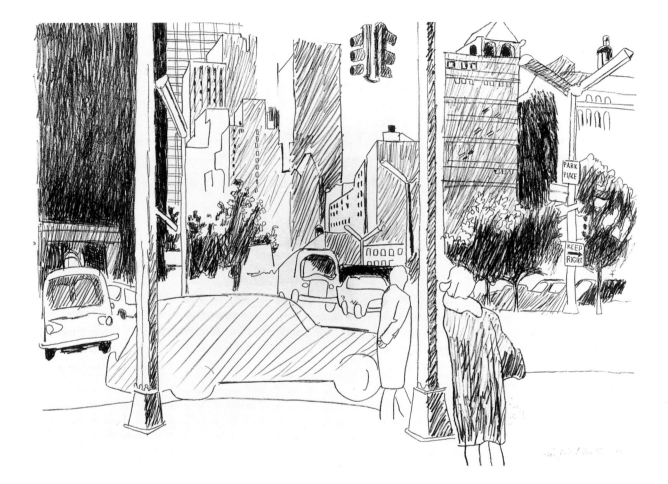

ROBERT COTTINGHAM

American, b. 1935
Barrera-Rosa's, 1983
graphite on vellum
23 ½ x 41 ¾ inches
The Barrett Hamilton Acquisition Fund, 1984.
84.29.2

When surveying the twentieth century to find those artists who found inspiration in the urban landscape, images of streetcorners and backyards, viewers are led to Robert Henri, John Sloan and William Glackens. In the work of John Marin, Abraham Walkowitz and Lyonel Feininger, the dynamism of the city's skyline and buildings were intriguing sources. In Edward Hopper, the isolation and loneliness of the city's inhabitants were the focus. In the work of Robert Cottingham, we find a very different concentration on the urban environment. Cottingham's subjects are the signs and storefronts themselves. Eliminating any reference to nostalgia or a bygone era, he uses the streetscape to connect contemporary life to man, finding vitality, persuasion and humor along the way.

Cottingham, a graduate of Pratt Institute in Brooklyn and a recipient of a National Endowment for the Arts award in 1974-75, is often called a "photorealist." The term, made popular in the mid-1970s, refers to work that has a clarity and "truth-to-the-eye" that is associated with photography, though it is not necessarily a reproduction of a photographic image. His work has been included in two of the major traveling exhibitions on this theme, *Contemporary American Realism Since 1960* (organized by the Pennsylvania Academy of Fine Art) and *Real, Really Real, Super Real* (organized by the San Antonio Museum of Art). He has taught at the Art Center College of Design in Pasadena, California.

The drawing *Barrera-Rosa's* is based on a single image of a city street in Los Angeles; the name derives from the Mexican restaurant depicted in the center. The drawing is one of a series that supports the large five-by-fourteen-foot painting of the same title and image formerly from the Fendrick Gallery, Washington, D.C. The drawings are studies, some investigating abstract patterns within the scene, others detailing shapes and lines, others like the Arkansas Arts Center's pencil drawing, dealing with values. With respect to content, Cottingham fills his work with messages. In his crisp, clear panorama, signs have relationships to people: the bar and liquor store refers to consumption; the barber shop to fashion; the office entrance to a work ethic; and the Mexican restaurant to cultural diversity. There are several cultural icons in familiar logos and a subtle humor in the juxtaposition of these varieties with the simple one-way sign.

For Cottingham, signs are communication. They are objects rich in language, ideas and ingenuity. In the context of storefronts, the images become metaphors for the activities and choices in our daily lives. Through *Barrera-Rosa's*, we see a reflection of ourselves and of the world we have built around us. G.N and M.P.

Sources:
Meisel, Louis K. *Photo Realism*. New York: Harry N. Abrams, 1980.
Preble, Michael. *Cottingham: Barrera-Rosa's*. Little Rock: Arkansas Arts Center, 1985.
Spencer, DaLee. *Robert Cottingham*. Wichita, KS: Wichita Art Museum, 1984.

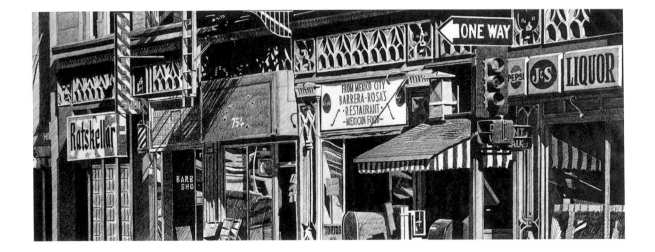

II. PORTRAITS

Bernard Perlin

American, b. 1918
Portrait of E. M. Forster, 1947
silverpoint on prepared paper
11 x 9 inches
The Arkansas Arts Center Foundation Purchase, 1986.
86.35

Bernard Perlin began to study painting the summer after graduation in 1934. He was enrolled at the New York School of Design (1934-36); the National Academy of Design (1936-37); and the Art Students League (1938). His instructors included Isabel Bishop and William Palmer. At the beginning of World War II, he worked for the Office of War Information, and then became a war correspondent for *Life* magazine in the Middle East (1943-44) and for *Fortune* magazine (1945) in the Pacific and the Orient. Following the war, Perlin became an instructor at the Brooklyn Museum of Art School. From 1948 to 1954, he lived in Italy. Despite his residence abroad, he exhibited in the U.S. during those years and immediately following: the Art Institute of Chicago (1949, 1954, 1959); the Metropolitan Museum of Art (1950); the Whitney Museum of American Art (1951, 1955, 1956). These shows were followed by ones in the Cincinnati Art Museum (1958), and the Detroit Institute of Arts (1960). In 1969 a retrospective exhibition was presented at the University of Bridgeport. Numerous prestigious institutions continue to exhibit his work to the present.

According to Bruce Weber, in 1947 Perlin was asked by the author Glenway Wescott to draw in silverpoint the portraits of well-known writers Katherine Anne Porter, Somerset Maugham and E(dward) M(organ) Forster. (See note.) The latter, the subject of the Arkansas Arts Center's drawing, was a Fellow of Kings College,

Cambridge, and the distinguished author of *A Room with a View, Howard's End, Maurice* and *Passage to India*. During the Renaissance, when silverpoint drawing was developed, the technique was understood to be among the most demanding of media with which to work. It was employed by masters such as Leonardo Da Vinci, Raphael and Albrecht Dürer. Images are created when fine, treated paper pulls off minute particles of metal from a sharpened, silver-tipped pen. Because the image is created following a chemical reaction between pen and paper, errors may not be erased or forgiven. The advantage of this medium is the subtlety that it affords. Silverpoint was a lost process and was not introduced to American artists until the late nineteenth century. In the case of the Forster portrait, the subtlety in shadows, the sense of volume and the texture of the flesh seem to match the presumed sensitivity of the writer. G.N. and B.Y.

Sources:
Weber, Bruce and Agnes Mongan. *The Fine Line: Drawing with Silver in America.* West Palm Beach, FL: The Norton Gallery of Art, 1985.
Wescott, Glenway. *Bernard Perlin.* New York: Catherine Viviano, 1963.

Note:
Bruce Weber and Agnes Mongan, *The Fine Line*, p. 28, fn. 25.

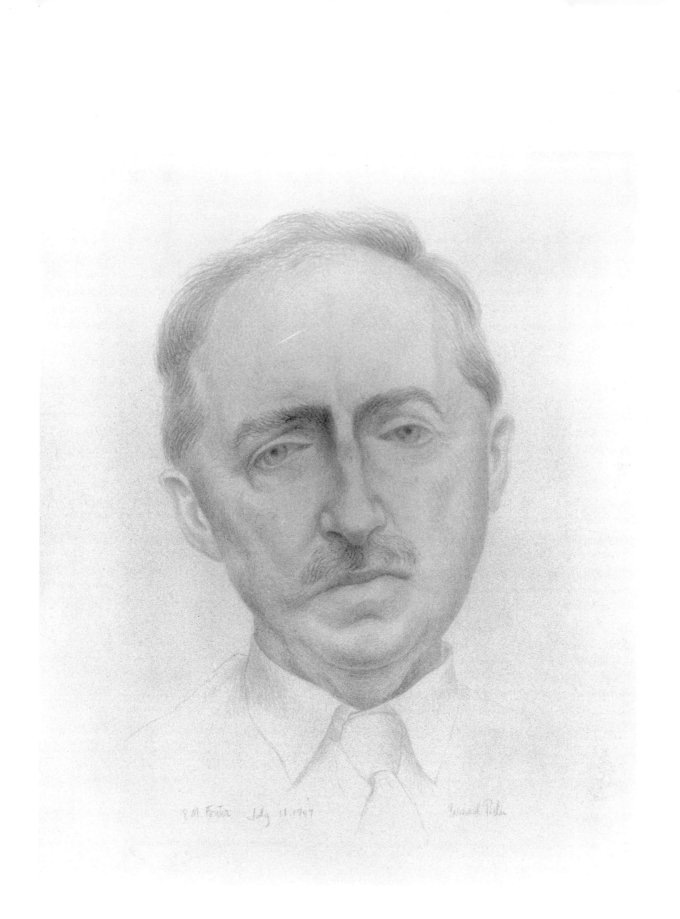

E.M. Forster July 11.1947 Bernard Perlin

JOSEPH STELLA

American, 1877-1946
Therese Duncan Bourgeois, c. 1920
silverpoint on paper board
21 ⅜ x 17 ½ inches
Arkansas Arts Center Foundation Purchase, 1989.
89.11

Joseph Stella was born in Muro Lucano, Italy, arrived in New York at the age of nineteen and shortly after was enrolled at the Art Students League. This was followed by instruction from William Merritt Chase at the New York School of Art (1889-1900). Early in his career, Stella published drawings in *Outlook* magazine; illustrated Ernest Poole's novel *The Voice of the Street* and even recorded mine disasters in West Virginia. In 1911-12, he traveled back to Europe where he met fellow artists Henri Matisse, Amedeo Modigliani, Umberto Boccioni and Gino Severini in Paris. Returning to the U.S., Stella was included in the Armory Show of 1913. A year later he exhibited at the Montross Gallery, New York. Walter Arensberg, the great collector, frequently received Stella at his home in 1915, where he met Marcel Duchamp, Francis Picabia, Man Ray and others. Stella became one of twenty directors of the newly formed Society of Independent Artists in 1917. A few years later he had a retrospective at Stefan Bourgeois Gallery. In 1922 he was included in *Salon Dada: Exposition International* at Galerie Montaigne in Paris. Later in the twenties and thirties, he was frequently the subject of solo exhibitions in New York. After a four-year stay in Europe (1930-34), he returned to the U.S. and worked on the WPA Federal Art Project in New York (1934-39). From 1942 until his death in 1946, he was represented by M. Knoedler & Co., New York. The Whitney Museum of American Art held a retrospective of Stella's work in 1994.

Stella was regarded as a "Futurist" and of course was acquainted with nearly all of the accredited members of that movement. The use of industrial and mechanistic subject matter, including *The Voice of the City*, was only part of his achievement, however, since he had a very traditional respect for classical subjects and treatments, including the Madonna, the portrait, as well as romantic still life and landscape subjects.

Beginning in the first half of the 1920s, Stella produced a number of penetrating silverpoint portraits of his friends in New York. Always executed in profile, the sitters include Marcel Duchamp (at least twice), Joseph Gould, Edgard Varèse, Louis Elshemius and others. He liked the profile because, as he felt, it required skill and discipline. It was also a salute to the painted or cast medal portraits associated with Renaissance Italy, particularly those by Ghirlandaio and Veneziano. For those artists, profile view offered a more dignified appearance than did a three-quarter or full faced portrait. In addition to the link with the Renaissance, Stella's portrait of Therese Duncan Bourgeois is consistent with silverpoint's revival in the U.S. Weber has pointed out, "America's earliest practitioners of the silverpoint medium most commonly rendered portraits (usually heads) of young women or girls." (See note). In this regard, Stella's work is consistent with Philip Leslie Hale, Thomas Dewing, William MacGregor Paxton and others. In particular, Dewing's *Head of a Young Woman*, c. 1895 (Memorial Art Gallery of Rochester) may be one such prototype for Stella, with its taught features, hair up, and long neck, set timelessly floating in the center of the paper. Unlike the aforementioned practitioners of the medium, Stella's silverpoints serve notice of his range, contrasting greatly with his more famous modernist aesthetic. G.N. and B.Y.

Sources:

Baur, John I. H. *Joseph Stella*. New York: Praeger Co., 1971.

Gerdts, William H. *Drawings of Joseph Stella*. Newark, NJ: Rabin & Krueger Gallery, 1962.

Haskell, Barbara. *Joseph Stella*. New York: Whitney Museum of American Art (distributed by H. N. Abrams), 1994.

Moser, Joann. *Visual Poetry: The Drawings of Joseph Stella*. Washington, D.C.: Published for the National Museum of American Art by the Smithsonian Institution Press, 1990.

Weber, Bruce and Agnes Morgan. *The Fine Line: Drawing with Silver in America*. West Palm Beach, FL: The Norton Gallery of Art, 1985.

Note:
Bruce Weber and Agnes Morgan, *The Fine Line*, p. 20.

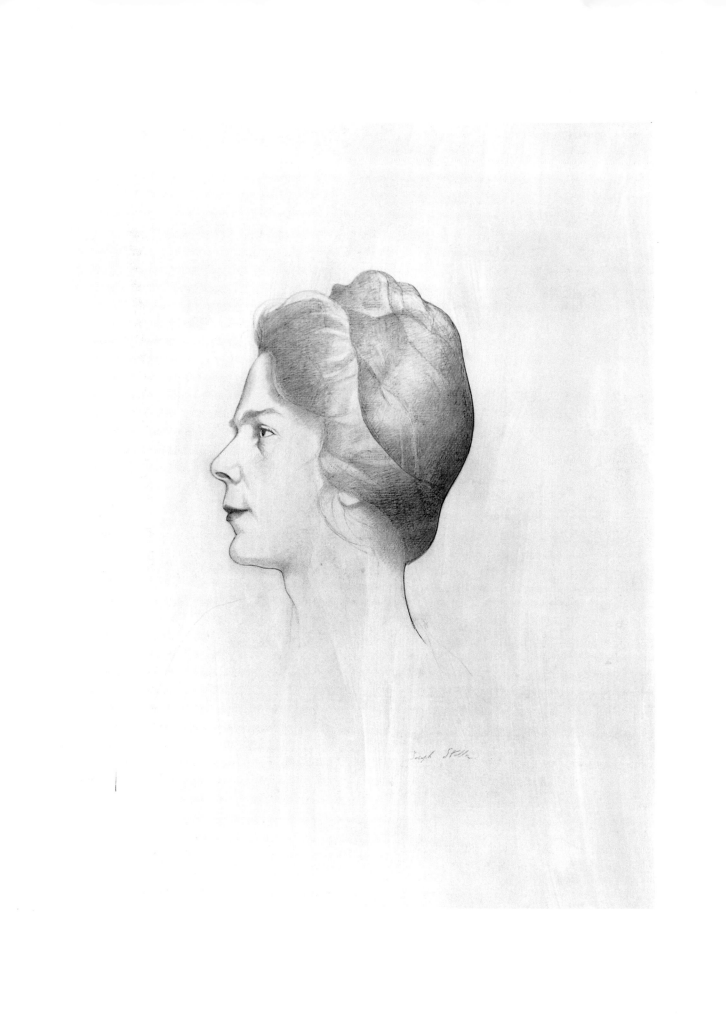

John Storrs

American, 1885-1956
Woman with Hand on Chin, 1931
silverpoint on paper
13 x 8 inches
Purchased with Gallery Contributions, 1985.
85.55

John Storrs, the son of an architect, lived in Chicago until he traveled to Europe in 1905, studying sculpture with Arthur Bock in Hamburg. (Bock's concept of unity and harmony among design, architecture, decoration and furnishings to create a total environment became a guide for Storrs.) In 1908, Storrs stopped in New York and was deeply affected by the towering skyscrapers. He studied at the School of the Art Institute of Chicago, the School of the Boston Museum of Fine Arts and the Pennsylvania Academy of the Fine Arts. In 1911 he studied at the École des Beaux Arts and the Académie Julien. In 1912 he began to study with Auguste Rodin; they became friends. Storrs even installed Rodin's work at the Panama Pacific Exposition, San Francisco, in 1917, along with two of his own works. Following Rodin's death, Storrs was asked to do a deathbed portrait of the famous sculptor. (It was executed in drypoint, later transformed into lithography.)

In the 1920s, Storrs developed a series of studies in architectural form with a broad variety of materials— metal, granite, marble and plaster. These constructions are among his most original achievements in three dimensions, establishing a machine-age imagery that contributed to the iconography of the modern era. Storrs received a number of commissions from architects in the U.S. and France, including the Trade Building, Chicago (1930); an Art Deco figure and twelve panels at the Century of Progress, also Chicago (1933);

and the U.S. Navy Monument, Brest, France (1937). His sculpture also won prizes at the 40th, 42nd, and 44th Annual Exhibitions of American Art at the Art Institute of Chicago.

Like the silverpoint by Stella and those before him, Storrs's *Woman with Hand on Chin* exemplifies the preference in this medium for the classical female bust-portrait. For Storrs, the relationship of this drawing to his work in sculpture is stylistically close. A preparatory pencil study, *Study for Hall of Science Relief* for the 1933 Chicago World's Fair, shows the same blank eyes, idealized features, and general lack of detail. Meredith Ward may have stated Storrs's artistic aim perfectly: "In his quest for formal purity, he successfully combined diverse styles of the past with contemporary artistic innovations, distilling and synthesizing them into a single, perfectly balanced unit." (See note.) Storrs's line is reminiscent of the masters from Leonardo to Ingres, but the drawing's details, such as the earring, bow and pensive gesture, remind the viewer this sitter is an elegant, contemporary figure, not the sterile embodiment of an ageless virtue. G.N. and B.Y.

Sources:

Frackman, Noel. *John Storrs*. New York: Whitney Museum of American Art, 1986.

Gordon, Jennifer, Laurie McGovern, Sally Mills and Ann Rosenthal. *John Storrs & John Flannagan, Sculpture and Works on Paper*. Williamstown, MA: Sterling and Francine Clark Institute, 1980.

Kirshner, Judith Russi. *John Storrs 1885-1956, a Retrospective Exhibition of Sculpture*. Chicago: Museum of Contemporary Art, 1976.

Ward, Meredith G. *John Storrs: Rhythm of Line*. New York: Hirschl & Adler Galleries, 1993.

Note:

Meredith G. Ward, *John Storrs: Rhythm of Line*, p. 9.

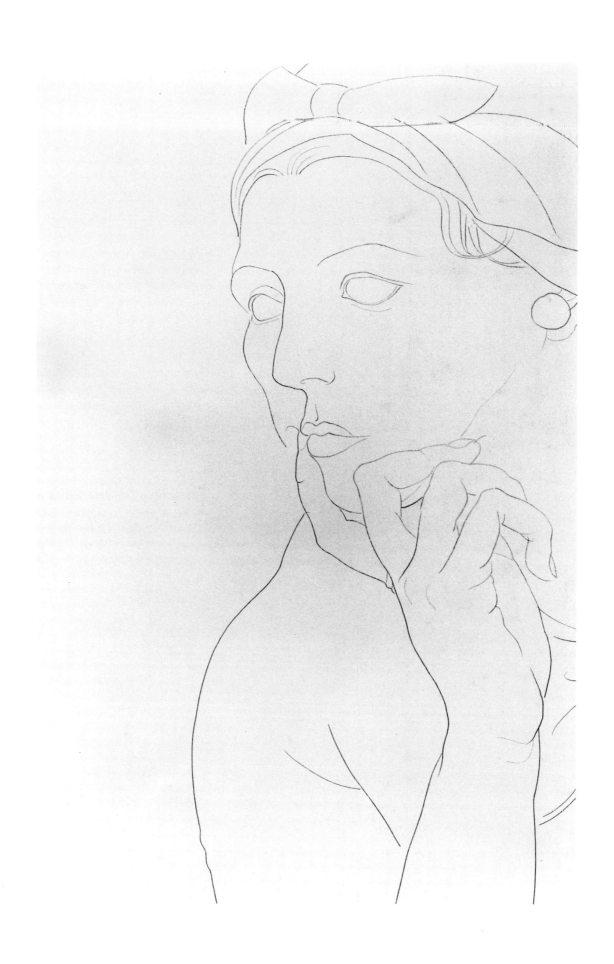

John Graham

American, b. Russia, 1881-1961
Study for Cave Canum, c. 1950s
ink, pencil and colored pencil on vellum
25 ½ x 15 ¾ inches
The Tabriz Fund, 1992.
92.8

Ivan Dabrowsky, born in Kiev, and former officer in the regiment of Grand Duke Michael and Czar Nicholas, later told a friend "… that he would have been quite content to have remained an officer in the Czar's foot-guard and tried to think of an alternative that would satisfy him as much." (See note 1.) But Dabrowsky escaped Russia, came to New York in 1920 and assumed the name John Graham in the late twenties, when he studied with John Sloan's class at the Art Students League. Despite conflicts in the facts concerning his life, he was able to move quickly in the upper echelon of artistic circles in the U.S. and abroad. In Paris his work was featured in a one-person exhibition at Galerie Zbrowoski, which also featured the work of Chaim Soutine and Amedeo Modigliani. In the U.S., in 1929, Graham was given an exhibition at the Phillips Memorial Gallery. He counted Arshile Gorky, David Smith, Dorothy Dehner, Stuart Davis, Lee Krasner and Jackson Pollock among his close associates. Graham was also a writer, occasional curator, critic and art collector. In 1937 he published *System and Dialectics of Art*, a text that championed modern and African art. Both areas formed an aspect of his personal collection as did Renaissance medals. (See note 2.) He exhibited frequently, including a show at McMillen, Inc., where his work was featured with Georges Braque, Pablo Picasso, Henri Matisse and the early Expressionists.

In his text, Graham includes a brief passage on portrait painting: "Portrait with likeness as an aim, cannot be a work of art … " (See note 3.) He explains that the artist's actions are imperfect as he attempts to place the three-dimensional onto the flat, premeasured surface. Thus, the wandering eyes in the female and dog in *Study for Cave Canum* are an example of a common motif in Graham's work, as is the slight, dripping wound. The economical line is also typical, reflecting Graham's belief that shapes within the space are as important as that which is depicted. Graham's diverse interests in magic, previous lives, mythology and philosophy make the determination of a clear subject tempting, but Eila Kokkinen cautions, "Since the sources from which Graham drew are so diverse, any attempt to interpret his symbols remains speculative. However, in later years Graham himself said his pictures were not intended to be beautiful, but to convey occult information which would be recognizable to only a few." (See note 4.)

Sources:

Graham, John. *System and Dialectics of Art*. New York: Delphic Studios, 1937.

Green, Eleanor. *John Graham, 1881-1961, Drawings*. New York: Andre Emmerich Gallery, 1985.

————. *John Graham, Artist and Avatar*. Washington, D.C.: Phillips Collection, 1987.

Kokkinen, Eila. "Ioannus Magus Servus Domini St. Georgii Equitus." *Art News*, vol. 67, no. 5 (September 1968).

Notes:

1. Eila Kokkinen, *Art News*, p. 64.
2. Ibid., p. 65.
3. John Graham, *System and Dialectics of Art* (1971 edition), p. 182.
4. Ibid., p. 66.

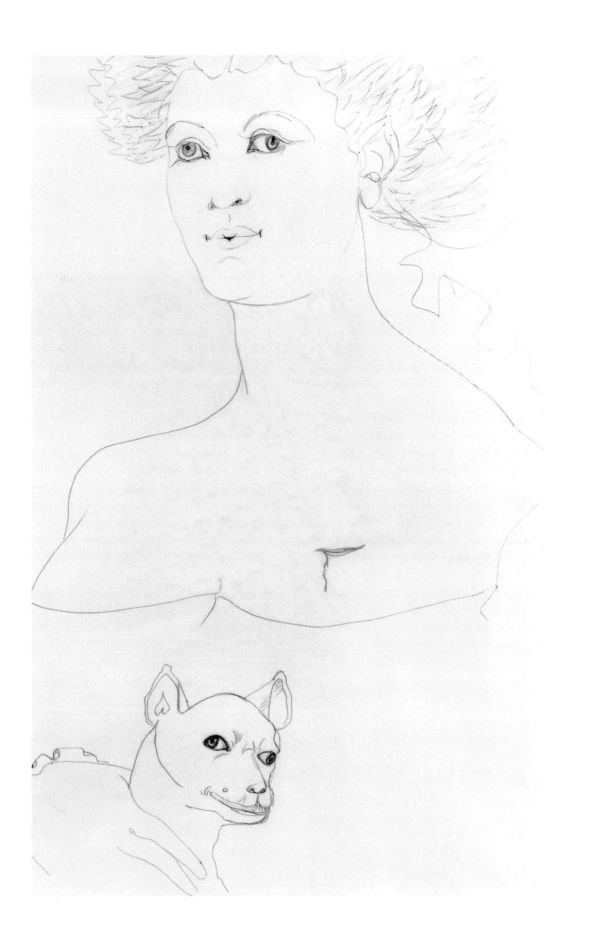

WILLIAM BAILEY

American, b. 1930
Portrait Head, 1977
pencil on paper
15 x 11 ¼ inches
The Barrett Hamilton Acquisition Fund, 1981.
81.63.1

William Bailey graduated from Yale with a BFA degree in 1955 and an MFA in 1957. He has remained on campus, at least in part, as a professor of painting for the Yale School of Art. Since the early 1970s, Bailey has also been returning regularly to Italy. Significant solo exhibitions in his career have come at the City University of New York, Queens College (1972); the Tyler School of Art, Temple University (1972); André Emmerich Gallery, New York (1992); and Southern Methodist University, Dallas (1993).

The frequent trips to Italy, and Bailey's admiration for the old masters, may explain the conservative nature of the subjects and their treatment in Bailey's pictures: carefully arranged still lifes and quiet female nudes. Bailey draws frequently, often for use in later paintings. Yet, one would not refer to *Portrait Head* as a mere study. The economy in preserving much of the paper's purity is intentional. Roger Kimball remarked of Bailey's use of space, "It has something of the flatness of de Chirico's dreamscapes without their creepiness, something of the sparseness of Balthus's portraits without the hint of perversion that are his trademarks." (See note.) The reference to Balthus is appropriate, or one may find Bailey's portraits resting somewhere within the uneasiness of John Graham's *Study for Cave Canum* and the idealism of Joseph Stella's *Head of a Woman in Profile* silverpoint.

Sources:
Brigante, Giuliano and John Hollander. *William Bailey*. New York: Rizzoli, 1991.
Cather, Willa. *A Lost Lady*. (Illustrations by William Bailey, introduction by John Hollander) New York: The Limited Editions Club, 1983.
Kimball, Roger. "Apart From the Mainstream." *Wall Street Journal*. May 18, 1992.
Strand, Mark. *William Bailey*. New York: Harry N. Abrams, 1987.

Note:
Roger Kimball, "Apart from the Mainstream," *Wall Street Journal*.

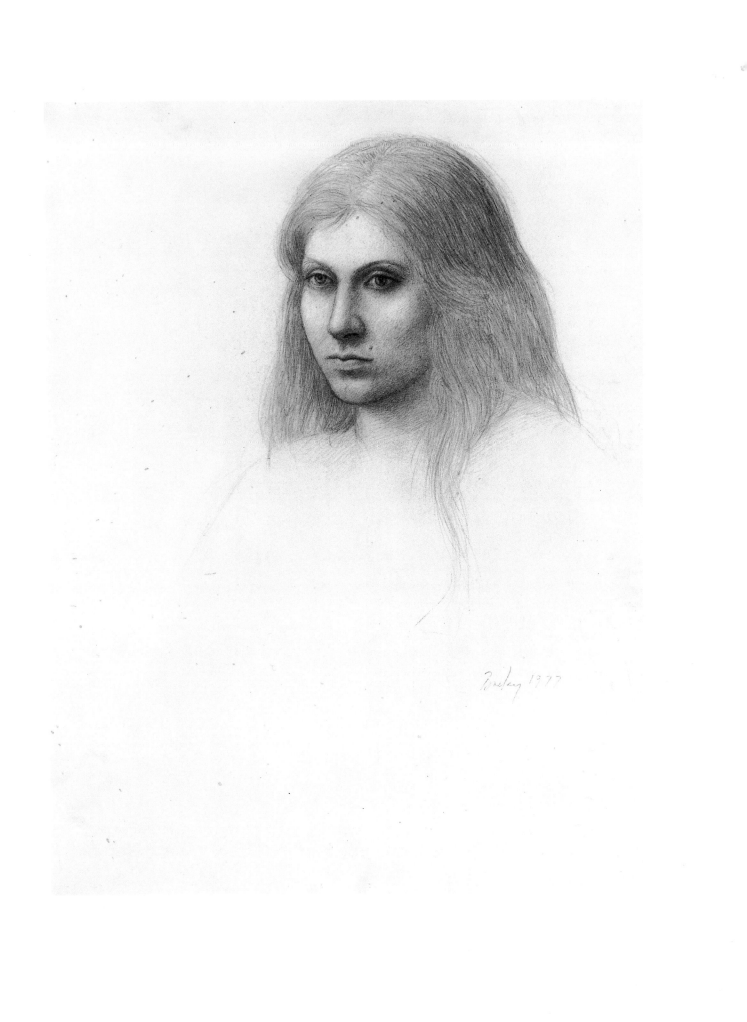

PAUL OTERO

American, b. 1950
Her Waiting: Edda's Voice, 1991
graphite on paper
21 x 19 inches
The Tabriz Fund, 1992.
92.24

Paul Otero feels that he is something of an outsider. Born in Colorado and raised in Nebraska, Otero went on to earn his BA and MA degrees at the University of Nebraska-Kearney in the years 1978 and 1979. Recent one-person exhibitions have often been hosted in smaller campus venues: Creighton University (Omaha), Kearney State College (Nebraska), Iowa Western Community College, and Dana College (Nebraska). In 1991 he showed at Artspace in Omaha and Alexander F. Milliken, Inc., New York. Group exhibitions tend to offer him greater national recognition, including the *163rd Annual Exhibition* of the National Academy of Design, New York (1988), and the *Collectors Show*, Arkansas Arts Center (1988).

For the last ten years, drawing in pencil has been Otero's principal medium. He has been known to shift to another medium, such as watercolor, in order to clear his head and refresh himself for pencil drawing, but that is more for exploration and change of pace than to produce art. "With a pencil in my hand it is like hunting, and chasing something down." (See note.) To take notes on images he finds interesting, he keeps a notebook to record impressions, feelings and a sense of what is communicative in a particular image. Otero also uses a 35mm camera to record images of value. Occasionally he returns to the photographs and notebooks for hints of what he might do next. *Her Waiting: Edda's Voice* was stimulated by a photograph he took of a young woman in Victor, Colorado, during a family trip. He was intrigued by the subject's intense, silent gaze and he felt a sympathy for what he sensed was her dawning awareness that life is uneasy, uncertain and saddening. Later, while listening to the soundtrack for the film "Once Upon a Time in the West," he heard the songs of the singer Edda. Her voice, that music and the image of his photographic subject—June Sullivan—"clicked" for him, and he had the title and theme he wished to explore. "June was caught somewhere between music and silence, listening to an inner dialogue of complex life stirring beneath the surface." (See note.) He spent four and one-half months on the drawing. He is clearly contrasting the fresh vitality and wonder of youth with the decay and deterioration of the worn backdrop building.

Note:
Conversations between Otero and the author, May-June 1995.

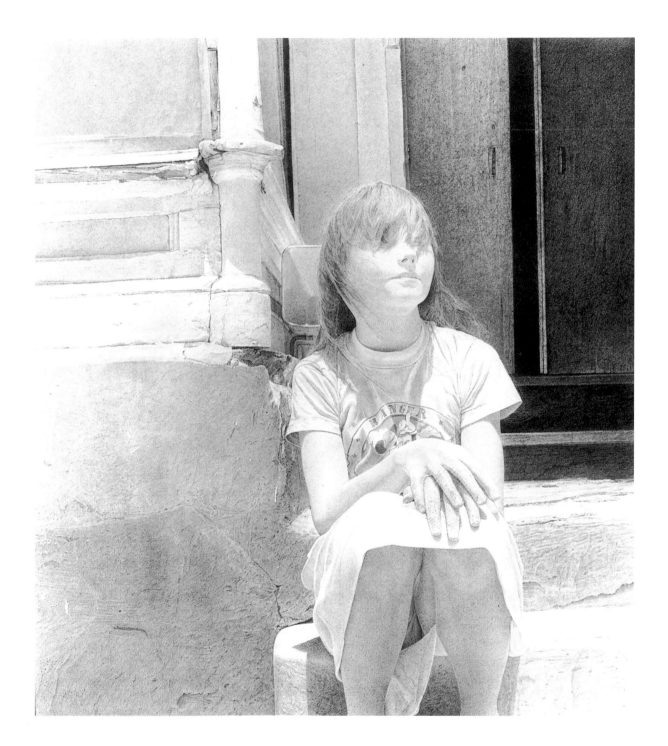

PHILIP EVERGOOD

American, 1901-1973
Girl in Brocade Chemise (Mrs. Akstow), 1964
ink, chalk and wash on paper
24 ⅛ x 19 ¼ inches
Purchased with a gift from Virginia Bailey, 1986.
86.27

Philip Evergood was born in New York City to a Polish-Austrian father (a landscape painter) and an English mother who had studied music in Vienna and art in Paris and Munich. Philip was educated in English boarding schools and attended Cambridge University, where he met sculptor Harvard Thomas. In the early twenties, he studied with George Luks at the Art Students League in New York. In 1923 he was in Paris and studied at the Académie Julien with André Lhote. It was in Paris that he met Emile-Antoine Bourdelle, Jules Pascin, Man Ray, Paul Signac and Maurice Utrillo. He returned to the U.S. in 1925, lived in New Jersey and began to exhibit at Dudensing and Montross Galleries, New York. In 1931 he met Ben Shahn and Reginald Marsh and exhibited a painting at The Museum of Modern Art, New York. In 1934 he exhibited at the Whitney Biennial and the Art Institute of Chicago. In 1935 he had a solo exhibition at the Denver Art Museum. The University of Minnesota, Duluth, featured a retrospective of his work in 1953. Tulane University and the Iowa State Teachers College hosted exhibitions devoted to his drawings.

Evergood was an idealist, an imaginative, even fanciful painter who became charged with the social issues of his times and by the political problems of the Great Depression. His instinctive sympathies for the downtrodden, the working man, black rights and the Loyalist cause in Spain led him to the political Left, and he became a social realist painter. Tragic subjects were not exclusive to his earlier years in the thirties. In 1962, for example, he painted *Abandoned Doll*, which was a tribute to Marilyn Monroe who succumbed to an untimely death.

Evergood's portrait drawing is not altogether different from his social realist painting. It is a more intimate introduction to the artist's work and may tend to catch the artist in a more personal and less public posture. *Lady in Brocade Chemise* is a vigorous image of an intense young woman, focusing on her head, posture, wrists and especially her hands, emerging from a dark but diaphanous, patterned garment. The face is both a portrait and an Evergood in that it resembles an inquiring female face, not unlike those that appear in the foreground of *Mine Disaster* and *American Tragedy*, both from the thirties. Notably, the drawing was included in the exhibition *A Decade of American Drawings, 1955-1965*, at the Whitney Museum of American Art (1965). It was reproduced in John Baur's lengthy monograph on the artist—one of only a handful of drawings featured. G.N. and B.Y.

Sources:
Baur, John I. H. *Philip Evergood*. New York: Whitney Museum of American Art, 1960.
————. *Philip Evergood*. New York: Harry N. Abrams, 1975.
Larkin, Oliver. *Philip Evergood: 20 years*. New York: ACA Galleries, 1946.
Taylor, Kendall. *Philip Evergood: Never Separate from the Heart*. Lewisburg, PA: Bucknell University Press, Association of University Presses, 1987.

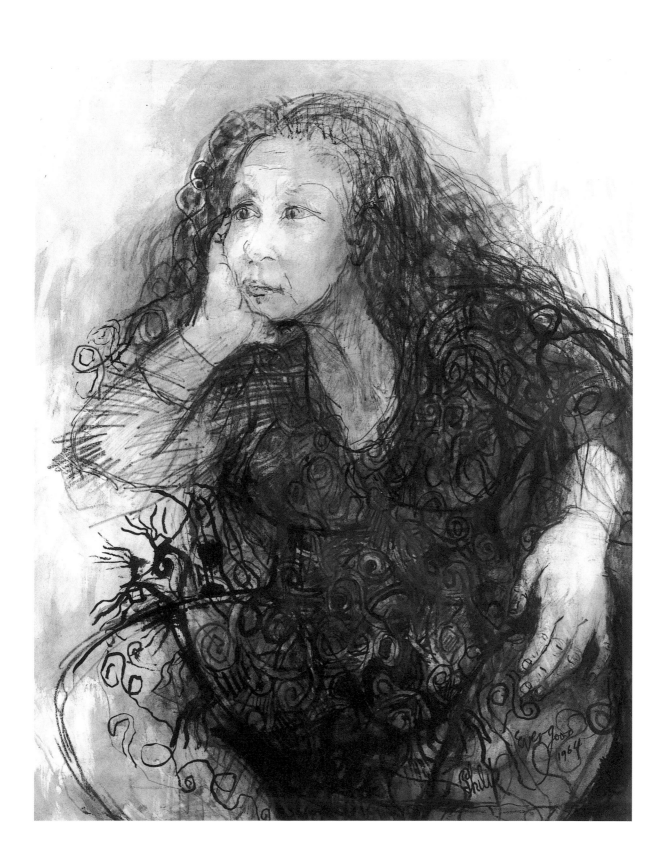

JIM DINE

American, b. 1935
Mauve Figure, 1978
pastel, charcoal, oil and collage on paper
45 x 31 ½ inches
The Museum Purchase Plan of the NEA and the Tabriz
Fund, 1980.
80.10

A native of Cincinnati, Jim Dine conveniently studied
art as a child at the Cincinnati Art Museum and as a
high schooler at the Art Academy of Cincinnati.
Following further study at the University of Cincinnati
and the Boston Museum of Fine Arts School, he
received a BFA degree from Ohio University. He moved
to New York in 1958 where he associated with Claes
Oldenburg through the Judson Gallery. By the early
1960s, apparently against his wishes, he became known
as one of the leaders of the Pop Art movement.
Following exhibitions in Paris, Milan, Cologne and
Brussels, he was included in the Venice Biennale of
1964. In 1970, the Whitney Museum of American Art
hosted a retrospective for Dine. Ten years later *Jim Dine:
Figure Drawings*, 1975-79, came to the Arkansas Arts
Center, including *Mauve Figure*, which the Center pur-
chased from Pace Gallery, New York, at the conclusion
of the tour. The Walker Art Center, Minneapolis, gave
Dine a retrospective in 1986.

Often for Dine the drawing process is not merely an
additive one (that is, involving the application of mate-
rials); it is also an equally rigorous, subtractive one. The
surface may be torn, rubbed, mechanically sanded and
reworked until Dine is satisfied. Such are the effects on
Mauve Figure. Dine summed up his work from 1974-80:

I specifically sat down to train myself. I went back to
the figure, as it were…. It goes into everything.
Every drawing, every painting, is about those figure
drawings, in that I've learned how to sense what is
needed, to correct, and to love correcting. I am
interested in the drawing being a living object that is
constantly changed by me—corrected and corrected.
(See note.)

In *Mauve Figure*, the drawing reveals a daring process
and a bold composition, far from the polished look of
the Pop artists, including Oldenburg, for example, with
whom Dine did not want to join in the burden of con-
forming to the critics' label.

Sources:

Glenn, Constance W. *Jim Dine: Figure Drawings, 1975-79*. Long Beach, CA: The Art Museum and Galleries, California State University, Long Beach, 1979.
———. *Jim Dine: Drawings*. New York: Harry N. Abrams, 1985.
Shapiro, David. *Jim Dine: Painting What One Is*. New York: Harry N. Abrams, Inc., 1981.

Note:
In Constance W. Glenn, *Jim Dine: Drawings*, p. 11.

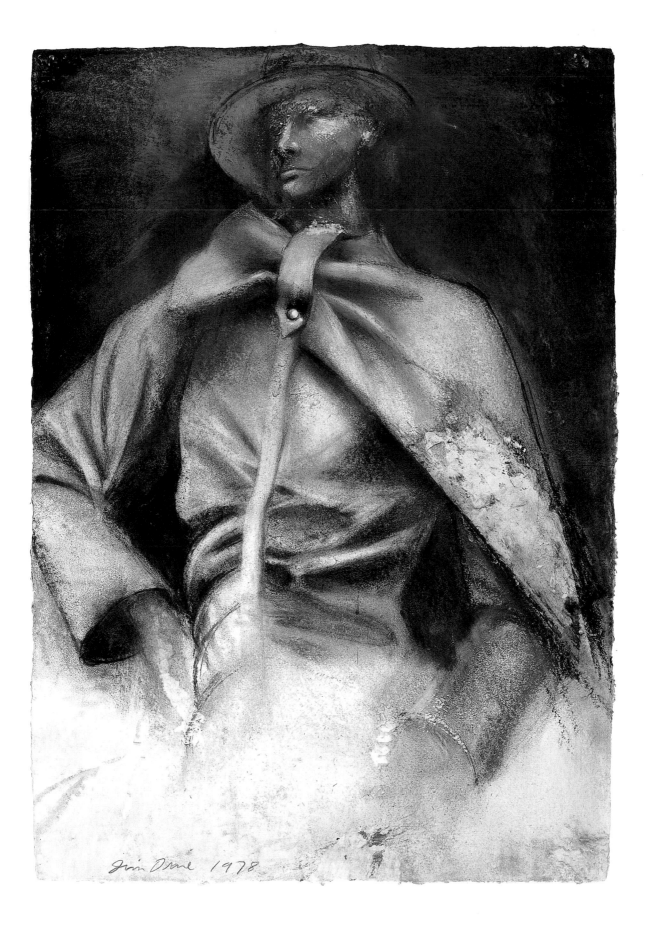

Jim Dine 1978

Ivan Albright

American, 1897-1983
The Vermonter I, 1965-66
charcoal and chalk on canvas
32 ¼ x 23 ¼ inches
The Memorial Acquisition Fund, 1981.
81.42

Ivan Albright's father was a painter, as was Ivan's identical twin brother. He attended Northwestern University, near his hometown of North Harvey, outside of Chicago. Following a brief period in college, he served as a medical draftsman in World War I, documenting war wounds and operations for an army hospital in France. Albright acknowledged that studying X-rays was excellent training. In 1920 he enrolled at the School of the Art Institute of Chicago and graduated in 1923. By 1933 he had exhibited in major museums including the Art Institute of Chicago, the Dayton Art Institute, the Corcoran Gallery, Washington, D.C., The Museum of Modern Art, New York, and the Pennsylvania Academy of Fine Arts. He may have achieved his greatest celebrity when he was commissioned to paint a portrait of the protagonist for the 1945 MGM film *The Picture of Dorian Gray*, in which the dramatic presentation of Albright's painting of the corrupted antihero is a climactic high point. Albright never had a primary dealer and placed high prices on his work, partly to discourage purchases. He was accorded solo exhibitions in major museums including the Tate Gallery, London (1963), and retrospectives at the Art Institute of Chicago (1964) and the Whitney Museum of American Art, New York (1965). In the 1970s, two schools gave him an Honorary Doctor of Fine Arts degrees, while another gave him an Honorary Doctor of Arts.

Since the beginning of his career in the late 1920s, Albright painted figures that fill almost the entire canvas. With their meticulously rendered and greatly magnified features, every wrinkle, birthmark, stray hair and blemish of exposed, discolored skin could be documented in his exploration of the human condition. He accepted death as an essential part of living, a condition that gives life meaning. His technique was painstaking; often he used a brush with only three hairs and covered only a tiny patch of canvas in a day. His canvases observe decay and degeneration and experiment with multiple perspective and the expression of movement.

Typical of Albright's practice, the artist's model for *The Vermonter I* was a friend, Kenneth Harper Atwood, a seventy-six-year-old retired Vermont maple syrup farmer and member of the Vermont House of Representatives. Albright chose a model "who has lived and who feels as tired as I do." (See note 1.) Albright assembled the figure's setting and bought the clothing that he wanted Atwood to wear. Albright built a mannequin, which he dressed in the same clothes, to enable himself to continue to work in the model's absence. The artist was aiming to make an image that would evoke the mysterious and miraculous process of life, how life transforms and transcends the body, and what aging can bring in its wake. He was a painfully self-critical worker who made meticulous studies for major works. In this case, The Arkansas Arts Center's is the first; the second is owned by the Art Institute of Chicago; and the final version, *The Vermonter*, oil on hardboard, 1966-77, is owned by Dartmouth College, Hanover, New Hampshire. The finished painting is generally held to be among the artist's major works. Albright said that in this work he intended "to make the most human head ever made. Make it great—eye sockets that tell the years—folds that bespeak flesh—eyes that bring pity, eyes that have seen better." (See note 2.) Albright's craftsmanship and profound belief in the primacy of visually perceived information came together in one of his most characteristic syntheses.

Sources:
Croydon, Michael. *Ivan Albright*. New York: Abbeville Press, 1978.
Cummings, Paul. *Artists in Their Own Words* (Interviews). New York: St. Martin's Press, 1979.
Donnell, Courtney and Susan Weininger. *Ivan Albright*. Chicago: Art Institute of Chicago, 1997.
Jaffee, Irma B. *Selections from the Permanent Collection of The Arkansas Arts Center Foundation*. Little Rock: The Arkansas Arts Center, 1983.
Kuh, Katharine. *The Artist's Voice*. New York: Harper & Row, 1982.

Notes:
1. In Irma B. Jaffee, *Selections From the Permanent Collection of the Arkansas Arts Center Foundation*, pp. 90-91.
2. In Michael Croydon, *Ivan Albright*, p. 256.

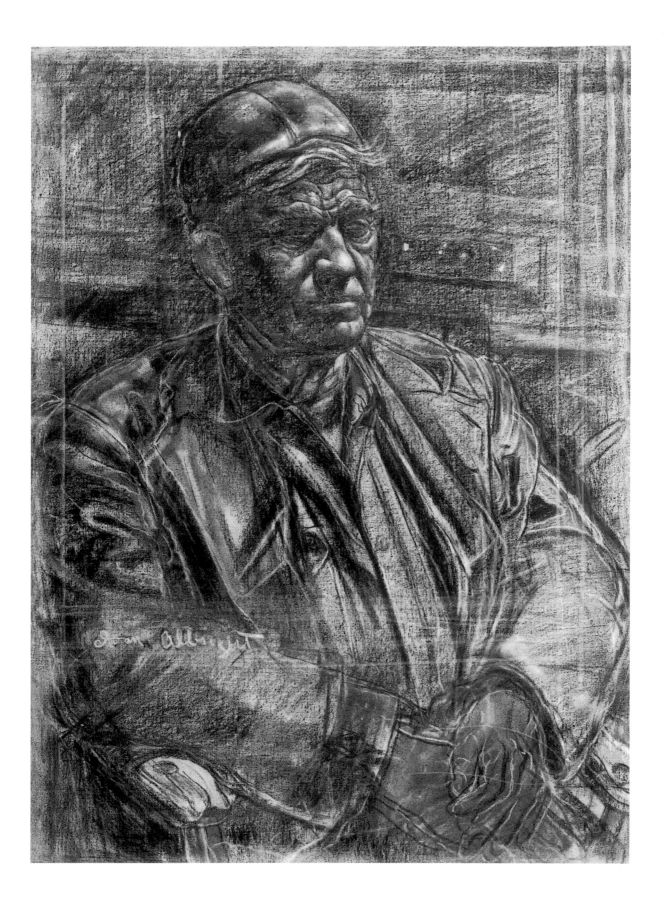

RICHMOND BARTHÉ

American, 1901-1989
Portrait of a Man, c. 1938
charcoal on paper
17 ½ x 12 ½ inches
The Sam Strauss Memorial Fund, 1993.
93.24

Growing up in Mississippi, Richmond Barthé drew from an early age, expected to become a painter and, thus, attended the School of the Art Institute of Chicago, from 1924 to 1928, where it was suggested he do some clay modeling to work out the dimensionality of his portrait subjects. He moved to New York in 1929 and studied at the Art Students League. His raw work in sculpture prompted the artist to create autonomous three-dimensional pieces. His work *African Dancer* of 1933 was the first piece by an African-American accessioned by the Whitney Museum of American Art, New York. In 1937 he was commissioned to create sculptural pieces for the Harlem River Housing Project. Notably, he also designed several Haitian coins which remain in use. From 1951 until the early sixties, Barthé resided in Jamaica, and he spent the years 1965 through 1970 living in Europe. When he returned to the U.S., he lived in Pasadena, California, until his death. Barthé had solo exhibitions at the Montclair Art Museum, New Jersey (1949), the Institute of Jamaica, West Indies (1959), and the Museum of African American Art, Los Angeles (1990).

Barthé had a lifelong interest in the specific beauty of African-Americans, and he has recorded them in portraits, including full-figure athletic poses and in his monuments. His depictions of boxers, dancers and warriors are introspective, suggesting a meditative aspect. His monuments, often larger than human scale, dramatize significant African-American leaders and performers. *Toussaint L'Ouverture* and *General Dessalines Monument* (both Port-au-Prince, Haiti), are among the notable.

The drawing *Portrait of a Man* captures the subject's face in full right profile, with its moustache and goatee. The artist has established the figure, in its well-fitting, light-valued shirt (as seen from the rear) and its rolled-brim woven hat, against an undulant mottled-charcoal background. He has rendered the subject with a dignity and a respect consistent with the athletes and dancers depicted in his sculptures. G.N. and B.Y.

Sources:
Locke, Alain. *Exhibition of Richmond Barthé*. Chicago: South Side Community Arts Center, 1932.
Lewis, Samella. *Two Sculptors, Two Eras: Richmond Barthé, Richard Hunt*. Los Angeles: Landau/Traveling Exhibitions and Samella Lewis, 1992.

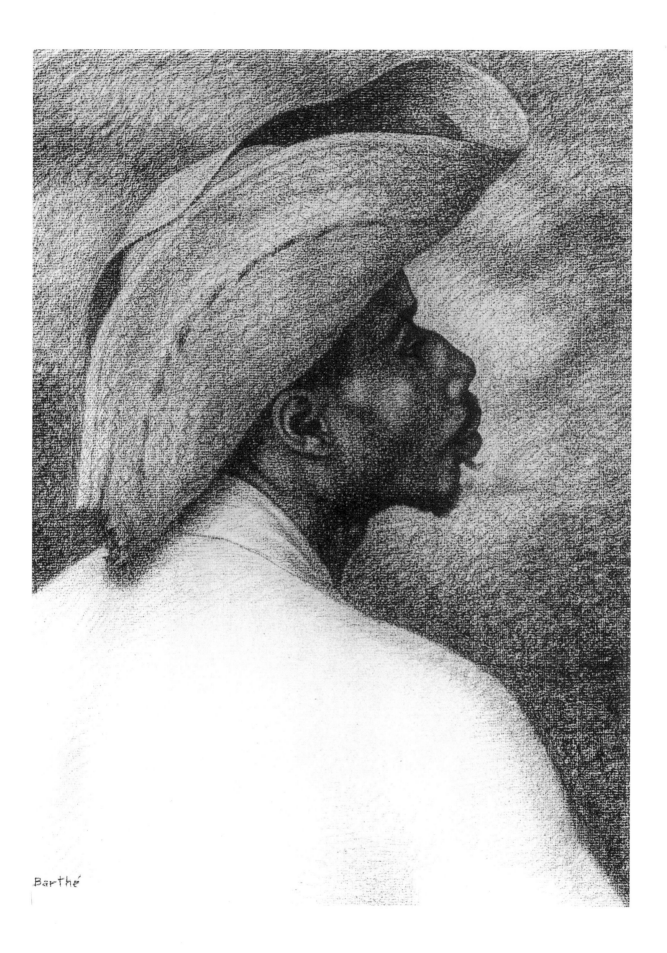

Barthé

Pavel Tchelitchew

American, b. Russia, 1898-1957
Robert Cluzan, 1932
gouache on paper
23 ½ x 17 ½ inches
Purchased with a gift from the Vineyard in the Park, 1979.
79.67

Pavel Tchelitchew is considered to be the leader of the neo-Romantic painters in the 1920s, but it is an unconvincing epithet for an artist of such diverse talents. He was raised in Russia by noble parents, and his recreation away from his parents' estate included the ballet and opera. In 1918, during the Revolution, his parents were expelled and Tchelitchew moved to Kiev, where he studied with Alexandra Exter, a student of Fernand Léger. About a year later, he continued to move, first to Odessa, then Constantinople and Berlin. Early acquaintances who influenced his vocation were Diaghilev and El Lissitzky. Tchelitchew moved to Paris, where at Diaghilev's urging he designed the set for the ballet *Ode,* which debuted in the French city in 1928. He worked on stage designs for prominent ballet companies between the years 1919 and 1942. While in Paris he met expatriate Gertrude Stein, who introduced him to other Americans. In 1930, The Museum of Modern Art, New York, offered him the chance to debut his drawings in the United States during a group exhibition. Four years later he came to live in the U.S. Retrospectives of his work were hosted at the Institute of Modern Art, Buenos Aires (1948); the Ringling Museum, Sarasota, Florida (1951); and the Detroit Institute of Arts (1952), among others.

The neo-Romantic period was short-lived, even though the classification has endured in art circles. Regarding the portrait *Robert Cluzan*, one can see that Tchelitchew held a sympathetic view toward acrobats and circus performers, much like the Blue Period and Rose Period works by Picasso more than twenty years earlier. In the context of the collection of the Arkansas Arts Center, a compelling comparison can be made to John Steuart Curry's *The Flying Codonas* (page 120), of the same period. Unlike the Regionalist artist Curry, Tchelitchew focuses on the introspective nature of the sitter, not the drama or perceived excitement of the profession.

This portrait of Robert Cluzan, from the peak years of Tchelitchew's romantic period, is touched with a sense of suffering and disenchantment. There is nostalgia in the portrait, even a bit of romance, but the artist's firm design sense, precise drawing, and dry, subdued colors combine to create a melancholy turn—sympathetic and compassionate, but without sentimentality. G.N. and B.Y.

Sources:
Kirstein, Lincoln. *Tchelitchew*. Santa Fe, NM: Twelvetrees Press, 1994.
Kirstein, Lincoln, ed. *Pavel Tchelitchew Drawings*. New York: H. Bittner & Co., 1974.
Pavel Tchelitchew: *An Exhibition in the Gallery of Modern Art*. New York: The Foundation of Modern Art, Inc., 1964.
Soby, James Thrall. *Tchelitchew: Paintings, Drawings*. New York: The Museum of Modern Art, 1942.
Tyler, Parker. *The Divine Comedy of Pavel Tchelitchew.*New York: Fleet Publ. Corp., 1967.

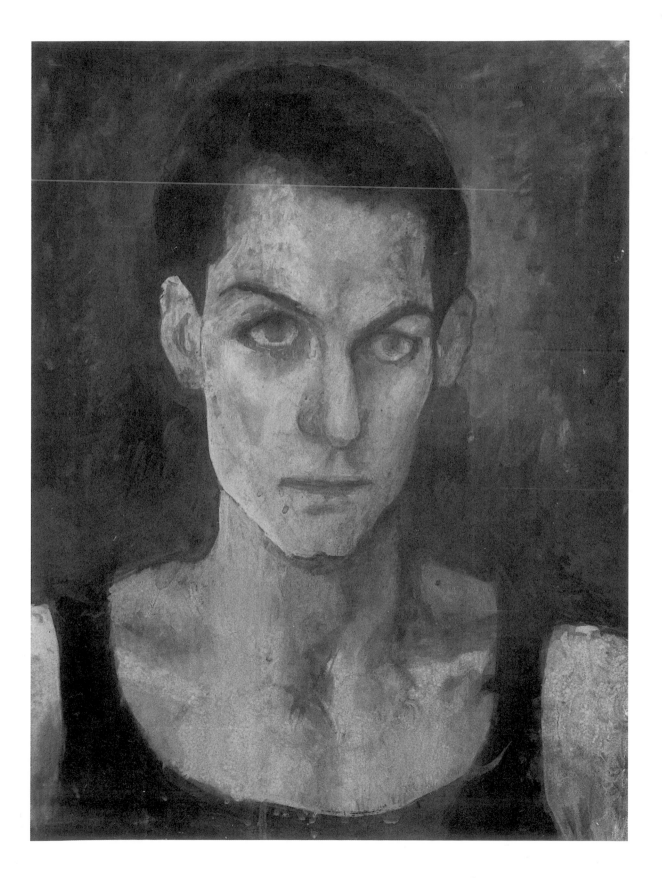

JAMES VALERIO

American, b. 1938
Portrait of Tom (Study for *Tom's Choice*), 1991
pencil on paper
28 ½ x 13 inches
Purchased by The Tabriz Fund, 1991.
91.50

James Valerio was enrolled in night classes in drawing and painting at Wright Junior College when he decided to go to art school full time. His choice was the School of the Art Institute of Chicago, where he received both a BA and an MFA degree. (Through his education at the Institute, he has cited Ivan Albright's work as one of his greatest inspirations.) Valerio has also taught, including positions at Rockford, Illinois; the University of California, Los Angeles; Cornell University; and Northwestern University. His work has appeared in solo exhibitions at the Delaware Art Museum, Wilmington; Allan Frumkin Gallery, New York; and the University of Iowa Museum of Art, Iowa City. In a commercial sense, the greatest recognition of his work may have come when one of his paintings was chosen from a group exhibition at the Metropolitan Museum of Art, New York, to be used in a best-selling poster.

James Valerio is a realist who uses photography for information, but paints directly from his observation, thinly developing his imagery without painting over or painting out. He juggles a number of disparate elements to balance the sources for visual information—reality, the posed model, actual objects, sketches and transparencies, which he uses to preserve his images.

Valerio's *Portrait of Tom* is a large and thoroughly developed drawing of the subject, made in preparation for translation into the painting of the same sitter. The artist's validation of photo transparencies for information is more than justified by his capturing the subject's hair, the fall of light on the forehead, nose and cheeks, the rendering of skin and the fall of the material in the subject's flowered shirt. The introspective mood is effectively conveyed through posture, visual concentration and the quietude of the pose. Even though the drawing is one step in the preparation for a painting, it remains a powerful and independent documentary on its own terms—a tour de force in pencil, which implies color.

Sources:

Adrian, Dennis, Kathy Foley, M.M. Gedo and Michelle Vishny. *Painting at Northwestern: Conger, Paschke, Valerio*. Evanston, IL: Mary and Leigh Bloch Gallery, Northwestern University, 1986.

Curran, Pamela. *James Valerio*. Iowa City: University of Iowa, 1994.

Goodyear, Jr., Frank H. *Perspectives on Contemporary American Realism* (The Jalane and Richard Davidson Collection). Philadelphia: Pennsylvania Academy of the Fine Arts, 1982.

Martin, Jean, ed. *Newsletter of Frumkin/Adams Gallery*. New York: Winter, 1994.

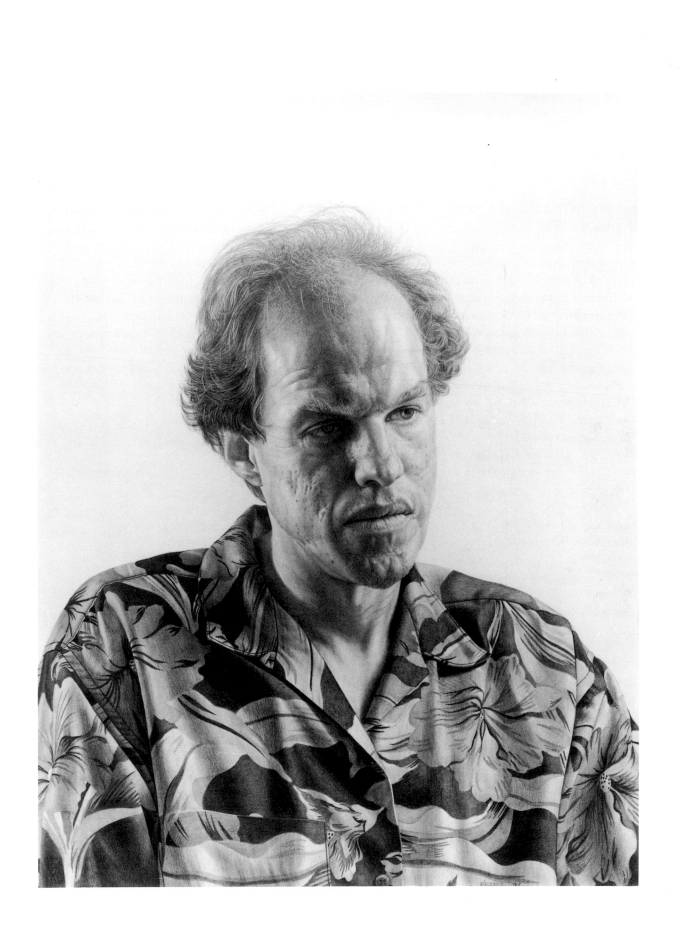

JOHN WILDE

American, b. 1919
Myself Paranoiac, 1944
pencil on wove paper
16 ¼ x 12 ½ inches
The Tabriz Fund, 1986
86.14.1

Recognizing the incongruous nature of his subject matter, John Wilde has acknowledged that some critics have called him The "Magritte of the Midwest." (See note.) Wilde attended the University of Wisconsin, Madison, where he obtained his BS degree in Art Education and MS degree in Art in 1948. He continued his ties to the school, teaching drawing in the university's department of art from 1952 to 1982. The university further recognized his talents by granting a 40-year retrospective in 1984. A partial list of prominent group exhibitions featuring his work on paper includes: *20th Century Drawings from the Whitney Museum of American Art* (1979-81); *American Portrait Drawings, 1780-1980*, National Portrait Gallery, Smithsonian Institution, Washington, D.C.; *American Master Drawings and Watercolors*, Minneapolis Institute of Art (1976-77); and *Recent Drawings*, The Museum of Modern Art, New York (1956).

John Wilde's watchword is "discipline," which is observed in the careful rendering of the most telling angle and incident in realizing his frolicsome, sympathetic and sometimes profound subject matter. While often associated with the Surrealists, his aesthetic kinship is with the early Italian Renaissance and the fifteenth-century Flemish masters. Wilde paints and draws still lifes, portraits and fanciful subjects, all of which tend to be quite small in scale, with whole worlds held within tiny dimensions.

Wilde's drawing *Myself Paranoiac*, a variation on Albrecht Dürer's self-portrait at the age of twenty-two, offers Wilde's own likeness at the age of twenty-four. It has a delicacy of line associated with silverpoint, and yet the intensity in the eyes compels the viewer to study it, discovering the inscription and tiny nude in the background. The raised left index finger is a sign—asserting the artist's individuality—proclaiming that he is still vertical in the great war where many are no longer so. "Paranoiac," a word from the early years of psychiatry, describes one suffering a chronic mental disorder characterized by delusions of persecution and hallucinations. Salvador Dali described his method for achieving Surrealist juxtapositions as *paranoiac-critical*, and Wilde, at twenty-four, winks at that artist's vogue while relating himself to Dürer's tradition and to his own time.

Sources:

Atkinson, Tracy. *Wilde*. Milwaukee: Milwaukee Art Center, 1967.

Leaders in Wisconsin Art 1936-1981: John Steuart Curry, Aaron Bohrod, John Wilde. Milwaukee: The Milwaukee Art Museum, 1982.

Wilde, John. *W H M S H W (What his Mother's son hath wrought)*. Reproductions of 24 paintings with excerpts from his notebooks, 1940-1984. Mt. Horeb, WI: Perishable Press, 1988.

Wilde, John. *John Wilde: Eros and Thanatos*. Madison: Madison Art Center, 1993.

Wolff, Theodore F. *John Wilde/1984*. New York: David Findlay, Jr. Inc., 1984.

Note:

In *John Wilde: Eros and Thanatos*, p. 6.

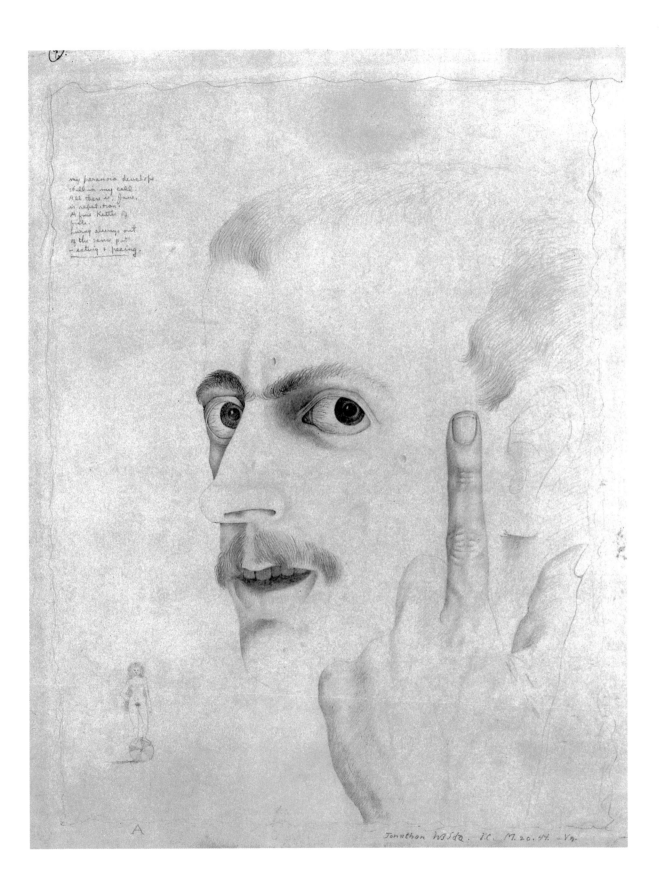

my paranoia develops
still in my cell.
All there is', Jane,
is repetition.
A fine kettle of
fish.
Living always out
of the same pot
— eating & peeing.

A

Jonathan Waldo. IC M. 20. 54 - Vn.

JARED FRENCH

American, 1905-1988
Chimera, c. 1968
pencil and ink on paper
39 ½ x 26 inches
The Tabriz Fund, 1993.
93.48

Jared French studied at Amherst College with Robert Frost, taking an interest in literature, music and the visual arts. He graduated in 1925, took a position on Wall Street and began to study part time at the Art Students League with Boardman Robinson, Thomas Hart Benton and Kimon Nicolaides. The crash of Wall Street and his acquaintance with Paul Cadmus in 1929 may have cemented his decision to become an artist. After a brief period in Europe, he returned to work on the Public Works of Art Project and, in 1935, took a studio with Cadmus. While French had a close association with Cadmus and, beginning in the 1940s, with George Tooker, he is not as well recognized as the other two. Late in his career, French often withheld his works from exhibition and sale and even purchased back some works that had reached private collections. He remained less willing to discuss his art in public or in print. As a consequence, in subsequent years less attention was given to his work compared to that of his prominent contemporaries. French has enjoyed many important exhibitions, and *Chimera* was included at New York's Midtown Payson Galleries' *Jared French (1905-1988): Drawings from the 1960s* in 1993.

In 1964, French began a series of sketches leading to *Chimera* and, in general, to his last period, which was not a break with the past but a development and clarification of earlier works in "magic realism" and allegory. *Chimera* seems to be a self-portrait figure seen in a dis-torting mirror, with his muscular, masculine torso bursting forth from a feminine cocoon or article of clothing. Another drawing from the period, *Guardian*, 1966-67, evokes a similar mood, wherein fragments of sculpture are standing and assuming a recognizable form or disintegrating and losing their classical clarity in deconstruction.

Sources:
French, Jared. *Jared French: Painting and Drawings 1944-1969*. New York: Banfer Gallery, 1969.
Grimes, Nancy. *Jared French's Myths*. San Francisco: Pomegranate Artbooks, 1993.
Jared French (1905-1988) / Drawings from the 1960s. New York: Midtown Payson Galleries, 1993.
Payson, John Whitney and Jeffrey Wechsler. *Jared French*. New York: Midtown Payson Galleries, and Mead Art Museum, Amherst College, 1992.
Wescott, Glenway. *Jared French*. New York: Julien Levy Gallery, 1939.

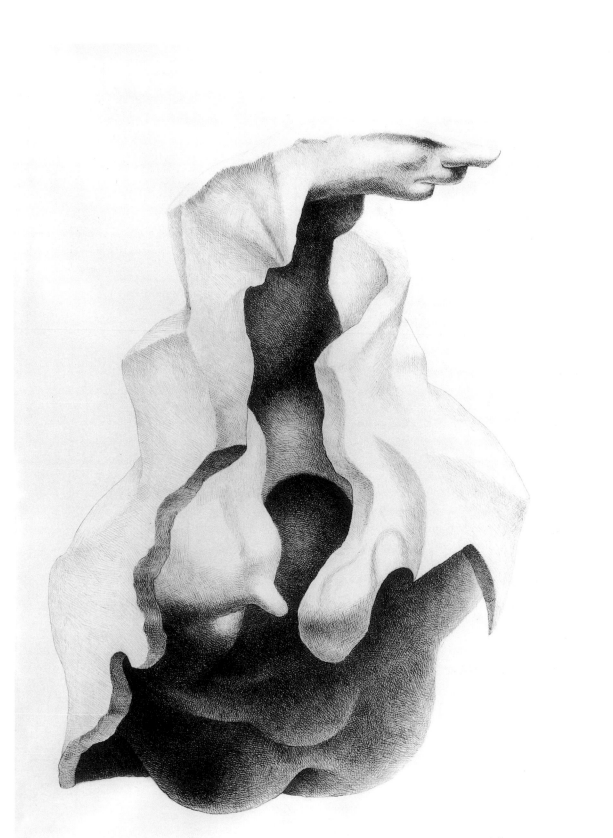

ROMARE BEARDEN

American, 1914-1988
At the Clef Club (Piano Player), 1975
watercolor on paper
41 ½ x 29 ½ inches
The Memorial Acquisition Fund in memory of
John Thompson Meriwether, Jr., 1981.
81.22

Romare Bearden's art began in a social consciousness rooted in the Great Depression of the 1930s and in his awareness of life in Charlotte, Pittsburgh and Harlem. Thomas "Fats" Waller, the famed pianist, was a family friend, and Bearden met W.E.B. DuBois, "Duke" Ellington and Langston Hughes in his youth. Bearden was educated at New York University, where he studied with George Grosz, who introduced the young artist to the work of Kathe Köllwitz and Honoré Daumier, artists whose aim was to document social change. Later, following service in the army, Bearden used his G.I. Bill to live in Paris and study at the Sorbonne (1950-51). While in Paris, he met Constantin Brancusi, Georges Braque and Henri Matisse. A few of the solo exhibitions of Bearden's work have appeared at The Museum of Modern Art, New York, the Detroit Institute of Arts and the Harlem Studio Museum.

Bearden produced work related to the daily life he knew—women meeting and talking on the street; men returning home from an exhausting day's work; women cooking, cleaning and sewing. In the late 1950s and early 1960s, he experimented with improvisational painting, influenced by Carl Holty's enthusiasm for the teachings of Hans Hofmann. In the mid 1960s, with its explosive civil rights climate, Bearden was moved to return to his earlier themes. He developed cycles of paintings based on bible stories, the rituals of quotidian life and both the blues and jazz. His new work was in collage, pasted papers and overworking with paint.

At the Clef Club (Piano Player) is a large and spontaneously worked watercolor from a period (1974-76)

when Bearden developed several series of works on jazz and blues themes. Major collage compositions, such as *New Orleans Farewell, At Connie's Inn, One Night Stand,* and *Empress of the Blues*, recall the traditions of the music, revered players and singers, and famous clubs and theaters where he had listened to the music. He admired the Harlem "stride piano players" as powerful virtuosi and inventive composers. The Clef Club was founded by James R. Europe, the first celebrated black band leader. The name first referred to an organization of New York musicians who had been given a chance to play by Europe. Later, Clef Club became the name of an orchestra. Because we do not know to which Bearden is referring, we can only assume *At the Clef Club* salutes a musical performer through equally direct and improvisational drawing and brushwork. Bearden's work captures the spontaneity of ragtime and the energy of the original club.

Sources:

Anderson-Spivy, Alexandra. *Romare Bearden / The Human Condition*. New York: ACA Galleries, 1991 (in English and German).

Conwill, Kinshasha, Mary Schmidt Campbell and Sharon F. Patton. *Memory and Metaphor / The Art of Romare Bearden 1940-1987*. New York: The Studio Museum of Harlem, 1991.

Greene, Carroll. *Romare Bearden: The Prevalence of Ritual*. New York:The Museum of Modern Art, 1971 (with extensive chronology and bibliography).

Schwartzman, Myron. *Romare Bearden / His Life & Art*. Foreword by August Wilson. New York: Harry N. Abrams, 1990.

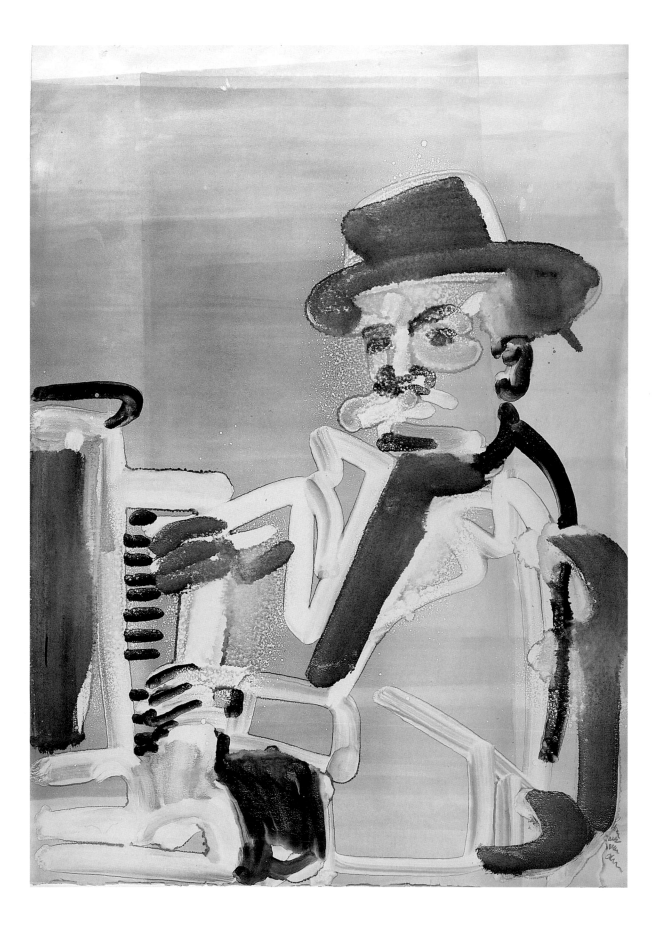

LARRY RIVERS

American, b.1923
De Kooning in My Texas Hat, c. 1963
pencil on paper
14 x 17 inches (sheet)
The Museum Purchase Plan of the NEA and the Tabriz
Fund, 1976.
76.12

Larry Rivers studied first at the Hans Hofmann School of Fine Arts, New York (1948-49), then received a BA degree from New York University in 1951. In 1979 he wrote an article in *New York* magazine, "Friends, Lovers, Artists: Larry Rivers Remembers the Greenwich Village of the Fifties," in which he described his neighborhood friends Franz Kline, Jackson Pollock and Willem de Kooning: "Most of the artists in Cedar bar were abstract artists. I was the only one who was painting realistically, and I felt very self-conscious about it." (See note 1.) Because Rivers was creating realism in an abstract world, as it was, he did not receive the same degree of fame as his aforementioned peers. He did, however, enjoy a one-person show of drawings at the Art Institute of Chicago in 1970. Group shows have been numerous, including several Whitney Annuals, *Twelve Americans* at the Museum of Modern Art, New York (1966), and *Two Decades of American Painting*, also at MOMA.

Rivers, committed to working within the figurative mode, felt that drawing from the figure was at the very center of art training and practice. He worked quickly and usually made more than a single image when his friends posed for him, such as his portrait of *De Kooning in My Texas Hat*. This piece is typical in regard to Rivers's technique. Like Jim Dine's method, erasure is integral to the final product. Rivers feels that the erasures and rubbing provide the subtle grays and scale of tones which are so important to the drawing. Fortunately, Rivers commented specifically on this portrait:

> I remember I just plunked this hat on him and made him sit while I did a drawing of him. I don't know, he had some curious vanities … I reverted here to a very strict attempt at getting what he looked like. In this case the two eyes and even the rendition of the hat are quite accurate with the curves the twists and the dents. You can see I tried to even get part of his stubble … Anyway, that's Bill de Kooning. (See note 2.)

Sources:

Brightman, Carol. *Drawings and Digressions by Larry Rivers*. New York: Clarkson N. Potter, Inc., 1979.

Hunter, Sam. *Larry Rivers*. Waltham, MA.: Rose Art Museum, Brandeis University, 1965.

————. *Larry Rivers*. New York: Harry N. Abrams, 1989.

Rivers, Larry. "Friends, Lovers, Artists: Larry Rivers Remembers the Greenwich Village of the Fifties." *New York*, 5 November, 1979.

————, and Arnold Weinstein. *What Did I Do? The Un-authorized Autobiography*. New York: Harper-Collins, 1992.

Vonnegut, Kurt. *Larry Rivers: Recent Relief Paintings*. New York: Marlborough Gallery, Inc., 1989.

Notes:

1. In "Friends, Lovers, Artists…," p. 40.

2. Ibid., p. 44.

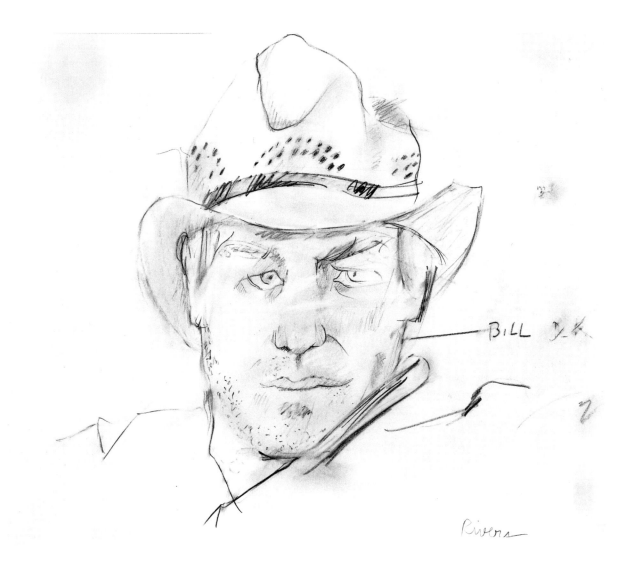

BILL D.K.

Rivers

FEDERICO CASTELLON

American, b. Spain, 1914-1971
Portrait of Vincent Freeley, 1939
ink on paper
8 ⅛ x 6 ¼ inches
Arkansas Arts Center Foundation Purchase, 1990.
90.13

Federico Castellon came to New York from Spain at the age of seven. When he was a student working on a mural for his high school, his mother thought he might benefit from meeting Diego Rivera, who was working on the Rockefeller Center Murals. The Mexican painter was impressed enough by Castellon that he showed the young man's work to Carl Zigrosser of Weyhe Gallery, who gave Castellon the chance to display his work. From 1934 to 1938, Castellon received a Traveling Fellowship from the Spanish Government. This allowed the artist to travel throughout Europe. Following the fellowship, Castellon had a one-person show that traveled to Dartmouth College, the Seattle Art Museum, the University of Nebraska, and three other venues. During his long career, notable solo exhibitions of his work were seen in South America (1954-55), the University of Maine (1953), the Los Angeles County Museum of Art (1968), and the Storm King Art Center, New York (1968).

Castellon was influenced by the surrealist and modernist movements of the 1920s and 1930s and knew the work of its exponents and leaders, especially Salvador Dali. Paul Cummings, the drawing scholar, remarked of Castellon's oeuvre, "The portrait was a mutable source of elements to be refashioned in his own mind, demonstrating his vision of idea over personality." (See note.)

The subject of Castellon's portrait, Vincent Freeley, was an acquaintance of the artist, and a sportswriter for New York magazines. This drawing was commissioned by *Fortune* magazine specifically to illustrate an article on the writer. Freeley is depicted in a business suit and tie, seated in a fringed armchair, as an outdoorsman, cradling in his arms fishing rods, reels, floats, and fish, as well as exhibiting attributes of football, squash, skeet or bird shooting. A horselike animal implies that Freeley was also a horseman. The drawing appropriates the sharp-focus manner, in pen and ink, of "dream photography," and reveals Castellon's affinities with earlier Spanish Surrealist artists.

Sources:

Cummings, Paul. *Federico Castellon: Surrealist Paintings Rediscovered 1933-34*. New York: Michael Rosenfeld Gallery, 1992.

Freundlich, August L. *Federico Castellon, His Graphic Works, 1936-1971*. Syracuse, NY: College of Visual & Performing Arts, Syracuse University, 1978.

Note:

Paul Cummings, *Federico Castellon: Surrealist Paintings Rediscovered 1933-34*, p. 3.

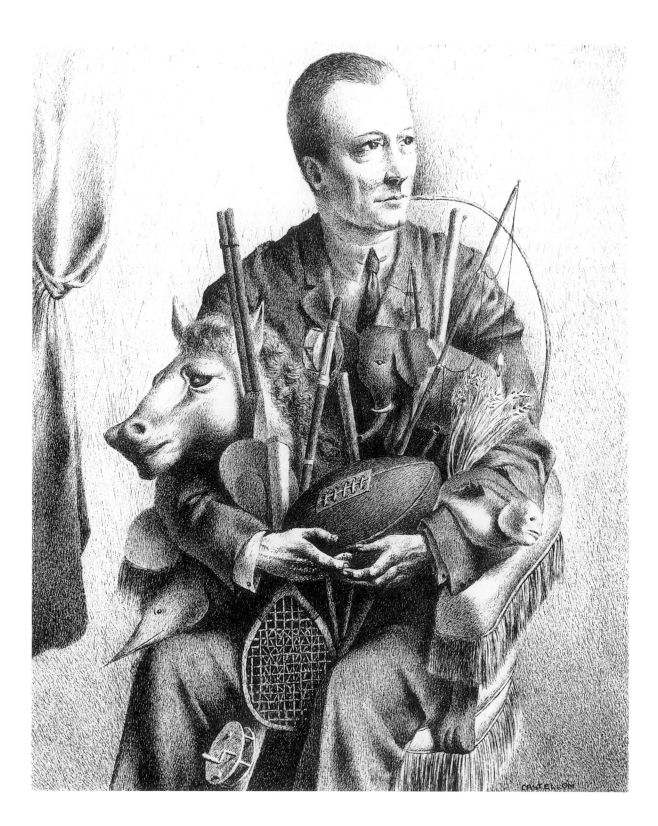

ROBERT ARNESON

American, 1930-1993
Pic, 1978
conte crayon and pencil on paper
41 ½ x 29 ¾ inches
The Museum Purchase Plan of the NEA and the Tabriz Fund, 1980.
79.61

In 1949 Robert Arneson began studies at the College of Marin, Kentfield, California. Three years later, he received a scholarship to the California College of Arts and Crafts in Oakland, where he received his BA degree. During this same year, he began a serious interest in ceramics. In 1958 he earned his MFA from Mills College, also in Oakland. Several years later, he received an appointment to teach Art and Design at the University of California, Davis. This same year he was part of a two-person show at the M.H. De Young Memorial Museum, San Francisco. Throughout his nearly thirty-year teaching career, his colleagues included Roy De Forest, Manuel Neri, Wayne Thiebaud and William T. Wiley. Two significant exhibitions of his work especially relevant to the Arkansas Arts Center's drawing were the retrospective of ceramics and drawings at the Museum of Contemporary Art, Chicago (1974), which traveled to the San Francisco Museum of Art; and *Robert Arneson: Self-Portraits*, Moore College of Art, Philadelphia (1979). He was included in numerous prominent group exhibitions and was represented throughout his career by Alan Frumkin Gallery, Chicago and New York.

Arneson intended to become a ceramic artist. He "was going to be an artist not a potter." In the 1960s he gave a twist to popular imagery in his ceramic sculptures of "pop" bottles, telephones, toasters, toilets and typewriters, all with Surrealist resonances inspired by the Dada protest of World War I, especially the shocks and word games of Duchamp's *Fountain*, for instance, and the work of Man Ray. Arneson's objects were curatorially appropriated into a Bay Area "new wave" given the catchy name "funk art." The term is drawn from black American blues and particularly the unpretentious, gospel-tinged country blues often referred to as "dirty" or "low down." Included in the visual funk group were Joan Brown, Bruce Conner, James Melchert, Harold Paris, William T. Wiley and Peter Voulkos, artists who shared a concern for honest, earthy and irreverent expression. In the 1970s Arneson moved to portraiture and self-portraiture of an ironic sort.

Arneson considered drawing a primary medium for his thought and the development of ideas, but it also became an end product for finished "presentation drawings" as his work evolved. He worked on sheets of paper and on wallboard with a spontaneous and expressive hand. Some of his independent drawing ideas came to influence his sculpture. In a work such as *Portrait of George Moscone*, 1981—the assassinated Mayor of San Francisco—Arneson found a vehicle to carry his drawing improvisations onto the sculpture's pedestal, again in a controversial manner. The commissioned work was eventually refused by the City of San Francisco.

Arneson embraced the idea that artists must be challenging, present controversial subject matter, and confront socially problematic and even offensive issues. By doing so he extended his range of content and stretched the audience's capacity to deal with art, its surrounding ideas and the artist's role in pushing the bounds of cultural acceptability, as in *Pic*. Picking one's nose may be a low-level social offense, but it is representative of Arneson's continuous testing of the audience and the work. It is also an example of his thought that any artist is always presenting himself in any work, therefore the making of his art in his own image is inevitable.

Sources:

Coffelt, Beth. *Robert Arneson/Self Portraits*. Philadelphia: Moore College of Art, 1979.

Nordland, Gerald. *Controversial Public Art from Rodin to di Suvero:* Milwaukee Art Museum. Milwaukee: Milwaukee Art Museum, 1984.

Prokopoff, Stephen S. and Suzanne Foley. *Robert Arneson*. Chicago: Museum of Contemporary Art, 1974.

Selz, Peter. *Funk*. Berkeley: University Art Museum, University of California, 1967.

2/21/78

ALFONSO OSSORIO

American, b. Philippines, 1916-1990
Breath of Life, 1940
ink on paper
21 ½ x 16 inches
The Tabriz Fund, 1993.
93.47

Alfonso Ossorio was born in the Philippines, but was educated in preparatory schools in England (1924-30) and in Rhode Island (1930-34). He graduated from Harvard in 1938, the same year he met Jared French, Paul Cadmus and Eric Gill. Then he attended the Rhode Island School of Design, but stayed only one year. Following stints in Taos, New Mexico, and New York City, he worked briefly for the U.S. Army (1943-44), where he was assigned to medical drawing in a hospital near Camp Ellis, Illinois. In 1949 he purchased a work by Jackson Pollock from Betty Parsons Gallery, the source of his acquaintance with the artist and Lee Krasner. That same year he went to Paris, where he came to know Jean Dubuffet. In the early fifties Ossorio strengthened his relationship with the Betty Parsons Gallery and showed a selection of drawings entitled "Victorias." Later in the decade, as a curator, and through his own Signa Gallery, Ossorio featured Pollock, Mark Rothko, Willem de Kooning, Jean Dubuffet, Hans Hofmann, David Smith and others. Throughout Ossorio's career and following his death, his work—especially the drawings—was included in numerous prominent exhibitions. For example, in 1991, the Pollock-Krasner House featured *Alfonso Ossorio: The Victorias, 1950*, and a year later, the Whitney Museum of American Art hosted *Alfonso Ossorio Drawings, 1940-48: The Anatomy of a Surrealist Sensibility*.

After meeting most of the leading figures of Abstract Expressionism, Ossorio became involved with expressive "action painting" gestures and materials. In 1960 he replaced paint and brush with found materials such as antlers, sea shells, bones, and driftwood in an assemblage style he called "The Conglomerations," which brought him international attention.

Breath of Life is a relatively early work signed "Taos N.M. Nov 30" at lower right. The piece is dated only two years after Ossorio completed his art history thesis, entitled *Spiritual Influences on the Visual Images of Christ*. As Klaus Kertess describes the thesis, "(Ossorio) charted the changes in Christian art and iconography with the concurrent changes in social and intellectual life from earliest Christianity to the Romanesque era."(See note.) In *Breath of Life*, the powerful frontality of the face of Adam relates to images of Romanesque art which deeply impressed the artist. The inscription across the image refers to the Book of Genesis and the Gospel of St. John: "The Lord God breathed the breath of life into his face and man was made into a living soul." The drawing style can be associated with Albrecht Dürer's gothic spirituality, and the "AO" monogram at left-center echoes Dürer's monogram. Each eye reflects a different vision, suggesting that the subject—man—is in a conflicted or contradictory state.

Sources:

Friedman, B.H. *Alfonso Ossorio*. New York: Harry N. Abrams, 1973.

Kertess, Klaus. *Alfonso Ossorio Drawings, 1940-1948: The Anatomy of a Surrealist Sensibility*. New York: Whitney Museum of American Art, 1992.

Ossorio, Alfonso, Forest Selvig and Judith Wolfe. *Alfonso Ossorio 1940-1980*. (transcribed interview). East Hampton, NY: Guild Hall Museum, 1980.

Note:

Klaus Kertess, *Alfonso Ossorio Drawings, 1940-1948*, p.14.

ARNOLD BITTLEMAN

American, 1933-1985
Death, Christ and the Artist, 1970-74
ink on paper
22 ½ x 30 inches
Arkansas Arts Center Foundation Purchase, 1990.
90.48.14

Arnold Bittleman began his formal education at the Rhode Island School of Design (1951-52) but received his BFA and MFA degrees from Yale University, New Haven, Connecticut, in 1956 and 1958, respectively. He stayed at the New Haven campus and taught at the School of Art and Architecture from 1958 to 1963.

Bittleman did not conceive of drawing as a preparatory stage in the development of his paintings or elaborate pastels, but as an end in itself. He worked slowly, methodically, over a period of months or even years, on a single work. He used a variety of materials, including pencil, charcoal, pen and ink, sepia, white ink, and oil pastel, and occasional combinations of two or more media in a single work. His subjects ranged from figure studies to landscapes, from studio still lifes to fantasies combining all of these elements.

Death, Christ and the Artist is from an important body of work executed between 1970 and 1974, during the Vietnam War, an event which triggered memories of Spanish Holy Week activities and the processions of penitents held in Zomorra, near the Portuguese border, where holy images of Christ, made in wood, and painted effigies were carried high on platforms through the streets. Bittleman would often start these seventies drawings with one set of forms, but introduced his horror of the Vietnam War into them. The images themselves changed and became mixed in terms of time and locale, but the essential and continuing thread in the series is sadness and horror. The artist came to recognize that his clearest expression was indirect, through forms and rituals that had retained their beauty despite degradation and exploitation of their original meanings.

Death, Christ and the Artist recalls works by Albrecht Dürer and other sixteenth-century Northern European masters of drawing and the graphic arts. It is an allegory of the dead and the risen Christ, and of the perplexed artist, the creator of design and order, mystified by the horror of contemporary life and the heedless behavior of mankind. The head of Christ conveys a sense of shock, tinged with compassion. Upon close inspection, viewers will see a hand coming in from the right side, apparently from the direction of the viewer. Daniel Robbins has aptly theorized that the hand may be determining the reality of the figure of Christ. (See note.) In the context of the Vietnam War, such a drawing may carry a powerful message or pose a difficult question.

Sources:
Birmelin, Blair T. "Arnold Bittleman at Alexander Milliken." *Art in America* 73 (October 1985): 161-62.
Campbell, Lawrence. "Arnold Bittleman." *Art in America* 70 (May 1982): 143.
Robbins, Daniel. *Arnold Bittleman*. New York: Alexander Milliken, 1984.
————. "Arnold Bittleman's Drawing." *Arts Magazine* 56 (April 1982): 112-14.

Note:
Daniel Robbins, *Arnold Bittleman*, p. 24.

LEE BONTECOU

American, b. 1931
Untitled, 1974-75
pencil and gesso on paper
35 ¾ x 12 ½ inches
The Museum Purchase Plan of the NEA and the Tabriz Fund,
1978.
78.12.i

Lee Bontecou was born in Rhode Island but spent her early life in Nova Scotia. Initially she attended college in Boston but then attended the Art Students League from 1952 to 1955, studying with William Zorach. She also studied at the Skowhegan School of Art, Maine; in Rome and, later, in Greece. She gained national attention with an article in *Art in America,* "New Talent," 1960, and through representation and exhibitions from Leo Castelli Gallery. During this time her work caught the attention of Donald Judd, who wrote favorably of it in *Arts Magazine.* In the 1970s, her drawings were featured in group exhibitions such as *Works on Paper* at the University of North Carolina, Chapel Hill, and *American Drawing,* 1970-1973, Yale University, New Haven, Connecticut. Throughout the decade and in the eighties, she taught at Brooklyn College. In 1993 the Museum of Contemporary Art, Los Angeles, organized *Lee Bontecou: Sculpture and Drawings of the 1960s.*

While developing armatures for models in plaster to be cast, Bontecou became focused on that usually hidden structure, drawing it, developing it for new sculpture. She discarded the exterior in order to devote her attention to the interior, the process, and the material of her work. She developed geometric welded-metal frames upon which she installed panels of canvas, denim, and other fabrics attached by wire fasteners. The result became a hollow volume of varying shades of gray, hung on the wall, lying somewhere between painting and sculpture. The often concentric forms of frame and panel presented orifices which critics related to mouths, eyes, and sexual organs, and they found the imagery aggressive and menacing. These works seem to combine the biological and the mechanical as strangely organic machines, involving an asymmetric balance that is quite un-biological. The works were fueled by Cold War fears of nuclear holocaust.

Bontecou has always drawn for a variety of purposes— as studies for aspects of a sculpture, as a general design for a piece, or as a finished work standing apart. The Arkansas Arts Center drawing is an independent work, a fantasy dealing with the emergence of an incompletely seen but monstrous force, a mouth (or a reflection?), a distorted face, a looming and fearsome dome, perhaps a school of monsters, huge and horrible, emerging on the horizon.

Sources:
Field, Richard S. *Prints and Drawings by Lee Bontecou.* Middletown, CT: Davison Art Center, Wesleyan University, 1975.
Judd, Donald. "Lee Bontecou" . *Arts Magazine,* April 1963.
Miller, Dorothy C. *Americans 1963.* New York: The Museum of Modern Art, 1963.
Ratcliff, Carter. *Lee Bontecou.* Chicago: Museum of Contemporary Art, 1972.

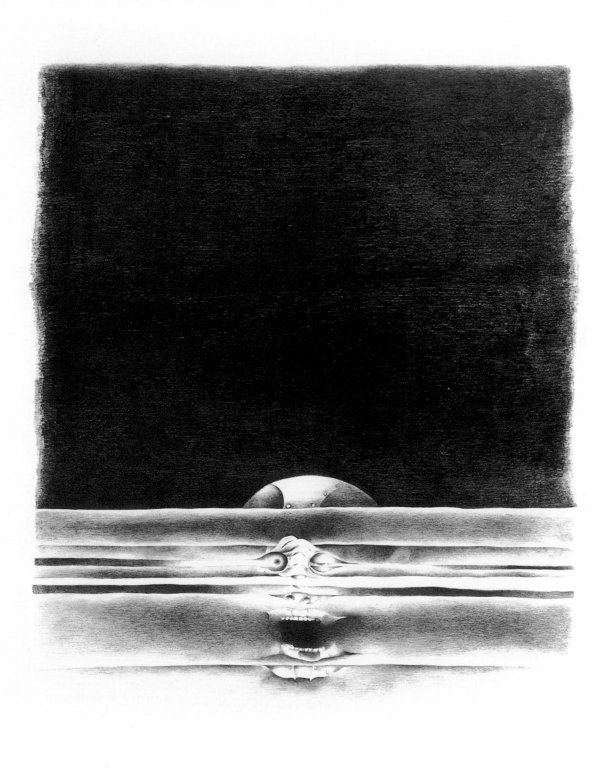

Nancy Grossman

American, b. 1940
Double Head Drawing, 1968
pen and ink on paper
10 x 14 ½ inches
The Tabriz Fund, 1993.
93.23.1

Through her family's New York garment business, Nancy Grossman became proficient in her early years with the trade procedures of pattern making, sewing, and piecing, and became knowledgeable in a variety of materials including fabrics, leather, zippers and dyes. Grossman attended Pratt Institute, New York (1958-62), where she received her BFA degree. Influence upon her work also came from the output of David Smith and Richard Lindner. She was included in the group exhibition *Drawing Now: 10 Artists*, Soho Center for Visual Arts, New York (1976); *Collage: American Masters*, the Montclair Art Museum, New Jersey (1979); and *Works on Paper*, Newhouse Galleries, Snug Harbor Cultural Center, Staten Island, New York (1980). She has been included in numerous museum and gallery exhibitions, especially with her sculpture.

In her drawings, Grossman works in a variety of media ranging from pencil, crayon and pastel to pen and ink in her search for a technical, precise rendering of her imagery. Her drawings are not restricted to studies for assemblages and constructions, but involve fanciful totems, torsos, and full figures. In the late 1960s she created heads encased in leather helmets. These reflected an aggressive, possibly sado-masochistic imagery, with references to the clothing of Hell's Angels, military combat gear or deviant sexual practice. *Double Head Drawing* was produced in 1968, a year prior to the construction of the first leather-covered heads. It is an exploratory examination of the idea of the covered head, in profile and full-face (as if a blueprint for the making of the work). The focus is on the exterior, the covering: on the materials, straps, buckles and fasteners which envelop the dark head, rather than the mysterious life and energy within the head itself. One can make analogies to the masks of medieval knights, but always present are more contemporary and darkly threatening references implicit in Grossman's heads, with suggestions of cruelty and even criminality.

Sources:
Raven, Arlene. *Nancy Grossman*. Brookville, NY: Hillwood Art Museum, Long Island University, 1991.

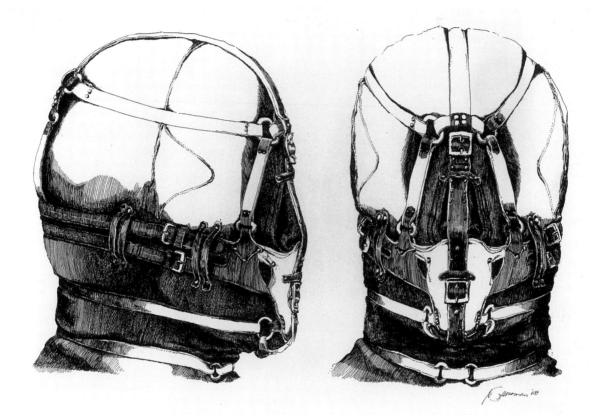

III. NATURE

ABRAHAM WALKOWITZ

American, b. Russia, 1878-1965
Abstraction, 1912
pencil and crayon on paper
12 ½ x 8 ⅛ inches
Gift of Zabriskie Gallery, New York, 1993.
93.15.1

Abraham Walkowitz was born in Tyumen, Siberia, in 1878 and came to the U.S. in 1889 following the death of his father. In 1898 he began study at the National Academy of Design, New York, under Kenyon Cox, followed later, in 1906, with instruction from the Académie Julien in Paris under Henri Laurens. While abroad, a notable experience for the artist was meeting Isadora Duncan in the studio of Auguste Rodin. Back in the states, in 1909, Walkowitz lived with Max Weber for a brief time after the latter's return from Europe. In 1912 Walkowitz met Alfred Stieglitz (following an intro-duction from Marsden Hartley) and showed at his 291 Gallery in December of the same year. The next year Walkowitz's work was included in the Armory Show. From 1917 to 1938, he served as a Director of the Society of Independent Artists. In 1939 he was given a retrospective of paintings, prints and drawings at the Brooklyn Museum, New York. Two years later, another retrospective was held at the Newark Museum, New Jersey. The Wadsworth Atheneum, Hartford, Connecticut, showed a selection of his drawings in 1950.

The exhibition of Fauve artists in the Salon d'Autumne in Paris of 1906 proved to be influential on Walkowitz. He was also inspired by his experience of Isadora Duncan's improvisational dance and made thousands of drawings describing her movement and that of her students in the studio. Walkowitz's work can be divided into three main styles—the Fauve-expressionist figure paintings, the improvisations made in the spirit of Duncan, and the city compositions. The latter works are all vertical, with jagged sequences of diagonal lines or serpentine swirls which convey a sense of restless energy of a city that is both animate and inanimate, while reflecting torrents of human energy.

Abstraction reflects Walkowitz's awareness of the Fauve, Cubist and Futurist ideas current among advanced artists of his acquaintance, including Weber, Arthur Dove, John Marin and Morgan Russell, and it is reflec-tive of the privileged relationship he enjoyed with Steiglitz, whose gallery brought modernists such as Picasso, Matisse, and Brancusi to New York's attention. While the drawing is worked only in black, grays and white, the patterned tensions of linear rhythms and the flatness of the frontal picture plane parallel Analytical Cubism and the Futurist experiments.

Source:
Sawin, Martica. *Abraham Walkowitz 1878-1965*. Salt Lake City: Utah Museum of Fine Arts, University of Utah, 1975.

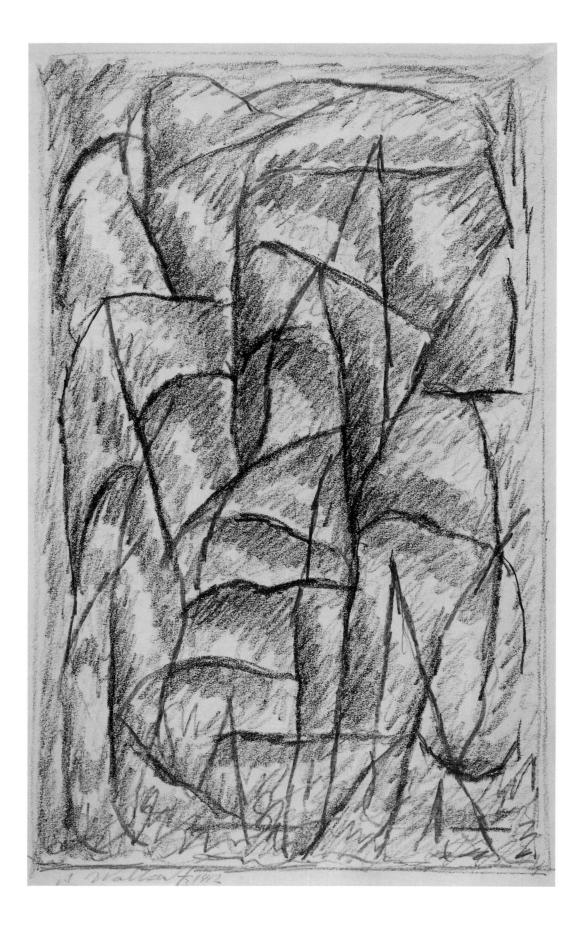

PETER TAKAL

American, b. Romania, 1905-1995
Untitled, 1990
ink on paper
30 ⅛ x 21 ⅞ inches
Gift of Mrs. Peter Takal, Geneva, Switzerland.
96.42.2

Peter Takal was born in Bucharest to a musical family who took their son with them on concert tours throughout Europe and South Africa. As a young adult, Takal wanted to be an actor, but at the age of twenty-five elected to become an artist. He was educated in Berlin and Paris; the latter is where he took his art training. In 1935 Takal exhibited at the Salon d'Automne, Paris, where the show's drawings eventually came to the attention of curator Katharine Kuh, who gave a two-person show featuring Takal and Picasso in Chicago. Because of the success of the show given by Kuh, and with war in Europe looming, Takal made the United States his home in 1939. Three years later, the E. B. Crocker Art Gallery, Sacramento, California, and the M.H. de Young Memorial Museum, San Francisco, prominently featured Takal's works on paper. An exhibition *Road, Field and Sky*, at the Brooklyn Museum (1949), featured ninety drawings by Takal. In 1956 the Dallas Museum presented a solo exhibition. *Recent Work of Peter Takal*, was sponsored, in part, by the Cleveland Museum of Art, in 1958, where it left for circulation through the Smithsonian Institution Traveling Exhibition Service in 1959-60.

Takal drew for many commercial purposes, including illustrations for newspapers, magazines and books. When free of such restrictions, he drew for the creative enjoyment of extending his reach. His subjects varied from portraits, figures, and the nude to the trees and plant life he so greatly enjoyed in his mountain retreat in Pennsylvania. Bark formations, dried flowers, swirling water and meadows hedged by encroaching forests enchanted him equally. His drawings were always conceived as autonomous works rather than as studies for paintings.

Takal drew from life: from models, the landscape and cities, from vistas seen through windows or doors. In addition to objective "realism," he invented linear fantasies of plant life that cannot be identified. In *Untitled*, one reads a structure of immense proportions, somewhere between an American Indian cliff dwelling and a curvilinear cubist castle. Hundreds of short parallel penlines describe shadowed planes, which reinforce the light-drenched cylindrical towers and darkened windows. This method results in a composition which optically shifts: As soon as the viewer registers one sense of order, a shadowed area will pop into the positive while an adjacent white volume recedes.

Sources:
Druey, Monique-Priscille, et al. *Takal / Dessins 1930-1990*. Geneva: Galerie Editart D. Blanco, 1990.
Johnson, Ishikawa. *Catalogue Raisonné of the Prints of Peter Takal*. East Lansing, MI: Kresge Art Museum, Michigan State University, 1986.
Takal, Peter. *About the Invisible in Art*. Beloit, WI: Wright Art Center, Beloit College, 1965.

CHARLES BURCHFIELD

American, 1893-1967
Burning Muckland, 1929
watercolor and pencil on paper
19 ½ x 26 ¾ inches
The Mrs. Frank Tillar Fund, 1995.
95.40.1

Charles Burchfield was born in Ashtabula Harbor, Ohio. His father died when he was five, causing the family to move to Salem, Ohio, to be near his mother's family. Charles graduated from high school as valedictorian in 1911 and won a scholarship to the Cleveland School of Art, which he attended from 1912 to 1916. After graduation, he was offered a scholarship to the National Academy of Design in New York and accepted, but stayed only one day. He returned to Salem where he worked in the mail department of the W. H. Mullins Co. Still longing to be an artist, he succeeded in placing *Drawings in Watercolor by Charles Burchfield* at the Kevorkian Gallery, New York in 1920. A year later, Burchfield submitted works to the Cleveland Museum of Arts' *First Annual Exhibition of Contemporary Painting*. He received First Prize in watercolor from a jury headed by George Bellows. In 1928 Edward Hopper wrote his essay "Charles Burchfield: American" for *Arts* magazine. Following successful showings in 1929 and 1930 at New York's Montross Gallery and Frank Rehn Gallery, respectively, he was given a one-person show of watercolors at The Museum of Modern Art, New York. Other solo exhibitions followed at the Phillips Collection, Washington, D.C. (1934); the Albright Art Gallery, Albany (1944); the Whitney Museum of American Art, New York (1956); and elsewhere. In 1967 the Charles Burchfield Center was founded and opened at State University of New York, Buffalo, three months before his death.

Burchfield's *oeuvre* divides into three periods—the early, smaller works, of intense fantasy, inspired by Salem; the middle period from his stay in Buffalo, which often features suburban realism; and the late works, begun during World War II, with their spiritually endowed landscapes. He was always a strong colorist given to capturing evanescent impressions and reflections. *Burning Muckland* belongs to the artist's middle period, one of great sobriety and reliance. Burchfield believed that this Gardenville landscape was flat and banal. Nonetheless, when drawn to the marsh, he made a delicately colorful work of his "burning marsh" or muckland, which reflects his unusual capacity to find inspiration in the most barren of landscapes. In 1928, a year before the date of the Arts Center watercolor, the famous regionalist painter Edward Hopper wrote of Burchfield, "… [From] what is to the mediocre artist and unseeing layman the boredom of everyday existence in a provincial community, he has extracted that quality we call poetic, romantic, lyric, or what you will." (See note.) This description may not apply to his later, almost baroque responses to spring and summer, which are brought to fulfillment with brilliant technique and a pantheistic spirit, but it is appropriate for more subtle works such as *Burning Muckland*. G.N. and B.Y.

Sources:

Baur, John I. H. *The Inlander: Life and Work of Charles Burchfield 1893-1967*. Newark, DE: University of Delaware Press, 1984.

Charles Burchfield: His Golden Years. Tucson: University of Arizona Press, 1965.

Hopper, Edward. "Charles Burchfield: American." *Arts* 14 (July 1928), pp. 5-12.

Maciejunes, Nannette V. and Michael Hall. *The Paintings of Charles Burchfield: North by Midwest*. New York: Harry N. Abrams, 1997.

Thompson, J. Benjamin, ed. *Charles Burchfield's Journals: The Poetry of Place*. Albany: The State University of New York Press, 1993.

Note:
Edward Hopper, "Charles Burchfield: American," p. 6.

ARTHUR GARFIELD DOVE

American, 1881-1946
Six untitled works from Sketchbook "*E*," c. 1940-46
pen, ink, and watercolor on paper
approximately 3 x 4 inches each
Gift of Willaim C. Dove, Mattituck, New York, 1992
92.55.1-28 (#9, #10, #12, #20, #22, #24)

Arthur Dove was born in upstate New York and graduated from Cornell University in 1903. That same year he moved to New York City to practice as an illustrator for *Collier's, Harper's, Life*, the *Saturday Evening Post* and other periodicals. From 1907 to 1909, Dove traveled to Europe where he became familiar with modern art, including the Fauves, Matisse and Cézanne. While there, he also met Gertrude Stein, Max Weber and Alfred Maurer. He returned to New York in 1910, gave up commercial illustration, and through Maurer met Alfred Stieglitz and his avant-garde circle. In 1912 Stieglitz mounted *Arthur G. Dove First Exhibition Anywhere*. Later Dove found support and patronage from Duncan Phillips. In 1933 at the Springfield Museum of Fine Arts, Dove had his first solo museum exhibition. Despite critical acclaim, Dove endured financial hardship most of his adult life, a divorce, and health problems; yet his relationship with Stieglitz remained strong until both died in 1946.

Arthur Dove is often mentioned in discussion of early abstraction, along with Wassily Kandinsky, Marsden Hartley and Georgia O'Keeffe. In 1913 Dove gave an explanation of his method to Arthur Jerome Eddy, a collector and author:

> This same law held in nature, a few forms and a few colors sufficed for the creation of an object. Consequently I gave up more disorderly methods (impressionism). In other words I gave up trying to express an idea by stating innumerable little facts, the statement of facts having no more to do with the art of painting than statistics with literature. (See note.)

It is well known that Dove made "thumbnail" studies in various media. He would select some of these to develop in larger, more complete watercolors or oil paintings. Six such works, drawn from Sketchbook "*E*," believed to have been executed 1940-46 in the artist's final years, demonstrate the breadth and character of his work at the time. Dove clearly developed forms which were fluid and rhythmic, and his color, while drawn from experience, has clear individuality. The compositional elements often include geometric forms—triangles, diamonds, rectangles—which are nonetheless soft-edged, organic, conditioned by the light of his home along the shore and the artist's purposeful directness in application. The imagery may refer to architectural structures, landscape, or a formal concept of pictorial organization, but it is inevitably imbued with visual surprise, activating the whole pictorial field as form, color and paintstroke coalesce into unity. Dove clearly sought order, appropriate size, intensity, spirit and "the music of the eye."

Sources:
Eddy, Arthur Jerome. *Cubists and Post-Impressionism* (2nd edition). Chicago: A. C. McClurg, 1914, 1919.
Haskell, Barbara. *Arthur Dove*. San Francisco: San Francisco Museum of Modern Art, 1974.
Johnson, D. R. et al. *Arthur Dove: The Years of Collage*. College Park: University of Maryland Art Gallery, 1967.
Mayfield, Signe. *Concept in Form: Artists' Sketchbooks & Maquettes*. Palo Alto, CA: Palo Alto Cultural Center, 1995.
Morgan, Ann Lee. *Arthur Dove: Life and Work, with a Catalogue Raisonné*. Newark, DE: University of Delaware Press, 1984.
Newman, Sasha M. *Arthur Dove and Duncan Phillips, Artist and Patron*. Washington, D.C.: The Phillips Collection (George Braziller), 1981.

Note:
In Arthur Jerome Eddy, *Cubists and Post-Impressionism* (2nd edition), p. 48.

EDWIN DICKINSON

American, 1891-1978
Summer Morning, Beach Point, 1934
pencil on paper
9 ⅜ x 12 ¼ inches
The Memorial Acquisition Fund, 1993.
93.26.4

Beginning in 1909, Edwin Dickinson had intended to enter the United States Naval Academy and went to Annapolis for tutoring. This proved unsuccessful, and in 1910 he went to Brooklyn to study at the Pratt Institute. From 1911 to 1912, he studied with William Merritt Chase at the Art Students League, New York. From 1912 to 1913, he was at the National Academy of Design and the Buffalo Fine Arts Academy. During the summers of 1912 through 1916, he studied at the Cape Cod School of Art, Provincetown, Massachusetts. Also in 1916, he exhibited at the Corcoran Gallery of Art, Washington, D.C. A year later, he exhibited at the Pennsylvania Academy of the Fine Arts in Philadelphia. After a brief period in the Navy, and subsequent travels in Europe, he began, in the early twenties, to teach and exhibit more frequently. His first one-person show was held at the Albright Art Gallery, Buffalo, in 1927. Wellesley College also presented a solo exhibition (1942), as did The Museum of Modern Art, New York (1961). In 1965 the Whitney Museum of American Art, New York, hosted a retrospective.

Dickinson's paintings are usually large, dealing with nocturnal worlds in which ambiguous figures and unrelated objects are depicted in mysterious settings, often in half light. He has written that he approached his paintings without preliminary drawings. Dickinson was a masterful technician, a traditionalist with a decidedly untraditional vision and subject matter. His large portaits usually took between two and ten years, and up to 400 sittings, to complete.

Dickinson considered his drawings as autonomous works of art and ends in themselves. They were always small, made without color or the complex techniques he had refined for his large-scale paintings. His subject matter ranged from the figure to architecture and landscape. As in *Summer Morning, Beach Point*, drawn in Provincetown, he sought form through line and design, working as purely and simply as possible. His line models the development of form, sensitive, precise and firm, but with a delicate almost evanescent tonality. There is a romantic edge in Dickinson's landscape drawings, as they are freely drawn views of actual places, without meticulous definition or high finish.

Sources:
De Kooning, Elaine. "Edwin Dickinson Paints a Picture." *Art News* 48 (September 1949), pp. 26-28.
Dobkin, John H. *Edwin Dickinson: Draftsman/Painter*. New York: National Academy of Design, 1982.
Goodrich, Lloyd. *Edwin Dickinson*. New York: Whitney Museum of American Art/Praeger, 1966.
_____. *The Drawings of Edwin Dickinson*. New Haven: Yale University Press, 1963.
Kuh, Katharine. *The Artist's Voice*. New York: Harper & Row, 1962.
Protter, Eric, ed. "Edwin Dickinson: On My Way of Painting," in *Painters on Painting*. New York: Grosset & Dunlap, 1963.

MILTON AVERY

American, 1885-1965
Black Goat, White Goat, 1958
ink and colored pencil on paper
20 ⅛ x 26 ¼ inches
The Tabriz Fund, 1984.
84.25

The Upstate New York-born Milton Avery began his career with a lettering class at a local art school in Connecticut as a way to earn money. Beginning in 1913, he studied at the Connecticut League of Art Students and then the School of the Art Society of Hartford. In 1925 Avery and the young woman he would marry, Sally Michel, moved to New York, where she provided much of their financial support working as an illustrator, allowing Avery to concentrate on his art. New York was a considerably more exciting art community than Connecticut, but by this time, Alfred Stieglitz had closed his 291 Gallery and Regionalism had begun to supplant the currents of European art from the previous decade. This may have suited Avery fine; by nearly every account he was quiet regarding his work. Fame still came his way with individual exhibitions at the Phillips Gallery, Washington, D.C. (1943, 1944, and 1952); The Whitney Museum of American Art, New York (1960); The Museum of Modern Art, New York (1965); along with countless other museum and gallery shows.

Like most of the early modernists, Avery stopped short of total abstraction, painting landscapes, figures and still lifes. He worked directly from life, sketching tirelessly, developing projects for later realization in watercolor or oil. He would simplify, flatten and distort his subject for expressive purposes, but he would never eliminate the representational images from his work nor would he introduce compositional elements which did not exist in the original concept. For Avery, any element of design—drawing, brushwork or color—which did not contribute to the total harmony of the work was extraneous and was eliminated.

Black Goat, White Goat is related to a painting of the same title dated 1951. This is a drawing of great subtlety. Avery has divided the picture plane into three distinct spaces: back, middle and foreground. The white goat is developed in silhouette in the foreground with a crosshatching of grasses. The black goat is defined both in silhouette and in linear form against the dotted midground, and the fenced and wired background (and horizon line) completes the rhythm.

Sources:

Chernow, Burt. *The Drawings of Milton Avery*. New York: Taplinger, 1984.

Haskell, Barbara. *Milton Avery*. New York: Whitney Museum of American Art in association with Harper & Row, 1982.

Johnson, Una. *Milton Avery: Prints and Drawings*. New York: Brooklyn Museum, 1966.

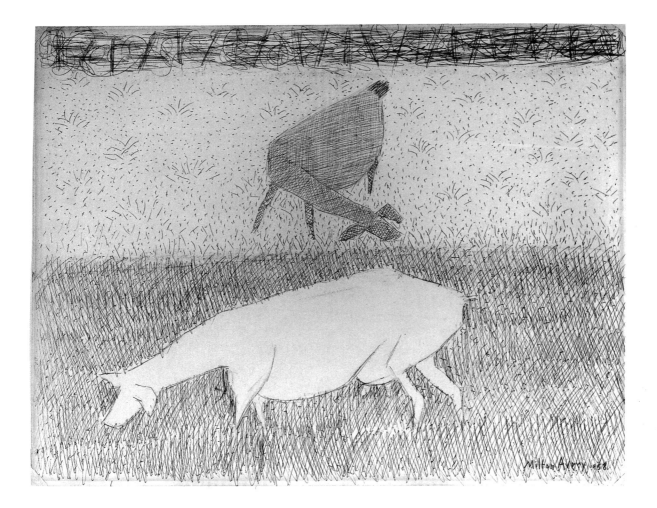

WILLIAM BAZIOTES

American, 1912-1963
Desert, 1954
colored chalk on paper
12 ½ x 25 inches
The Tabriz Fund, 1984.
84.18.3

Born Vasillios Angelus Baziotes in Pittsburgh in 1912 to Greek parents, William Baziotes was an artist of deep commitment. His Greek heritage and the secure upper-middle-class environment of Reading, Pennsylvania, where his family moved shortly after his birth, nurtured his strong love of learning—in his mind, the classics were his birthright. As a young man, he seriously studied the art of boxing, considering the struggle for perfection the greatest and most worthy of battles. The psychology of the boxing ring and the bullfight, taken not as spectator sports but as morality plays, were his inspirations. After brief employment antiquing glass at the Case Glass Company, Baziotes moved to New York in August 1933, where he enrolled at the National Academy of Design, studying with Charles Curran, Ivan Olinsky, Gifford Beal and Leon Kroll. From 1936 to 1941, he was intermittently associated with the Works Progress Administration, as a teacher and as a member of the Easel Painting Project.

Baziotes saw art as a fraternity—a brotherhood. He became close to a diverse group of artists in New York. Some, like Nassos Daphnis, Avram Schlemowitz and Michael Lekakis, shared a cultural background with him. Critical friendships developed with Matta and Gordon Onslow-Ford, and with others who shared a common aesthetic ground—Gerome Kamrowski, Jackson Pollock, Robert Motherwell, David Hare, Willem de Kooning, Estaban Vicente and Jimmy Ernst, and later, Mark Rothko, Clyfford Still and Adolph Gottlieb.

Baziotes was a remarkably eloquent writer as well. In 1948, he described his rather surrealistic approach to painting:

> Each painting has its own way of evolving. One may start with a few color areas on the canvas; another with a myriad of lines, another with a profusion of colors… Once I sense the suggestion I begin to paint intuitively. The suggestion then becomes a phantom that must be caught and made real. As I work, or when the painting is finished, the subject reveals itself. (See note.)

In *Desert*, we can see the elements of the essential Baziotes. While the classics taught him the precepts of the ideal, universal and impersonal, it was his love of the primitive and primordial that endowed his work with its existential forms. Here were creatures—real and imagined—that became metaphors for birth, life and death. In crocodiles, shellfish and prehistoric creatures we saw claws, heads, teeth, tails: the parts were as fascinating as the whole. In the primitive he found a language of line, shape and form, giving life to a world formed by confrontation, surviving by instinctive struggle in a hostile terrain. He was an ardent student of the struggle, which he found not only in Darwinism and the sports arena, but in the psychopathology of everyday life. G.N. and M.P.

Sources:

Alloway, Lawrence. *William Baziotes* (memorial exhibition). New York: Guggenheim Museum, 1965.

Baziotes, William. "I Cannot Evolve Any Concrete Theory," *Possibilities*. No. 1, Winter 1947-48.

Preble, Michael. *William Baziotes, Paintings and Works on Paper, 1952-1961*. New York: Blum Helman Gallery, 1984.

———, Barbara Cavaliere and Mona Hadler. *William Baziotes*. Newport Beach, CA: Newport Harbor Art Museum, 1978.

Motherwell, Robert and Ad Reinhardt, eds. *Modern Artists in America*. New York: Wittenborn, Schultz Inc., 1952, pp. 11, 13-17, 19.

Note:

William Baziotes, "I Cannot Evolve Any Concrete Theory," p. 20.

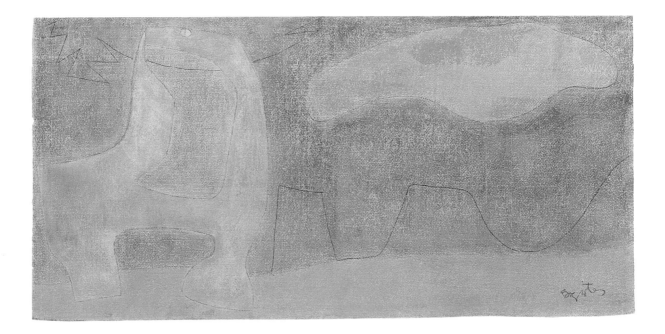

RICHARD DIEBENKORN

American, 1922-1993
Untitled (Ocean Park Series), 1972
charcoal and gouache on paper
27 ¾ x 18 ¼ inches
The Museum Purchase Plan of the NEA and the
Tabriz Fund, 1974.
74.11.e

Richard Diebenkorn studied at Stanford University, California, and the University of California, Berkeley—natural choices for a man who grew up in San Francisco. After his time during World War II as a Marine, he enrolled at the California School of Fine Arts, San Francisco, and studied with David Park.

Diebenkorn's introduction to the art of Edward Hopper had a profound effect on him. Early paintings as a student show Diebenkorn's fascination with American buildings and the play of light on surfaces. Hans Hofmann's theory on painting also had an early influence on him. He became devoted to expressive abstract painting in the 1940s, but in the 1950s he experimented with landscape painting, which led him back to figurative painting at the same time that his contemporaries David Park and Elmer Bischoff abandoned abstraction for figurative painting. In the 1960s Diebenkorn switched once again to painting abstractions with his *Ocean Park* series.

Diebenkorn referred to his works on paper as "drawings," even when they were fully developed in paint. The *Ocean Park* drawings show an appreciation of the unfinished paintings of Piet Mondrian and the corrected charcoals of Matisse (1909-40), output which revealed both artists' searching process—drawing, erasing and correcting. Diebenkorn enjoyed the word palimpsest—a parchment or tablet which has been used twice or three times, the earlier work having been partially erased. He found meaning in reinterpreting Mondrian's and Matisse's procedures, making them a part of his own. In *Untitled*, 1972, a rectilinear scaffold has been established, smeared, painted over, and a new more asymmetric scaffold developed over the earlier work, the smudged and defined preserved in spatial dialogue. The improvisational method represented in this work reflected the artist's procedure throughout his remaining years, both on paper and canvas.

Sources:
Buck, Jr., Robert T. *Richard Diebenkorn: Paintings and Drawings 1943-1976*. Buffalo: Albright-Knox Art Gallery, 1976.
Nordland, Gerald. *Richard Diebenkorn*. Washington, D.C.: Washington Gallery of Modern Art, 1964.
———. *Richard Diebenkorn*. New York: Rizzoli, 1987.

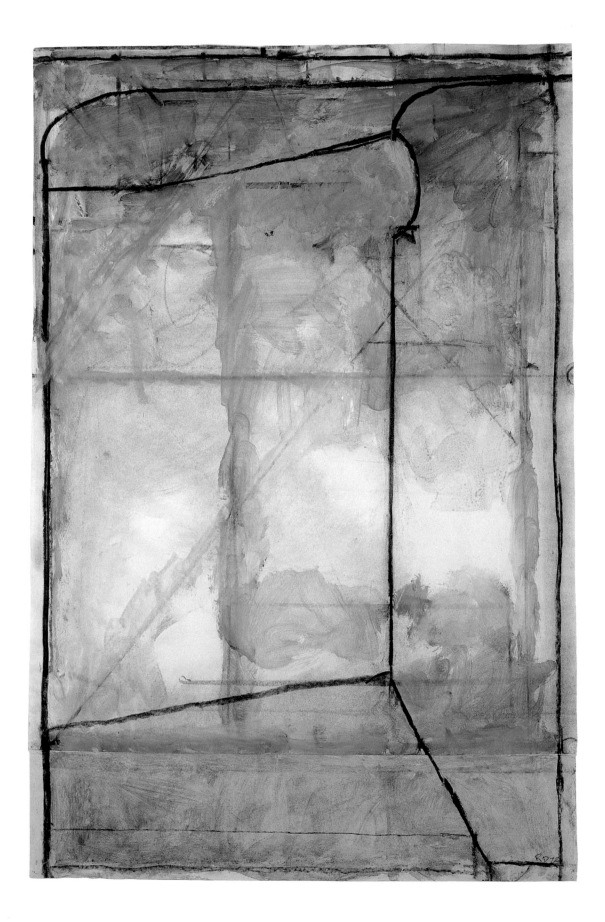

JAMES BROOKS

American, 1906-1992
Untitled, 1984
ink, acrylic and chalk on Arches paper
14 x 20 inches
Arkansas Arts Center Foundation Purchase, 1986.
86.33.2

Like many artists who have been assigned to the greater family of Abstract Expressionists, James Brooks developed his mature style quickly. And like many before him, he moved through a familiar sequence of decisions: He joined the Art Students League (1927), eventually left school for the adventure of independence (1930), worked through a short-lived "regionalist" phase (about 1931-35), and found both sustenance and support with the Federal Art Project of the Works Progress Administration (1936-43). Notably, his monumental mural, *Flight*, 1942, on the walls of the circular lobby of the International Marine Terminal Building, La Guardia Airport, New York, remains his most remarkable achievement of this period. After a brief assignment to the Middle East as an Art Correspondent with the U.S. Army in the early 1940s, Brooks returned to New York City in 1945, eager to take part in the revolutionary battleground that was Abstract Expressionism. His friendship with Bradley Walker Tomlin and Philip Guston were—like his appreciation of European modernism, the automatism of surrealism, and the art of Arshile Gorky—of fundamental importance. So, too, was his association with Lee Krasner and Jackson Pollock.

After a brief investigation of the spatial structuring familiar in Synthetic Cubism, Brooks quickly moved in the late 1940s and early 1950s to his signature work. An active surface and surprising depth, with commanding color and without the repetition of overall patterning—these were the characteristics of a master craftsman of the genre at work. While Pollock, Rothko, Gottlieb and de Kooning may have garnered the headlines, Brooks remained active and robust. His description of his approach to painting bears witness:

> My paintings start with a complication on the canvas surface, done with as much spontaneity and as little memory as possible. This then exists as the subject. It is as strange as a new still life arrangement, as confusing as an unfamiliar situation. It demands a long period of acquaintance during which it is observed both innocently and shrewdly. Then it speaks, quietly with its own peculiar logic. Between painting and painter a dialogue develops which leads rapidly to the bare confrontation of two personalities. At first a rhythm of the paintings is modified, then a chain of formal reactions sets in that carries painting and painter through violent shifts of emphasis and into sudden unfamiliar meanings.... At some point, the subject becomes the object, existing independently as a painting. (See note.)

In *Untitled*, 1984, Brooks explores familiar themes but on a distinctly smaller scale. The massing of shape, the illusion of form, the introduction of calligraphic spontaneity and the limitation of color all serve to reinforce the essence of his art, particularly in his late work. He seldom titled, lettered or numbered his drawings. Through them, he sought direct expression, vitality and rhythm. Brooks reasserts the presence of the artist in each of his works. Rather than attempting to remove the human mark for a purer geometry or exclusively emotional spirit, he reminds us, in each line, shape and form, of the artist's mind and hand at work. G.N. and M.P.

Sources:
Contemporary American Painting. Urbana,IL: University of Illinois, 1952.
Hunter, Sam. *James Brooks*. New York: Whitney Museum of American Art, 1963.
Preble, Michael. *James Brooks / Paintings and Works on Paper*. Portland, ME: Portland Museum of Art, 1983.
Rueppel, Merrill. *James Brooks*. Dallas Museum of Fine Arts, 1972.
Varian, Elayne H. *James Brooks (Paintings)*. New York: Martha Jackson Gallery, 1975.

Note:
In *Contemporary American Painting*, p. 174.

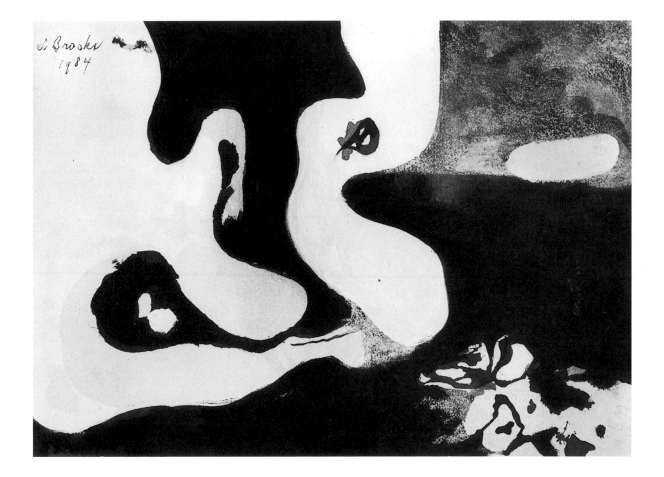

GEORGIA O'KEEFFE

American, 1887-1986
Banana Flower No. 1, 1933
charcoal on paper
22 x 15 inches
The Museum Purchase Plan of the NEA and the Tabriz
Fund, 1974.
74.11.h

Georgia O'Keeffe began her studies at the Art Institute of Chicago in 1905-06, followed by two years at the Art Students League, New York. She gave up painting for a while—nearly four years—and then took a class with Alon Bennett at the University of Virginia, who was a student of Arthur Wesley Dow. Thus, for further study she went to Columbia University, New York, to learn directly from Dow, whose system was based on principles of design as he interpreted them in Far Eastern Art: flat patterning, simplification and harmony. In 1915 she sent new drawings and watercolors to Anita Pollitzer, who presented them to Alfred Stieglitz. In 1916 her works were included in an exhibition in Stieglitz's 291 Gallery, New York. Her works were shown again in what was the last exhibition in that gallery. Stieglitz and O'Keeffe married in 1924 and a year later Stieglitz opened a new gallery—the Intimate Gallery—which showed O'Keeffe's work for several years. At the end of the twenties, Stieglitz continued with another gallery—An American Place—which featured *Banana Flower No. 1* in an exhibition in 1935. In 1940 the artist bought a house in New Mexico, where she remained for the rest of her life. The artist enjoyed her first retrospective at the Art Institute of Chicago (1943); followed by The Museum of Modern Art, New York (1946); the Worcester Art Museum, Worcester, Massachusetts (1960); the Amon Carter Museum of Art, Fort Worth, Texas (1966), with many other retrospectives and important shows following.

O'Keeffe was a pioneer of the modern art movement in America, which centered around Stieglitz and his New York galleries. Like Arthur Dove, O'Keeffe extracted forms from nature to the point of abstraction. In her paintings and works on paper she brought flowers, skulls, landscapes, etc., into sharp focus, cropping their forms so that they loomed large in the composition.

O'Keeffe suffered a nervous breakdown in late 1932, was hospitalized in January through March 1933, and recuperated in Bermuda and Lake George, New York. In Bermuda she produced a series of four closely observed and extremely powerful charcoal drawings of banana flowers, of which *Banana Flower No.1* is an outstanding example. Paul Cummings, in his book, *American Drawings: the 20th Century*, commented specifically of this piece, "the Dow influence is apparent in *Banana Flower No. 1*, 1933, with its balanced lights and darks, clearly defined outlines, and elegant composition. The most complex of her drawings were produced during these middle years...." (See note.)

Sources:
Bry, Doris. *Some Memories of Drawings*. Albuquerque: University of New Mexico, 1988.
Cummings, Paul. *American Drawings*. New York: A Studio Book, Viking Press, 1976.
Goodrich, Lloyd and Doris Bry. *Georgia O'Keeffe*. New York: Whitney Museum of American Art, 1970.
Messinger, Lisa Mintz. "Georgia O'Keeffe," *Metropolitan Museum of Art Bulletin*, Fall 1984.
Robinson, Roxanne. *Georgia O'Keeffe: A Life*. New York: Harper & Row, 1989.

Note:
Paul Cummings, *American Drawings*, p. 71.

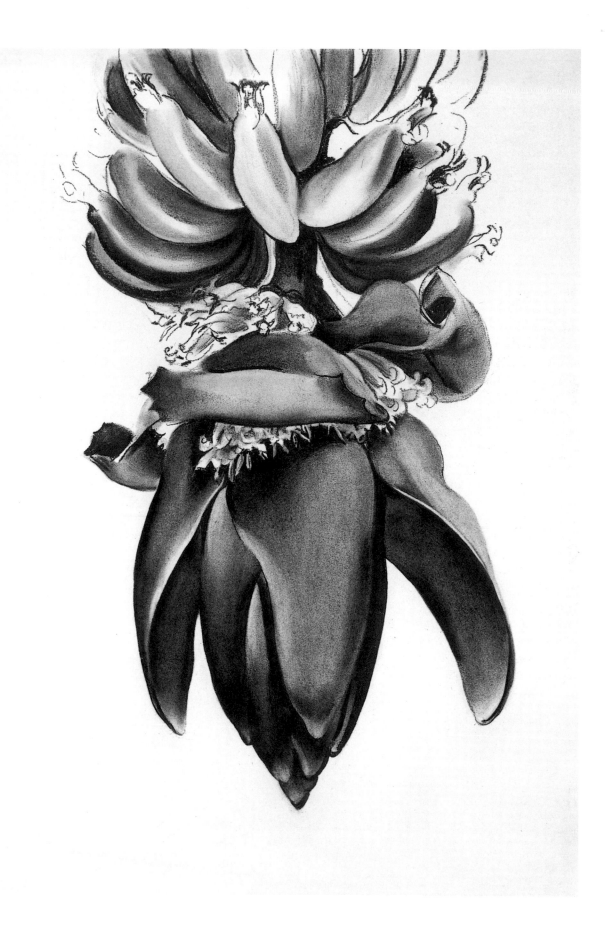

ELLSWORTH KELLY

American, b. 1923
Asiatic Day Flower, 1969
pencil on paper
29 ¾ x 21 ¾ inches
The Museum Purchase Plan of the NEA and the
Tabriz Fund, 1981.
81.15

Ellsworth Kelly attended the Pratt Institute in Brooklyn for a brief period, from 1941 to 1943, until he was called for service in the U.S. Army, where part of his assignment was to create silkscreen posters about camouflage. During his duty, he traveled through England, Germany and France. When discharged, Kelly attended the School of the Museum of Fine Arts, Boston, for two years. In 1948, still under the benefits of military service, he attended the École des Beaux-Arts in Paris. While there, he had vast opportunities to meet fellow artists and interested parties including Jack Youngerman, Joan Miró, Merce Cunningham, Alexander Calder, Constantin Brancusi and Alice B. Toklas, who showed Kelly the late Gertrude Stein's collection. By 1954 Kelly was back in New York and within two years had a one-person show at Betty Parsons Gallery. In 1957 and 1959, he was included in shows at the Whitney Museum of American Art and The Museum of Modern Art, New York, respectively. Kelly was firmly established as a leading artist in the 1960s and afforded a one-person exhibition of various media at the Gallery of Modern Art, Washington, D.C. The show also traveled to Boston. In 1965, the Whitney Museum included Kelly's work in *A Decade of American Drawings, 1955-1965*. Retrospective exhibitions of his work were held at The Museum of Modern Art in 1973 and at the Guggenheim Museum, New York, in 1996.

Kelly's oeuvre includes painting, polyptychs, sculpture, line drawings and prints. Of these, his polyptychs in pure, uninflected color and brushwork established his early reputation as a painter of abstractions. His work has continued to evolve, often in two strong contrasting colors and eccentric shapes, and in single-color shaped canvases and freestanding painted metal sculpture.

In Spring 1949, while a student at the École des Beaux-Arts, Kelly brought a potted hyacinth to his studio, which became a subject for his drawing. From that time onward he has filled notebooks with flower drawings. Plant drawings on large sheets of rag paper began to appear in exhibitions from 1957. These drawings demonstrate an impersonal observation of forms, Kelly's regard for the line drawings of Arp, Brancusi and Matisse, and his ability to exploit the tension between flat translations of three-dimensional forms through the precision of the encompassing line. There is no shading, no fattening or special emphasis to his line. The means are austerely economical. He is concerned with horticultural accuracy, an aesthetic ordering of the shapes on the page and the tensions between the line and the shape it describes—the facts. The plant drawings are related to Kelly's keen abilities in observation, his meticulous rendering of objective reality and his sense of style. The plant drawings have become the chamber music of his otherwise public wall paintings and sculpture.

Sources:

Ashbery, John. *Ellsworth Kelly / Plant Drawings.* New York: Matthew Marks Gallery, 1992.

Bell, Clare. *Ellsworth Kelly and the Legacy of Linear Drawing, On Paper*, vol. 2, no. 1. (September October 1997),pp. 33-36.

Goossen, E.C. *Ellsworth Kelly.* New York: The Museum of Modern Art, 1973.

Upright, Diane. *Ellsworth Kelly: Works on Paper.* New York: Harry N. Abrams, 1987.

Waldman, Diane, ed. *Ellsworth Kelly: A Retrospective.* New York: Guggenheim Museum, 1996.

SAM FRANCIS

American, 1923-1994
Untitled, 1954
watercolor on paper
22 x 17 ¾ inches
The Tabriz Fund, 1987.
87.35

Recovering from spinal tuberculosis following an air crash during training in the U.S. Army Air Corps, Sam Francis began to paint. He received BA and MA degrees from the California School of Fine Arts, San Francisco. Francis studied with David Park, but during the same period (1948-50), the school also presented classes with Richard Diebenkorn, Mark Rothko, Clyfford Still and Ad Reinhardt. In 1950 Francis went to Paris and became acquainted with Matisse's daughter, Marguerite, and her husband, Georges Duthuit, an art historian of Fauvism; Jean-Paul Riopelle; and other artists and critics. Francis exhibited at the Galerie du Dragon, Paris, in 1952, the Kunsthalle, Bern, and San Francisco Museum of Modern Art in 1955, and New York's Museum of Modern Art in 1956. Significant commissions came to him beginning in the late 1950s. In 1957 Francis completed the Chase Manhattan Bank Mural, New York. This was followed by a mural for the Sogetsu School, Tokyo (1967), and one for Mies van Der Rohe's Nationalgalerie, Berlin (1969). Retrospectives of his work began in 1967 at the Museum of Fine Arts, Houston, followed by the Albright-Knox, Buffalo (1972), and the Fundacion Eugenio Mendoza, Caracas, Venezuela (1974).

Francis's first mature paintings were airy veils of color, which expanded to fill canvases with clustered, cell-like modules of colored light. These personal veils of color established his international reputation within the decade of the 1950s. His later paintings evolved with stronger colors, and the white of the canvas became a shifting force changing from ground to figure.

This watercolor relates closely to Francis's formative canvases of the 1950-54 period. There is a sensitively painted silvery white ground from which emerges a web of colored strokes in pale pinks, dusty roses and subtle touches of yellow. The watercolor strokes are frankly distinguishable, and the edge of each stroke reflects how it has been absorbed into the paper or the ground. Francis was inspired by the late paintings of Claude Monet, but he also reflected the watercolor discipline of Paul Cézanne and demonstrated his awareness of the color experiments and technical innovations of Pierre Bonnard and especially Matisse. G.N. and B.Y.

Sources:
Feinblatt, Ebrin and Jan Butterfield. *Sam Francis*. Los Angeles: Los Angeles County Museum of Art, 1980.
Selz, Peter. *Sam Francis*. New York: Harry N. Abrams, Inc., 1982 (Rev. ed.).
Sweeney, James Johnson. *Sam Francis*. Houston: Museum of Fine Arts, 1967.

JACK YOUNGERMAN

American, b. 1926
February 20, 1968, 1968
ink on paper
23 ¼ x 28 ⅞ inches
Arkansas Arts Center Foundation Purchase, 1984.
84.33.2

A Saint Louis native Jack Youngerman attended the University of Missouri from 1943 to 1947, except for time during the war when he served in the U.S. Navy. Following his discharge, he found U.S. art schools to be crowded and moved to Paris (1947-56), and attended the École des Beaux-Arts from 1947 to 1949. There he became friends with fellow students Ellsworth Kelly, Eduardo Paolozzi and César and came to know Constantin Brancusi and Jean Arp. Paris was the site of Youngerman's first one-person show at Galerie Arnaud in 1951. In 1956 Betty Parsons urged him to return to the states. Like Kelly, he established his studio at Coenties Slip in New York, with neighbors such as Robert Indiana, Agnes Martin and Robert Rauschenberg. Youngerman was included in *Sixteen Americans* at The Museum of Modern Art, New York (1959). Prominent solo shows at museums include the Massachussetts Institute of Technology (1966); the Phillips Collection, Washington, D.C. (1968); and the Guggenheim Museum, New York (1986).

Youngerman had a modernist's tendencies toward frontality, flatness and simplicity, which had been fostered in his Parisian period. Impressed by the biomorphic sculptures of Brancusi and Arp and the *Klange* woodcuts of Wassily Kandinsky, he leaned toward bold, uncomplicated color sequences and forms with emphatic figure-ground relationships. He also found great power in the late *papier découpage* and ink drawings of Henri Matisse. In the U.S. he found himself looking at the work of Albert Pinkham Ryder, Arthur Dove and Georgia O'Keeffe, all of whom used black and focused on organic imagery. Black played a pivotal role in Youngerman's work of the late 1950s and 1960s. He found organic references to plant life and flowers. The big form became a hallmark of his work, for which he drew upon the work of Robert Motherwell and Clyfford Still, using jagged edges and knifed impasto. His canvases took on the look of large organic plant forms, executed with simplified shapes, and restricted color arrangements of only two or three colors.

This drawing appears to be a variation on many of the flower like compositions of the late 1950s and 1960s and might have indirect inspiration from plant and landscape compositions by O'Keeffe, Dove or Kelly. Youngerman's medium is black India ink on white paper. Like Matisse's late cutouts, there is a sense of the black form being carved out of the white.

Sources:
Miller, Dorothy C. *Sixteen Americans*. New York: The Museum of Modern Art, 1959.
Waldman, Diane. *Jack Youngerman*. New York: Solomon R. Guggenheim Museum, 1986.
Jack Youngerman: *Painting and Sculpture*. Stockholm: Heland Wetterling Gallery, 1989.

IV. THE FIGURE

MAX WEBER

American, 1881-1961
Seated Nude, c. 1914
gouache on paper
7 ⅝ x 6 ⅞ inches
The Tabriz Fund, 1994.
94.17.4

Max Weber was born in Russia in 1881, and his family settled in the United States ten years later. Considered one of the first American modernists, Weber was greatly influenced by Arthur Wesley Dow, his teacher at Pratt Institute, Brooklyn. Dow's teaching prepared Weber for his exposure to modernism in Paris. He spent one post-diploma year with Dow and several years teaching in Virginia and Minnesota (1900-1905), before moving to Paris, where he studied at the Académie Julien. He took classes with Henri Matisse, which had been organized by students and supervised by Mrs. Michael (Sarah) Stein, sister-in-law of Leo and Gertrude Stein. African tribal art was an interest of Weber's that would endure throughout his life. He also came to know and prize the work and friendship of many Paris artists, including Henri Rousseau, Pablo Picasso and Robert Delauney, before his return to New York in 1909. Two years later Stieglitz gave Weber a solo exhibition. In 1924 Bernheime-Jeune gave him a show, and in 1930 The Museum of Modern Art, New York, presented a retrospective.

Weber turned slowly from his Cubist style of 1913-1919 and the curvilinear abstract sculptures of 1915 to a figurative manner with some religious themes. He pursued a classic figurative direction through the 1920s as critical opinion shifted to approval. In his full maturity, Weber followed a figurative expressionism rooted in Parisian painting.

The drawing *Seated Nude* is a document of the consistency in Max Weber's life and work: it is a generous presentation of the classic female nude that he had studied in the French schools and with Matisse. The vigorous and wiry line, which Weber utilized for more than sixty years, has been subsumed into the heavy water paint. The work has fine color, but without the urgency of the Fauve era. The assigned date is 1914, and *Seated Nude* corresponds with works of the same year. Yet this drawing seems prophetic of larger and more ambitious figure projects Weber realized in the 1920s. Just as Picasso veered away from Cubism toward the classical nude in the early twenties, Weber mirrored his colleague's evolution. *Seated Nude* is measured only in inches and yet it conveys a sense of heroic scale consistent with the artist's most ambitious works in the oil medium.

Sources:

Danenberg Galleries. *Max Weber: Early Works on Paper*. New York: Bernard Danenberg Galleries. 1971.

Fortess, Lilian. *Max Weber Memorial Exhibition: Paintings, Drawings, Sculpture*. Boston: Boston University Art Gallery, 1962.

Goodrich, Lloyd. *Max Weber Retrospective Exhibition*. New York: Whitney Museum of American Art, 1949.

North, Percy. *Max Weber's Women*. New York: Forum Gallery, 1996.

Story, Ala. *Max Weber: 1881-1961*. Santa Barbara: The Art Galleries, University of California, Santa Barbara, 1968.

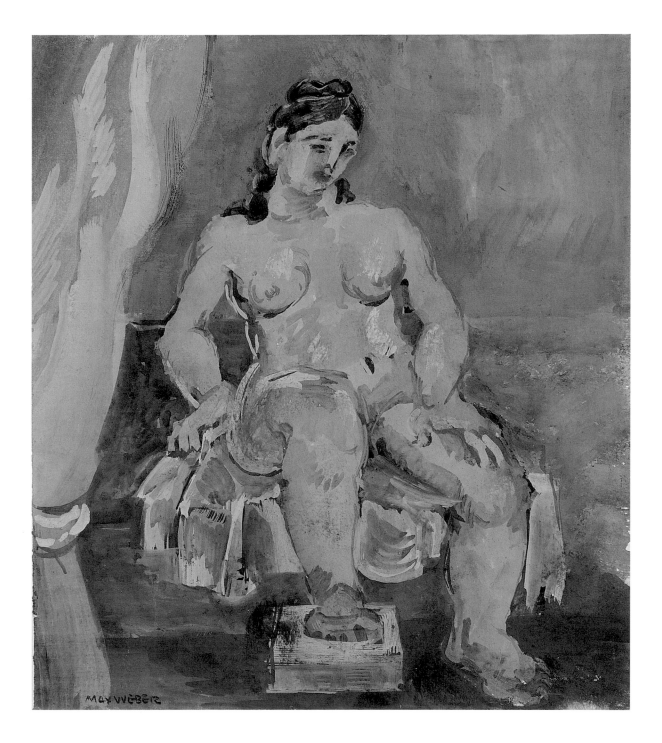

ELIE NADELMAN

American, b. Poland, 1885-1946
Standing Female Nude, c. 1908-11
pen and black ink on paper
12 ¼ x 5 ½ inches
Gift of John N. and Fay Stern, Winnetka, Illinois, 1993.
93.59

Elie Nadelman was born in Warsaw, Poland, from a prosperous family including artists, writers and musicians on his mother's side. He attended the Warsaw Art Academy from 1899 to 1903 but felt he could develop better in the culture of Munich, where he lived for six months, followed by a brief period in Paris, 1904-05. He knew Leo and Gertrude Stein and visited Picasso's studio in 1909. His work was included in the famous Armory Show (1913). In 1915-16, he showed at Alfred Stieglitz's 291 Gallery, New York. Later he had exhibitions at M. Knoedler, New York, and Bernheime-Jeune, Paris, to name only two venues. Nadelman was firmly in the correct circles of the Parisian and New York art worlds, but he also was a bit opinionated toward certain movements. He wanted to be considered a forerunner of Cubism, but would also claim to be an anti-Cubist. Nadelman on separate occasions refused to lend pieces to the Whitney Museum of American Art, New York, or the Metropolitan Museum of Art, New York, in the 1930s and 1940s because he felt they were not sufficiently supportive of him. Lincoln Kirstein's monograph on the artist (1949) helped to reestablish the sculptor's once faded reputation and return him to his proper place among the early modernists.

The drawing *Standing Female Nude* directly follows the artist's "proto-Cubist" period, roughly from 1904 to 1908. It is a variation on a drawing reproduced in Kirstein's 1949 monograph on the drawings [fig. 26], and is related to one of the artist's earliest bronze figures, *Suppliant Female Nude*, c. 1905. Nadelman derived the figure with variations of freehand curves used to define head, torso, arms and legs, while reflecting the tensions and balances in standing, shifting weight, extending the arms and thereby compressing the breasts. Starting with a curve, he added echoing and complementary curves, which ultimately describe the figure's volumes. He steadfastly eschews the straight line and any angle that might refer to Picasso's Cubism.

Sources:
Baur, John I. H. *The Sculpture and Drawings of Elie Nadelman, 1888 - 1946: An Exhibition*. New York: The Whitney Museum of American Art, 1975.
Kirstein, Lincoln. *The Sculpture of Elie Nadelman*. New York: The Museum of Modern Art, 1948.
Nadelman, Elie. *Drawings*. New York: H. Bittner, 1949.

Paul Cadmus

American, b. 1904
Drawing #3, c. 1964-65
charcoal and white chalk on paper
12 x 8 ⅝ inches
The Memorial Acquisition Fund, 1984.
84.21

Paul Cadmus was the son of immigrants from Holland. His father was a lithographer and a student of Robert Henri—the leading painter of "The Ashcan School"—and his mother was an illustrator of children's books. At fifteen, Cadmus began to study drawing at the National Academy of Design, New York, under Charles Hinton (a former pupil of Jean-Léon Gérôme). Shortly after his coursework, he began lithography study with Joseph Pennell at the Art Students League, New York. In October 1931, he traveled to Europe with Jared French, a fellow artist who would become a longtime friend. Two years later, Cadmus was accepted into the Federal Public Works of Art Project. However, his painting *The Fleet's In!* was ejected from the first WPA exhibition in Washington because of its overt sexual nature. The notoriety followed him; but between 1936 and 1938, he received commissions for public murals for the Port Washington, New York, Post Office and the Virginia Parcel Post Building. Between these projects, he held his first solo exhibition at Midtown Galleries, New York, in 1937. With 7,000 attendees at this show, his fame began to rise. In 1940, *Life* magazine commissioned him to paint *The Herrin Massacre*. The work was harshly criticized for being too violent and unsympathetic toward the labor union. In 1942 Cadmus had his first important museum exhibition, *Three American Painters*, at the Baltimore Museum. A year later he was featured in *Realists and Magic Realists* at The Museum of Modern Art, New York. During the 1950s, he began to exhibit internationally. A retrospective of his work was held in 1981 at the Miami University Art Museum, Oxford, Ohio.

Drawing #3 reflects the artist's classical academic training and his interest in anatomy, posture and careful observation of the weight of the limbs. The use of charcoal with highlighting in white chalk, in the old master manner, is a direct and understated technique for rendering a figure. It has been a convention for some artists to leave the head "blank" to avoid embarrassment for the nude model. As such, the focus of the piece becomes the skillful work of the artist, not the identity of the model. The Arts Center's work combines common studio props such as drapery and the suggested top of a crate, on which the figure places her right foot. This drawing is consistent with Cadmus's habit of drawing a nude model daily. Somewhat unusual is the gender—Cadmus tended to favor isolated, nude males. Although he utilized a posture and technique reminiscent of Italian Renaissance studies, Cadmus's oeuvre is separated in spirit from the earlier Italian masters because the number of his figural studies is too great to be intended as early studies for larger, finished paintings. G.N. and B.Y.

Sources:

Eliasoph, Philip. *Paul Cadmus / Yesterday and Today*. Oxford, OH: Miami University Art Museum, 1981.

Johnson, Una. *Paul Cadmus: Prints and Drawings*. New York: Brooklyn Museum, 1968.

Kirstein, Lincoln. *Paul Cadmus*. New York: Imago Imprint, 1984.

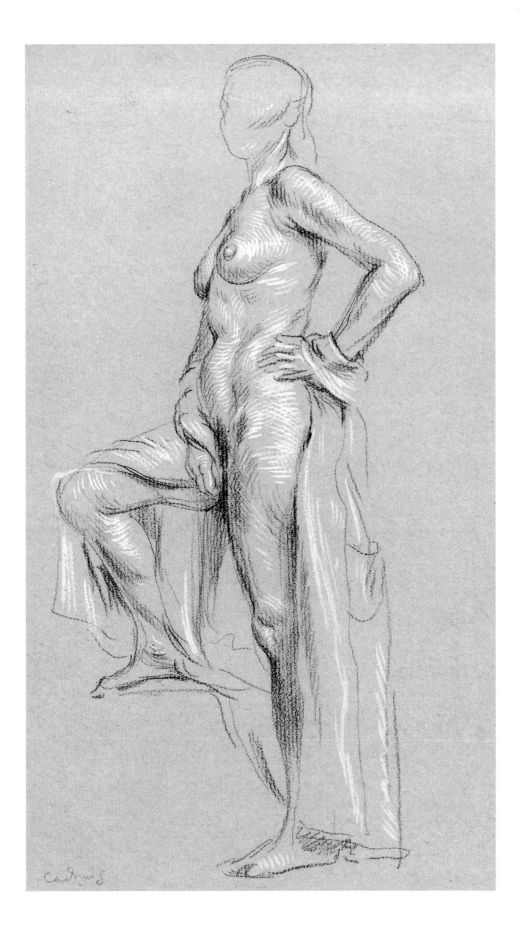

ELMER BISCHOFF

American, 1916-1991
Untitled, 1973
gouache and charcoal on paper
25 ¾ x 20 inches
The Museum Purchase Plan of the NEA and the
Tabriz Fund, 1976.
76.10.e

In 1946 Elmer Bischoff began teaching at the California School of Fine Arts with Douglas MacAgy, Clay Spohn, David Park and Clyfford Still. He stayed at the school until 1952. In this period Bischoff had translated his grounding in Picasso into a West Coast brand of Abstract Expressionism—spontaneous, minimizing line and cultivating color. Park, a colleague, paralleled Bischoff's path, but returned to figuration in 1950, and by 1952 Bischoff felt a similar impulse, inspired by his admiration for Giotto, Edvard Munch, Edward Hopper and Cézanne. Bischoff, Park and Richard Diebenkorn met each week for an evening of figure drawing at one of their studios, at which time they talked and criticized each other's work. Park and Bischoff were excited about their painterly expressive figuration, much involved with expressive paint handling. Diebenkorn began to paint figuratively in late 1955.

In 1972 Bischoff turned again to abstract painting. The new work displayed a freedom and authority that compared favorably with the pre-1952 painting. Still life or landscape might still be sensed as underpinning these new works. Bischoff drew for himself and to show others what he saw. His drawings were not made as studies or in preparation for a painting. They existed as independent works.

Untitled, 1973, was produced in direct response to a specific model. It was begun in charcoal and developed in gouache. The folding chair, the shawl or robe upon which the subject sits, and the shadowy background reflect an artist's studio—the after-hours habitat of those who feel that drawing is a major tool of the visual artist and a discipline which has to be tuned and sharpened through weekly practice, regardless of whether one is making abstract or figurative paintings or sculpture. In these sessions he usually worked in charcoal and ink, charcoal and gouache, or ink and gouache.

Sources:
Cathcart, Linda. *Elmer Bischoff*. Chicago: The Arts Club of Chicago, 1980.
Frash, Robert M. *Elmer Bischoff 1947-1985*. Laguna Beach, CA: Laguna Art Museum, 1985.
Kuspit, Donald. *Elmer Bischoff: Paintings from the Figurative Period, 1954-1970*. San Francisco: John Berggruen Gallery, 1990.

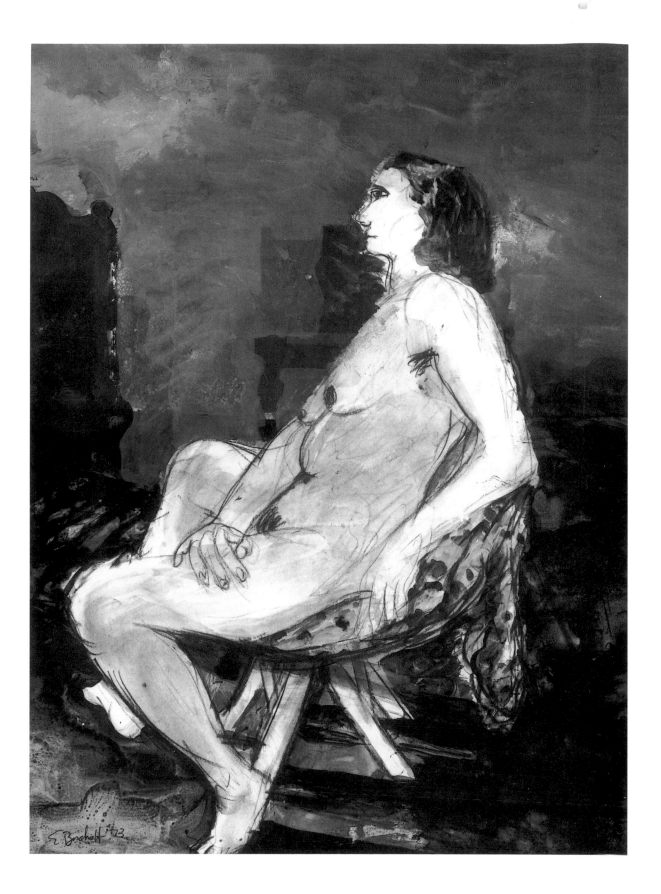

JACK BEAL

American, b. 1931
Drawings from the Model P, #2, 1985
conte crayon and chalk on paper
19 ¾ x 25 ⅝ inches
The Tabriz Fund, 1988.
88.20

Jack Beal was born in Richmond, Virginia, and educated at William and Mary College, Norfolk, Virginia, the School of the Art Institute of Chicago and the University of Chicago. He has taught extensively through positions at the University of Indiana, Bloomington; Purdue University, Lafayette, Indiana; the University of Wisconsin, Madison; and Cooper Union, New York. Allan Frumkin, his dealer, has exhibited his work frequently. In 1973 the Galerie Claude Bernard, Paris, gave him a show as did the Virginia Museum, Richmond. He has been featured in group shows at the Whitney Museum of American Art, New York, the Milwaukee Arts Center and others.

Although Beal's major medium is painting, he is also a draftsman, illustrator and printmaker who works in a modern, theatrical naturalism. His paintings of the 1960s, depicting furniture-crowded rooms, offered him a recognizable imagery with which he could experiment with directional light, extended shadows and a variety of patterns treated as abstract elements. He added human imagery to his interiors, often nudes, with an interest in "photographic angles" and the sense of separation available in that medium, achieving dynamic compositional effects. His work in drawing, illustration and printmaking is related to and parallels his painting.

Drawings from the Model P, #2, is a fully developed study, which may have been executed in preparation for an oil painting. It reflects the artist's familiar practice of working close to the nude model, viewing the subject from an unusual angle of vision. In this work Beal has disordered the bed-clothes and posed the subject both on and off the couch, while rendering the covers or pillows and side-table with the same close observation that he devotes to the figure. Strong directional light, shadows, complex wrinkle patterns in the comforter, the wooden end-panel of the couch, the end-table and lamp, and the scattered papers spread the compositional interest to all four sides and corners of the sheet. It is presumed that Beal uses a camera to preserve his forced perspectives and may often stand on a ladder to get his precise angle of vision. At the same time there is a planar tipping in that the couch and figure appear to lie in slightly different planes. The subject's left leg would not appear to have sufficient room to be extended as it is in the available space suggested by the couch's ruling contours. The artist has created a pictorial conundrum which calls the viewer's eye back to the lower left quadrant in an effort to understand it.

Sources:
Schjeldahl, Peter. "The Meaning of Jack Beal," *Jack Beal*. Richmond: The Virginia Museum, 1973.
Shanes, Eric. *Jack Beal*. New York: Hudson Hills Press, 1993.

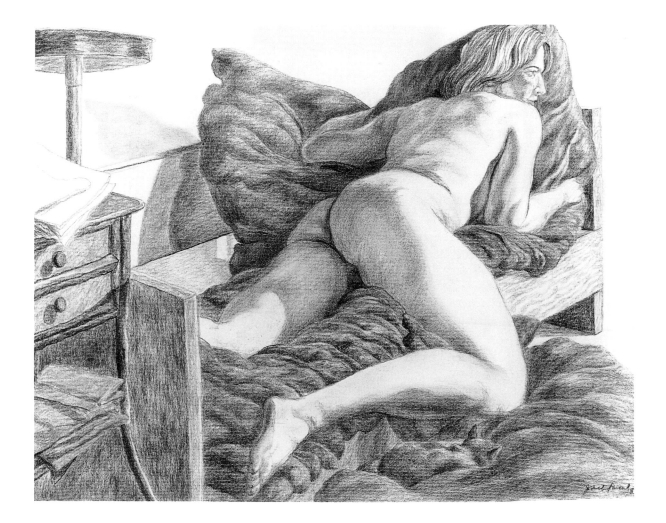

MARSDEN HARTLEY

American, 1877-1943
Ax Man, 1908
crayon on paper
12 x 9 inches
Purchased with a gift from Virginia Bailey, 1993.
93.7

Marsden Hartley was born in Lewiston, Maine, with the christened name of Edmund, and he assumed his step-mother's maiden name, Marsden, before the age of twenty. The family moved to Cleveland, where he won a scholarship to the Cleveland School of Art. In 1898 he went to New York and studied with William Merritt Chase. This was followed by instruction at the National Academy of Design, New York. In 1909 Alfred Stieglitz gave the artist his first solo exhibition at the famed 291 Gallery, New York. Stieglitz also included his work in the *Younger American Painters* exhibition, along with work by Arthur Dove, John Marin and Max Weber. In addition to these American modernists, in the early teens, Hartley also became acquainted with the paintings of Albert Pinkham Ryder, Franz Marc and Wassily Kandinsky. While Hartley had strong dealer support, including Montross Gallery, Charles L. Daniel, and others, he was poor much of his life. In 1935 he destroyed over 100 works of art because he was no longer able to pay storage bills on the pieces. Hudson Walker became his next dealer, 1937, and the artist continued to exhibit through him. In 1942, he received a purchase prize for an exhibition at the Metropolitan Museum of Art, New York.

Hartley worked his drawings in a variety of media, in a casual manner, recognizing them as preliminary stages for his visual ideas to be defined in painting. It should be clear from his paintings that his primary concern was not for drawing, but for color. Throughout his landscapes in 1908, Hartley used bright color, applied in short, deliberate strokes with a technique reflective of his influence from the Divisionist method of Giovanni Segantini. *Ax Man* is void of color but reveals an energetic application of line with quickly drawn marks. This drawing appears to have parallel, arbitrary strokes left of the figure and right of the tree, all of which fill voids in the paper and stabilize the composition. The resulting impression is not a hallmark of academic draftsmanship, but it successfully renders the brisk movement inherent to the figure's task. The same technique was used in his drawing *Self-Portrait as a Draughtsman* (Oberlin College, Ohio), also from 1908. Here, the rapidly drawn portrait reveals his method, evidenced by the drawing's technique and the depiction of the artist at work. G.N. and B.Y.

Sources:

Haskell, Barbara. *Marsden Hartley*. New York: Whitney Museum of American Art, in association with New York University Press, 1980.

Marsden Hartley 1908-1942: The Ione and Hudson D. Walker Collection. Minneapolis-St. Paul: University Art Museum, University of Minnesota, 1984.

McCausland, Elizabeth. *Marsden Hartley*. Minneapolis: University of Minnesota Press, 1952.

Mitchell, Joan. *Ninety-Nine Drawings by Marsden Hartley*. Lewiston, ME: Bates College, 1970.

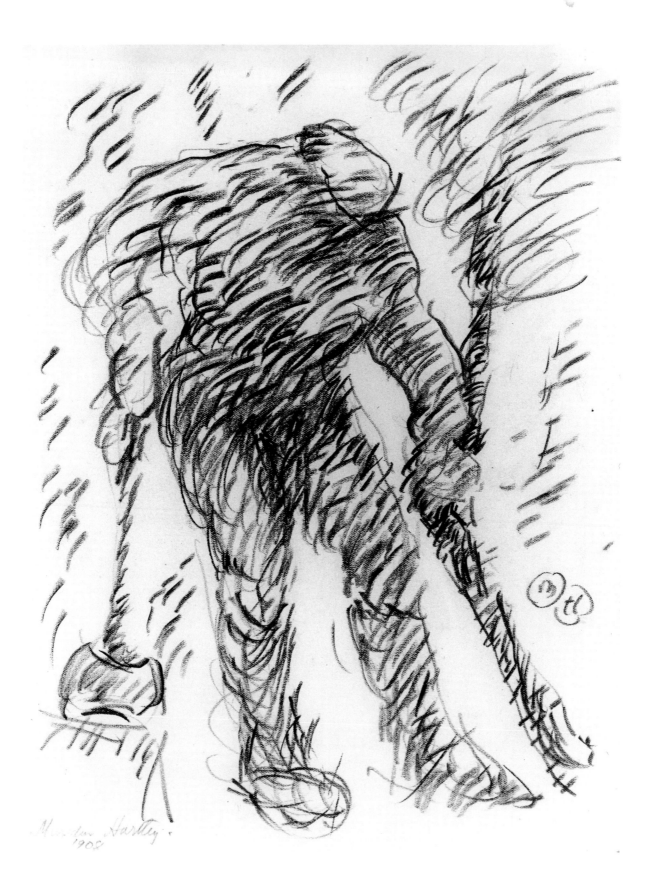

Marsden Hartley.
1908

Thomas Hart Benton

American, 1889-1975
Study for Man with Ax, c. 1935
pencil on paper
23 x 18 inches
Purchased with a gift from Eugene M. Pfeifer III and Mr. and
Mrs. Roger Horchow in honor of Fay Smulian Pfeifer, 1986.
86.56

Thomas Hart Benton was born in Missouri and found early employment as a cartoonist for the *Joplin America*, in Joplin, Missouri. From 1906 to 1907 he attended the Corcoran Gallery of Art and the School of the Art Institute of Chicago, and from 1908 to 1911 he attended the Académie Julien, Paris. While living in Paris, Benton associated with Leo Stein, John Marin, Diego Rivera, Morgan Russell and Stanton MacDonald-Wright. During World War I in Europe, Benton returned to the U.S., where he met Walt Kuhn and Arthur B. Davies, co-chairmen of the Armory Show of 1913. Shortly after, he exhibited in the *Forum Exhibition of Modern American Painting* at Anderson Galleries.

Benton identified with grassroots America after World War I and became critical of the international modernism in which he had been trained. In the 1920s he began a major mural program, established a reputation and assumed a teaching position at the Art Students League, New York (1926-35). He soon settled into a pattern of studio painting punctuated by mural commissions for the New School of Social Research, New York (1928-30); the Whitney Museum of American Art, New York (1932); (later given to New Britain Institute, Connecticut); and the Federal Post Office in Washington, D.C. (1934). His murals were criticized as politically reactionary and isolationist by the political left. Benton became very critical, in turn, of the North Eastern art establishment, its leftward leaning politics and modernist aesthetic views. He left New York in 1935, moving back to Missouri to paint the State Capitol mural and to teach at the Kansas City Art Institute.

Study for Man with Ax is a preparatory work for the mural *A Social History of Missouri*, which was completed in 1938. The figure develops in the North Wall of the House of Representatives Lounge, "Pioneer Days and Early Settlers," in a thematic group relating to the earliest construction in the state, represented by lumbermen, a blacksmith and historic buildings in the background, where a riverside baptism is taking place and, to the right, a slave is being auctioned. The *Study for Man with Ax* is an early version of the lumberman, just to the right of the door, with his ax raised above his head, being helped by a black assistant. Pioneers are seen swapping whiskey for furs with Osage Indians, and one can discern slaves being beaten and the Mormons persecuted elsewhere in the same wall. On other walls may be seen the legend of "Frankie and Johnny" and outlaw-hero Jesse James robbing a bank. Many Missourians felt that Benton had brought up too many subjects and issues that ought better to have been suppressed. Critics asserted that for some figures the anatomy was exaggerated, especially in the hands and feet. The artist replied, "I like the hands of working people. They are beautiful. I like to have them large enough to be seen." (See note 1.) Benton's subject matter and content, however, brought forward a far greater outcry. A prominent member of the community expressed the feeling that "[the murals] do not show Missouri in a proper light. Missouri is not proud of hangings and Negro honky-tonks. She is not proud of the whipping of slaves, the slave block and Jesse James holdups." (See note 2.) The passage of time has served to redeem the mural and community pride in it.

Sources:

Adams, Henry. *Thomas Hart Benton: An American Original*. New York: Alfred A. Knopf, 1989.

Benton, Thomas Hart. 1889-1975. *An Artist in America*. 4th rev. ed. Columbia, MO: University of Missouri Press, 1983.

Nordland, Gerald. *Controversial Public Art from Rodin to di Suvero*. Milwaukee: Milwaukee Art Museum, 1983.

Marling, Karal Ann. *Tom Benton and His Drawings*. Columbia, MO: University of Missouri Press, 1985.

Preble, Michael. *Benton in the Ozarks: Selections from the Thomas Hart and Rita P. Benton Testamentary Trusts*. Little Rock: The Arkansas Arts Center, 1986.

Notes:

1. In Henry Adams, *Thomas Hart Benton: An American Original*, p. 271.

2. Ibid., p. 269.

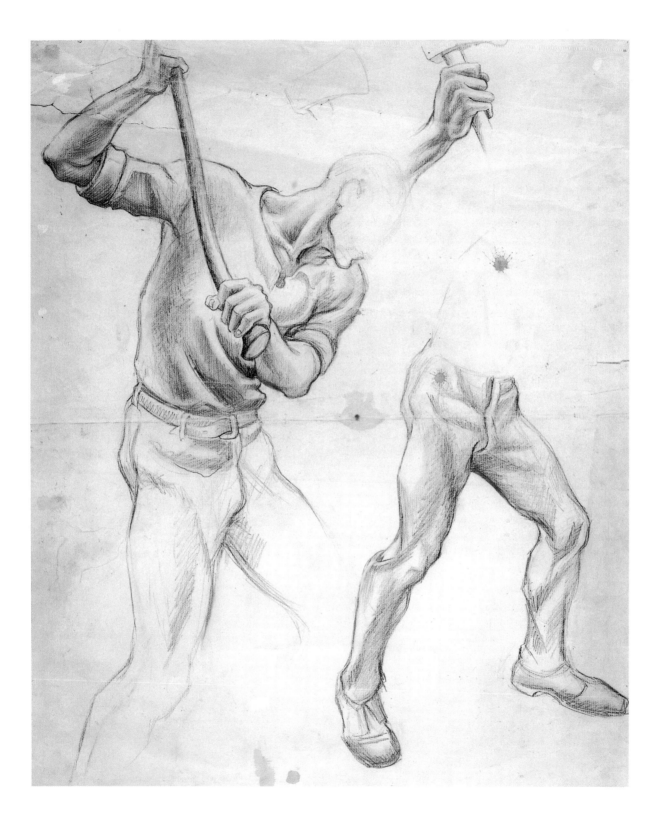

George Bellows

American, 1882-1925
Tennis at Newport, c. 1918
pencil on paper
18 ¼ x 20 inches
Anonymous Loan, 1980.
EL.12.a.1980

Bellows was a native of Columbus, Ohio, and attended Ohio State University before moving to New York City in 1904. There he studied art with Robert Henri, his instructor at the New York School of Art. He was classmates with Edward Hopper and Rockwell Kent. Often associated with "The Eight" because of his shared concern for contemporary subjects and his relationship to Henri, Bellows was of a later generation and did not show with the group in its formative years. However, by 1908, he did exhibit some early boxing works, including *Stag at Sharkey's* (The Cleveland Museum of Art) at the National Academy of Design. In 1913 his work was included in the Armory Show. In 1925, following his death, he was honored with a memorial exhibition at the Metropolitan Museum of Art, New York. Major exhibitions continue to follow, though they often focus on his paintings.

When compared with such rugged athletic images as *Stag at Sharkey's*, it may seem that the drawing *Tennis at Newport* (Rhode Island) is a somewhat delicate example of the artist's work. Bellows genuinely enjoyed lawn tennis as an activity and as a spectator sport, having summered in Rhode Island in 1918 and 1919. There, he visited the tournament at the Newport Casino, making many quick sketches for later development. He produced at least two lithographs in 1921 of a closely related game and crowd, and paintings of similar subjects are held by the the Metropolitan Museum of Art and the Dallas Museum of Art. Bellows was, of course, a keen observer, and he captures not only the stance, stroke and suggested movement of the players, but the weight and fashion attitudes of seated, slouched and reclining observers in the near, middle and far distance. He has produced an icon of summer life and pleasures in one of the great bastions of American privilege in the early decades of the century. His doubles players are crowded into the same side of the court, enabling the artist to accommodate his elegantly dressed and parasolled audience in chairs, on the grass and standing on the distant steps.

Sources:

Boswell, Peyton, Jr. *George Bellows*. New York: Crown Publishers, 1942.

Braider, Donald. *George Bellows and the Ashcan School of Painting*. Garden City, NJ: Doubleday & Co., 1971.

Morgan, Charles H. *George Bellows: Painter of America*. New York: Reynal & Co., 1965.

Oates, Joyce Carol. *George Bellows, American Artist*. Hopewell, NJ: The Ecco Press, 1995.

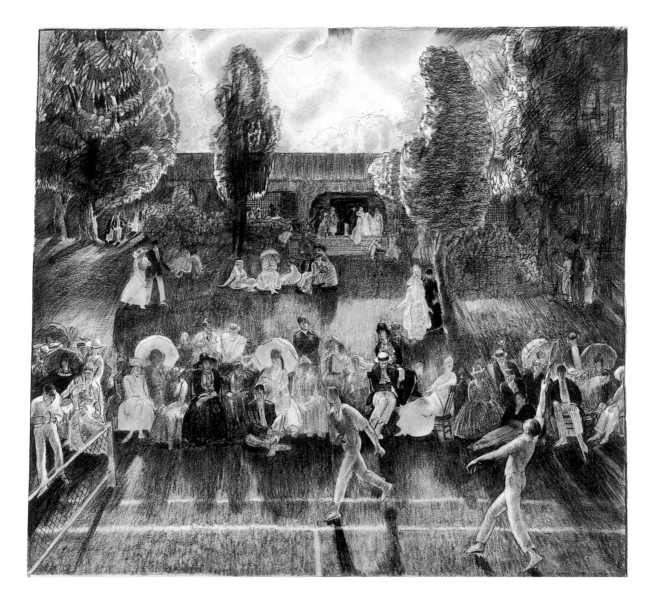

JOHN STEUART CURRY

American, 1897-1946
The Flying Codonas, 1932
conte crayon and pencil on paper
21 ⅝ x 18 inches
Purchased with a gift from Virginia Bailey, 1984.
84.42

John Steuart Curry was born on a farm near Dunavant, Kansas, and began art lessons at the age of twelve from a Paris-trained woman who lived nearby. As an adult, he enrolled at the Kansas City Art Institute and later at the School of the Art Institute of Chicago. In 1919 he moved to New Jersey to work for Harry Dunn, a recognized illustrator. Following a move to New York, then to Paris, he began to concentrate his art on themes of Kansas life. Success and recognition followed quickly.

American Scene painting, which had developed in the twenties, became a mid-western opposition to the international abstraction that had manifested itself after the Armory Show of 1913. A "social realist" branch concerned itself with political views and class consciousness, while the regionalist group tended to be apolitical and descriptive of universal themes through local events and subjects. Proponents of "regionalism" tended to speak for cultural isolationism and "Midwestern values." Thomas Hart Benton, Curry and Grant Wood were tied in the public mind to Regionalism in the 1930s, though Benton denied that any of the three were confined to a small-town view of American life. Curry believed in the enduring values of farm life and recorded this life, and the people who inhabited it, with fidelity. His parents, family and later his close friends were his subjects. Impressive events of rural life, such as fairs, evangelist meetings and the circus were sketched, put on canvas or made the basis of murals, all of which he believed served as documents of that life.

Curry had used the circus as subject in the late 1920s, but *The Flying Codonas* was created in the spring of 1932, when Curry literally followed the circus. The artist had recently separated from his wife and the lure of the show proved too strong. Featured in the drawing is the circus's biggest attraction: the brothers Alfredo and Lalo Codona, the only pair in the world who could successfully perform the triple somersault from the trapeze. (See note.) Here, Curry has captured the pinnacle of circus drama, the second before the catch, when Lalo awaits his spinning brother. Adding to the drama was the fact that many observers must have known that earlier in 1932, Alfredo's second wife died during a fall in one of her performing routines. Portraying a likeness of the Codonas was not the primary mission for the drawing. With the tilted, diagonal poles contrasting to the position of the two figures, one tightly closed and the other open, Curry reveals the dizzying movement essential to the drama. Curry's paintings from the circus proved to be quite popular. Ferargil Galleries hosted a popular exhibition of many of the pieces in April 1933. During this year, the Whitney Museum of American Art, New York, purchased the finished painting for which the Arkansas Arts Center drawing is a preparatory study. This work then served as the model for a lithograph edition of 50. G.N. and B.Y.

Sources:

Jensen, Dean, and Roselie Goldstein. *Center Ring: The Artist / Two Centuries of Circus Art*. Milwaukee: Milwaukee Art Museum, 1981.

Junker, Patricia. *John Steuart Curry: Inventory of the Middle West*. New York: Hudson Hills Press, in association with the Elvehjem Museum of Art, University of Wisconsin, Madison, 1998.

Schmeckebier, Laurence. *John Steuart Curry's Pageant of America*. New York: American Artists Group, 1943.

Note:

Patricia Junker, *John Steuart Curry: Inventory of the Middle West*, p. 157.

KENT BELLOWS

American, b. 1949
Four Figure Set Piece, 1988
pencil on paper
19 ¾ x 32 ¼ inches
Purchased with a gift from Virginia Bailey,
Curtis and Jackye Finch and Director's Collectors, 1989.
89.22

Kent Bellows was born in Blair, Nebraska, to a family where painting, literature, music and theater were part of life. He was trained in drawing and painting by his father. Though he was educated at the University of Nebraska, Omaha, he considers his parents among the most important influences. Bellows had his first solo exhibitions in Omaha in 1970 and 1971, but his reputation grew after showing with Tatistcheff Gallery, New York, in 1985, first in group shows, then in solo exhibitions in 1988 and 1993. He was included in the *Collectors Show* at the Arkansas Arts Center in 1986. Other prominent venues followed, including Florida International University, Miami; the Huntsville Museum of Art, Alabama; the Sheldon Memorial Art Gallery, Lincoln, Nebraska; the National Academy of Design, New York; and the Forum Gallery. In 1994 his work was included again in a group exhibition at the Arkansas Arts Center.

Four Figure Set Piece has a synthetic composition. It was composed from four separate models, who were never assembled at one time. (The Arkansas Arts Center also holds the finished *Study for Susan*, the woman on the far right.) The women on the left are leaders of regional theater in Omaha, where the artist lives. Typically for Bellows, he prefers to make drawings of friends or family. The two nude figures are young actors whose theatrical visions, and perhaps their very lives, are being shaped and expanded by the advice imparted by the

directors. In addition to optical truth, Bellows establishes other aims. Regarding a portrait of his wife, which the artist created one year after *Four Figure Set Piece*, he revealed insights applicable to other portraits, "… typically for me [it] is very detailed and finely articulated. It is a damn good likeness and that is important to me. But the essence of the thing is in the expression. I'll fuss endlessly with this; it's in the hands, nostrils, the ears, the eyes, the mouth, everything really." (See note.) To underscore the expressions in *Four Figure Set Piece*, the artist displays special merit in combining nude and clothed figures in a single composition, feeling that this establishes a powerful tension that must be confronted by each observer. G.N. and B.Y.

Source:
Kent Bellows (brochure). New York: Tatistcheff & Company, Ltd., 1988.
Contrasts: Kent Bellows and John Sparagna. Kearney, NE: Museum of Nebraska Art, 1990.

Note:
Contrasts: Kent Bellows and John Sparagne, n.p.

MAURICE BRAZIL PRENDERGAST

American, 1859-1924
Bathers, c.1919-20
watercolor and pencil on paper
10 ⅞ x 13 ¼ inches
The Mrs. Frank Tillar Fund, 1995.
95.5

Maurice Prendergast, America's first post-Impressionist, held a sophisticated international view of contemporary art up to the Cubist-Futurist movements. He was a member of "The Eight" but is also closely associated with modernism, perhaps more so than the others. As a youth in Boston he apprenticed at a commercial art firm. He was partly self-taught and also educated in Paris at the Académie Julien and the Académie Colarossi. In 1895 the artist returned to Boston, where his output consisted mainly of works on paper, including his vastly popular watercolors, which were shown at Boston's Watercolor Club, the Art Institute of Chicago, the New York Watercolor Society and other honored venues. His first solo museum exhibition was held at the Cincinnati Art Museum, 1901, featuring 64 watercolors and monotypes. Seven of the artist's pieces were selected for the Armory Show (1913). Duncan Phillips and Albert Barnes became ardent collectors of his work. Prendergast's first retrospective was held at the Cleveland Museum of Art (1926).

In 1916 Montross Gallery, New York, featured an exhibition with Prendergast's work along with previous French masters including Cézanne. *Bathers* reveals knowledge of not just Cézanne, and specifically his images of bathers, but also the idyllic work of Arthur B. Davies, an organizer of the Armory Show. In *Bathers*, one specific debt to Cézanne is the employment of large, framing trees to anchor the composition on either side. The nudity of the figure on the right and the light colors, compared to Prendergast's earlier Venetian watercolors, for example, indicate a timeless ideal for the artist rather than a specific site. His watercolors, especially the late works such as this, demonstrate the distance forged between Prendergast and his earlier contemporaries of The Eight .

Sources:
Breuning, Margaret. *Maurice Brazil Prendergast*. New York: Whitney Museum of American Art, 1931.
Green, Eleanor. *Maurice Prendergast: Art of Impulse and Color*. College Park, MD: University of Maryland Art Gallery, c.1976.
Memorial Exhibition of Maurice Prendergast. New York: Whitney Museum of American Art, 1934.
Maurice Brazil Prendergast Sketchbooks, 1899. Boston: Museum of Fine Arts, 1960.
Rhys, Hedley Howell. *Maurice Prendergast 1959-1924*. Boston. Museum of Fine Arts, and Cambridge, MA: Harvard University, 1960.
Wattenmaker, Richard. *Maurice Prendergast*. New York: Harry N. Abrams, in association with the National Museum of American Art, 1994.

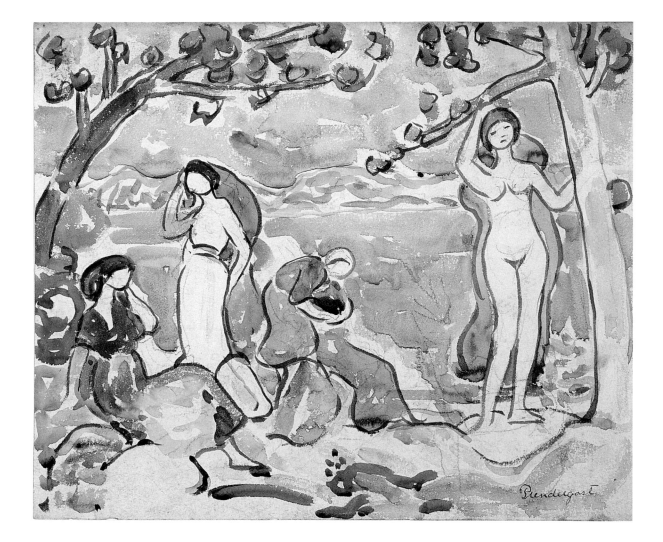

GEORGE GROSZ

American, b. Germany, 1893-1959
At the Seaside, 1928
pencil on paper
23 ¾ x 18 ¼ inches
Arkansas Arts Center Foundation Purchase, 1984.
84.33.1

George Grosz was the child of lower middle-class servants but had private drawing lessons from the age of nine. From 1909 to 1911, he studied at the Royal Academy of Art, Dresden, and moved to Berlin to study at the School of Applied Art. In 1913 he studied in Paris at the Académie Colarossi. Around 1919 he began to publish portfolios of graphics devoted to political criticism of the German government and the war. He also worked closely with the Berlin Dada group. Grosz worked in easel painting, drawing and fine art prints, but always with a social-political edge of commentary. In Germany, he was keenly aware of Cubist, Futurist, Dada, and Surrealist movements, which he both criticized and supported. He left Germany for the U.S. in 1932, where he taught at the Art Students League, New York. Shortly thereafter, he received his citizenship. The Whitney Museum of American Art, New York, granted Grosz a retrospective in 1954.

At the Seaside depicts an elderly uniformed Nazi volunteer, with cane and swastika flag, on duty at the seaside, surveying vacationers, sunbathers, cabanas, boats and a distant lighthouse. From his girth, beard and cane, we deduce that the official is not a storm trooper, but the representative of the Nazi Party's effort to restrict freedom by constant surveillance, which Grosz had opposed from the outset. As satirical as this drawing is of the self-important officer and his unworthy task, it offers

a less biting satire than had been Grosz's practice five years earlier, or three years later, after the burning of the Reichstag, when his eye for detail was more intensely vitriolic. In a letter Grosz wrote while vacationing on the Baltic shore, he described at length the German nationalists who carried their politics even into the building of sand castles at the shoreline.

Sources:
Schneede, Uwe M. *George Grosz: His Life and Work*. New York: Universe Books, 1979.

R. B. KITAJ

American, b. 1932
Bad Faith (Chile), 1978
pastel and charcoal on paper
30 ¼ x 22 ½ inches
The Fred W. Allsopp Memorial Fund, 1983.
83.18

R.B. Kitaj was born Ronald Brooks in Cleveland, Ohio. He was raised by his mother, who remarried. Brooks took his stepfather's name in 1941. Kitaj traveled extensively beginning with his duty as a merchant seaman in 1950. Later that year he enrolled at Cooper Union, New York, followed by study in Vienna at the Akademie. Following further military service, he studied at the Ruskin School, Oxford, on the G.I. Bill, beginning in 1957. He moved to the Royal College of Art in 1960-62, where he became friends with David Hockney. By 1962, he also knew Francis Bacon and Eduardo Paolozzi. His first solo exhibtion was held at Marlborough, London, in 1963. He has taught extensively including assignments at the Ealing Technical College and the Camberswell School of Arts and Crafts, both in England; the University of California, Berkeley, and the University of California, Los Angeles. In 1994, Kitaj was given a major exhibition at the Tate Gallery, London, which traveled to the Metropolitan Museum of Art, New York, in 1995.

Kitaj's paintings are allegories of human concern. He poses figures in social situations, suggestive frameworks, implicit urgencies, but draws attention to labels and prejudices that interfere with understanding. His paintings are tableaux which deal with issues of human interaction, mundane life and pretensions to morality. In the resonance of form and color, of figures and their emotional interaction, Kitaj suggests a form of communication that has the force of T.S. Eliot's poem "The Wasteland."

Kitaj began with drawing and has reaffirmed it as a key element in his sense of art in his mature years. The bare-chested, closed-eyed, Christlike figure in *Bad Faith (Chile)* conveys an image of torment or death, and the upside-down clock suggests disorder, a search, and violence. There is a sensuous directness in Kitaj's handling of pastel and charcoal that is very modern and yet related to the work of Edgar Degas and Odilon Redon. His subjects suggest shocking events and crimes—in this case, the American CIA's support of the murderous reactionary counter-force against the duly elected President of Chile.

Sources:

Ashbery, John. *Drawings, Paintings, Pastels*. New York: Thames and Hudson, 1981.
Kitaj, R.B. *First Diasporist Manifesto*. London: Thames and Hudson, 1989.
Livingston, Marco. *R. B. Kitaj*. New York: Rizzoli, 1985.

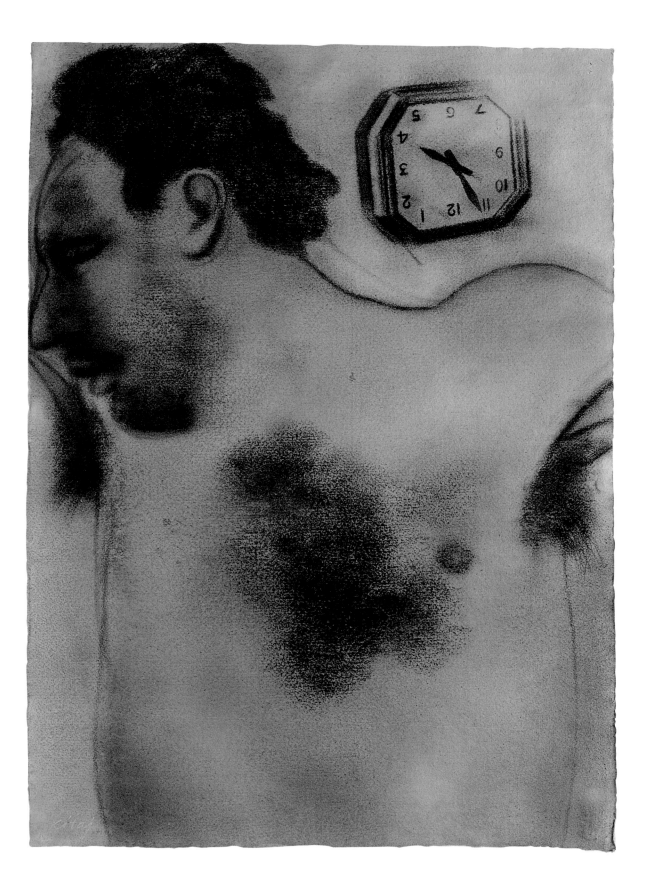

JACOB LAWRENCE

American, b. 1917
Carpenters Series #2, 1981
pencil on paper
23 ¾ x 18 inches
The Barrett Hamilton Acquisition Fund, 1987
87.4

Jacob Lawrence was born in Atlantic City, New Jersey, and moved with his family, in 1930, to Manhattan. He attended the College Art Association's Harlem workshop in 1932 and took WPA art classes in 1934-37 at the Harlem studio of Henry Bannarn. He received a scholarship from the American Artists School (1937-39). During that same time, he was also employed by the Easel Division of the WPA project. His first one-person show came in 1940 at the Harlem YMCA. *Fortune* magazine commissioned him to travel in the South in 1947 to make ten paintings. (They were later pulished.) In 1948 he illustrated Langston Hughes's new book, *One Way Ticket.* Lawrence began to teach at the Pratt Institute, New York, in 1960 and was appointed Professor of Art at the University of Washington in 1971. Exhibitions have been numerous with a fraction of the highlights including a solo show at The Museum of Modern Art, New York (1940); the Brooklyn Museum (1960); the Whitney Museum of American Art, New York (1974); and the Seattle Art Museum (1986), which traveled to eight museums.

Jacob Lawrence usually worked in series on narrative paintings dealing with themes relating to African-Americans. His preferred media have tended to be casein, gouache and tempera. For subject matter, he has shown empathy toward suffering, learning and purposeful labor through historic sequences on the northern migration, life in Harlem, the story of John Brown, war and the lives of black leaders of the Americas— Frederick Douglass, Toussaint L'Ouverture and Harriet Tubman.

Lawrence does not think of drawing as an independent medium and rarely makes sketches for their own sake. He treats drawing as a preparation for painting, which evolves in the process of its making. Yet drawing is a fundamental element of his style and the prime carrier of emotion for the posture, gesture and overall flat-patterned arrangement of his figures in what has been characterized as his "expressive Cubist" technique. He uses primary colors with great effect against neutral backgrounds and with economy and contrast.

In *Carpenters Series #2* four figures are seated in the center of a studio under a brilliant light, surrounded by paintings and sculpture; the workspace appears under renovation. Despite the simplicity of the medium— pencil on paper—value and color are suggested by the rhythmic weights and vigorous traces of the artist's hand. This drawing of 1981 is related to a series of works, *The Builders*, which began in the late 1960s and continued into the middle 1980s, where the "builder" serves as a metaphor for the artist himself. Tools refer to craftsmanship, the pride in doing. There is a passionate handmade quality to be noted in Lawrence's drawings, which is eliminated in the paintings, where color rules. The drawings afford him room to think, experiment and make corrections, allowing a view of the creation process.

Sources:

Saarinen, Aline B. *Jacob Lawrence*. New York: American Federation of the Arts, 1960.

Brown, Milton W. *Jacob Lawrence*. New York: Whitney Museum of American Art, 1974.

Wheat, Ellen Harkins. *Jacob Lawrence, American Painter*. Seattle: University of Washington Press/Seattle Art Museum, 1986.

ROBERT GWATHMEY

American, 1903-1988
Sewing, c. 1952
watercolor, pencil and ink on paper
18 ½ x 13 inches
The Museum Purchase Plan of the NEA and the
Tabriz Fund, 1974.
74.11.a

Robert Gwathmey studied at the North Carolina State College (1924-25), the Maryland Institute (1925-26), and the Pennsylvania Academy of Fine Arts (1926-30). His teaching experience was expansive and varied, including positions at Beaver College, Glenside, Pennsylvania (1930-37); the Carnegie Institute of Technology, Pittsburgh (1938-42); the Cooper Union, New York (1942-68); and also Boston University and Syracuse University. Gwathmey's first retrospectives were associated with academic settings: Randolph-Macon Woman's College, Lynchberg, Virginia (1967); Boston University (1969); and St. Mary's College of Maryland (1976). Group exhibitions were numerous, but Skidmore College, Saratoga Springs, New York, hosted *An Exhibition of Twentieth-Century Drawings* in 1975, which included Gwathmey's work.

In the late 1940s and early 1950s, as the Abstract Expressionist movement began to accelerate, Gwathmey endured a period of disinterest in his work. At the same time, he suffered from a repressive political climate typified by the Joseph McCarthy investigations. He joined with a group of figurative artists, including Ben Shahn, to launch the journal *Reality*. He continued to develop his art, drawing material from social subject matter, borrowing the color of medieval stained glass windows and learning the drawing of Picasso. With these forces, he chose to create a new genre of painting based on African-American rural life. In the 1960s he turned to a more active social advocacy and political commentary relating to civil rights and the Vietnam War.

The watercolor drawing *Sewing* depicts a barefoot African-American woman, attired in a "Sunday best" three-quarter-sleeved, patterned dress, sitting on a straight chair in an interior and working with a needle and thread to repair a napkin. The adjoining table supports a handsome bouquet of flowers in a simple vase. The clean-swept floor is of plain grained boards, and the wall behind the sewer appears to be papered in a mottled pattern. Gwathmey has taken a subject derived from Corot in the nineteenth century, or Vermeer in the seventeenth century, and modified it to a contemporary setting, offering only limited information. The image is one of purposeful dignity, orderly and peaceful.

Sources:

Piehl, Charles K. "The Social and Historical Context of a Southerner's Art in the Mid-Twentieth Century," *Arts in Virginia* (The Virginia Museum of Fine Arts), vol. 29, no. 1, 1989, pp. 3-15.

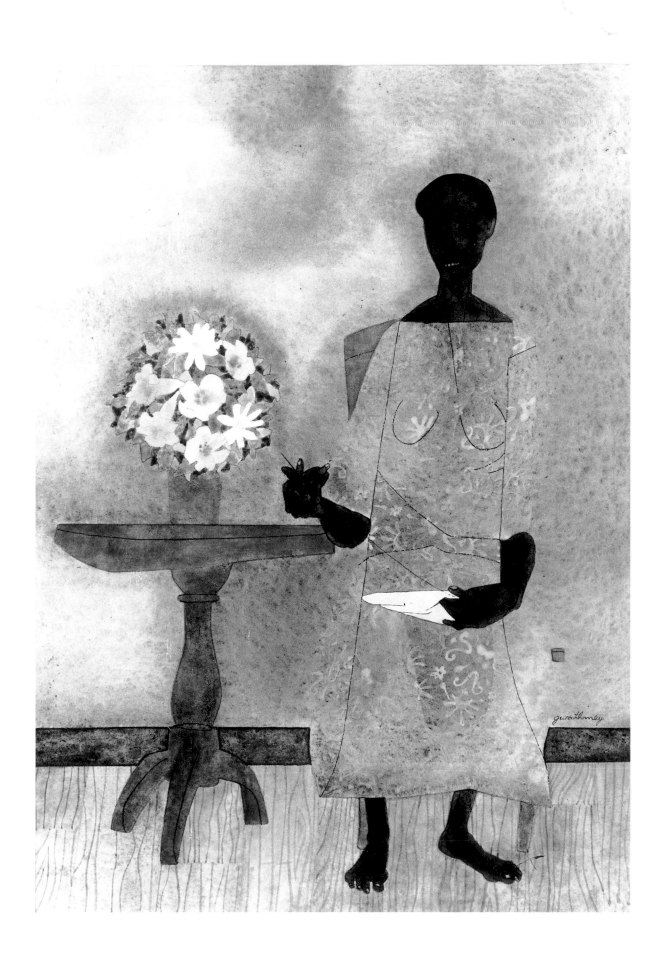

BOB THOMPSON

American, 1937-1966
Untitled (Bird Fight), 1962
tempera on paper
21 x 17 inches
Purchased with a gift from the Jonsson Foundation, 1987.
87.37

Bob Thompson's successful career was cut short by a premature death. He studied at the Boston Museum School in 1955 and the University of Louisville from 1955 to 1958, which was followed by exhibitions and extensive travel. The Delancey Street Museum, New York, afforded Thompson a one-person exhibition in 1960 and a number of galleries followed, including the Martha Jackson Gallery (1963, 1965 and 1968); the Drawing Shop, New York (1963-64); Richard Gray Gallery, Chicago (1964 and 1965). Retrospectives came shortly after his death, with the first ones being the New School for Social Research, New York (1969), and the Studio Museum in Harlem, New York (1978). In 1971 the Brooklyn Museum included Thompson in *Eight Afro-American Artist.*

A man of his time, Thompson was devoted to jazz and felt a correspondence between its improvisational nature and the most creative aspects of modernist painting. His meeting with expressionistic painter Jan Müller was decisive in helping him to combine improvisation, folk art and his love of old-master compositions with the expressive color of the German Expressionists.

Untitled (Bird Fight) features both the color and crowding of forms characteristic of Thompson's work. The strong color of the three "faceless figures" is directly related to notable paintings he executed in the same period in Paris and Ibiza, Spain. The silhouettes of the two huge birds fuse with the strong colors of the figures and the foreground in a personal counterpoint of flat-patterned magic. All of this activity is contrasted with the crowd of faces in the upper half of the sheet, which are engaged observers of the conflict. The arena, the animated crowd and the primary colors of the figures and birds combine to suggest a mythic trial or conflict, which is consistent with the artist's debts to Müller, to the German Expressionists and to earlier masters Piero della Francesco, Francesco de Goya and Nicolas Poussin.

Source:
Mocsanyi, Paul, Meyer Schapiro and Ulfert Wilke. *Bob Thompson (1937-1966)*. New York: New School Art Center, 1969.

ROY LICHTENSTEIN

American, 1923-1997
Study for Aviation, 1967
pencil, crayon and collage on paper
22 x 26 inches
The Museum Purchase plan of the NEA and the
Tabriz Fund, 1976.
76.19

Roy Lichtenstein began formal study with Reginald Marsh in the summer of 1939 at the Art Students League. His college years were spent at Ohio State University (1940-43), with an interruption for service in the armed forces, followed by completion of his BFA degree in 1948. He taught at OSU for two years while he completed his MFA, which he received in 1951. While teaching at Rutgers University, New Brunswick, New Jersey, he became familiar with New York City. His first exhibition was at the Leo Castelli Gallery, New York, in 1962. His work was also included in the Gugghenheim Museum, New York, show *Six Painters and the Common Object* a year later. Solo museum exhibitions soon followed, including the Cleveland Museum of Art (1966); the Pasadena Art Museum (1967); the Gugghenheim Museum (1968), and so on. By the end of the 1960s and onward Lichtenstein was seen as a towering figure of the Pop Art movement, which diverted attention away from the work of the Abstract Expressionists.

Lichtenstein appropriated images from popular magazines and newspapers and simplified and clarified them in transferring and recomposing them to his drawing. The image was then projected on canvas for a shocking change of scale, which he rendered in a matter-of-fact style, without evidence of emotion. These depictions of bathing beauties or comic strip characters were received as an ironic, or mildly humorous, intellectual commentary, in sharp contrast to the passionate seriousness of then mainstream Abstract Expressionism. His adaptation of trivial and banal subjects appeared radical in the climate of the early 1960s. The "Pop Art" slogan, which

had been applied to an English development, was recycled as the epithet of choice to characterize the varied subject matter and impersonal renderings of Lichtenstein, Andy Warhol, James Rosenquist and Claes Oldenburg.

Lichtenstein quickly adopted the Ben Day dot system of the color printing processes of newspapers to give an added dimension of impersonality; these he laid in by means of stencil. He followed his now famous advertisement and comic strip appropriations with images taken from college text books, stylized Abstract Expressionist brushstrokes and modern art deco paintings. In subsequent years he utilized imagery derived from mirrors, landscapes and variations on works by Léger, Mondrian and Picasso.

Study for Aviation is a document of the artist's working procedures, in which he has exposed his visual processes, the tentative cross-hatchings and the rearranging of elements to achieve an anonymous decorative solution. *Study for Aviation* was never reworked into a finished canvas, but his intentions would appear to mimic the movement of the propeller. The collisions of lines and strokes are appropriate for the whirl and vibrancy of traditional air travel. In this case the viewer has continuous evidence of the artist's hand, which would inevitably be eradicated in the final version through impersonal ruler-and-compass draftsmanship, Ben Day color screens and clear colors covering the brushwork.

Sources:
Coplans, John. *Roy Lichtenstein*. New York: Praeger Publishers, 1972.
Rose, Bernice. *The Drawings of Roy Lichtenstein*. New York: The Museum of Modern Art, 1987.
Waldman, Diane. *Roy Lichtenstein*. New York: Guggenheim Foundation, 1969.
———. *Roy Lichtenstein*. New York: Guggenheim Foundation, 1993.
———. *Roy Lichtenstein Drawings and Prints*. New York: Chelsea House Publishers, 1969 (A Paul Bianchini Book).

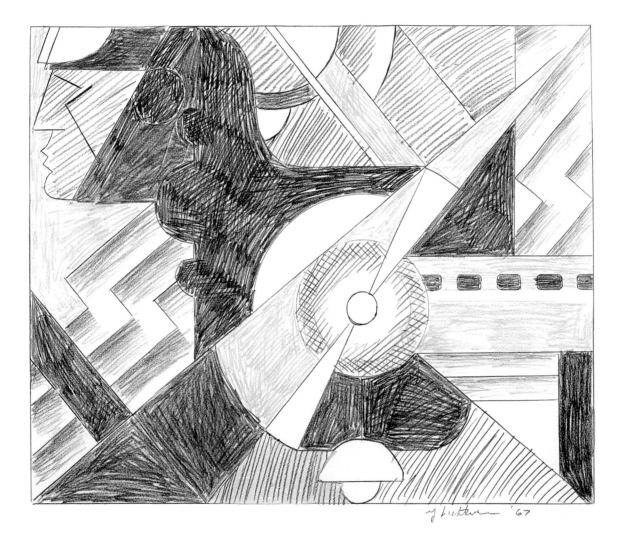

JIM NUTT

American, b. 1938
If I Could Only, 1975
pencil on paper
15 ¾ x 10 ¼ inches
The Tabriz Fund, 1992.
92.6

Though Jim Nutt was born in Massachusetts, his family moved often when he was young. As a young adult going to college, he repeated the pattern. He enrolled at the University of Kansas, Lawrence, beginning in 1956, then at the University of Pennsylvania, followed by classes at Washington University, and finally the Art Institute of Chicago, from which he received his BFA degree in 1965. Through support of the Hyde Park Art Center, Nutt and a small group of artists were able to exhibit in the years 1966-68. Nutt's work was included in the Venice Biennale (1972), and a midcareer review was mounted at the Museum of Contemporary Art, Chicago, in 1974. Retrospectives were organized by the Rotterdam Kunststichting (1980), and the Milwaukee Art Museum (1994).

Nutt's aesthetic was shaped by popular and ethnographic arts, by *l'art Brut* (the art of the untrained artist, including Wolffli, Yoakum, Martin Ramirez), by William Copley, comic strips, toys and publicity photos. He found merit in the vulgar and precious value in the sleazy subjects, crude forms and garish color of pulp magazine advertising. He has steadfastly questioned "good taste" and the "socially acceptable," believing that it can be a tyranny that stands in the way of honest expression. He has focused for his content on bodily functions, misspellings, semiliterate puns and the subconscious scatology of Western man.

In *If I Could Only*, the large male figure approaches the smaller female figure with a menacing right-hand claw, an aggressive sexual posture and an emphatic tug on his genitals. Smaller female figures approach from stage left and from the audience, as if to aid a sister in distress. The title *If I Could Only* recalls innumerable sweet love songs of romantic idealism, but the irony made clear here is that idealism is not on this male's mind. The artist intends the ironic tone of the title and the behavior of the leading figure to suggest a humorous reality, even though daily newspaper and television reports remind us that sexual harassment is always with us and is seldom humorous.

Nutt and his irreverent colleagues from Hyde Park Art Center might concur with Oscar Wilde, that art is most important when it approaches the obscene; when it defies community standards of good taste; when it stops our ordinary patterns of knowing and replaces them with disturbing queries.

Sources:

Adrian, Dennis. *Sight Out of Mind (Essays and Criticism on Art)*. Ann Arbor: UMI Press, 1985.

Bowman, Russell, et al. *Jim Nutt*. Milwaukee: Milwaukee Art Museum, 1994.

Halstead, Whitney. *Jim Nutt*. Chicago: Museum of Contemporary Art, 1974.

Schulze, Franz. *Fantastic Images / Chicago Art Since 1945*. Chicago: Follett, 1972.

H. C. WESTERMANN

American, 1922-1981
Untitled (Falling Man), 1973
ink and watercolor on paper
21 ¾ x 30 inches
Arkansas Arts Center Foundation Purchase, 1995.
95.59.2

Horace Clifford Westermann worked as a logger, as a Marine, for the Red Cross, and as an actor before attending the School of the Art Institute of Chicago for advertising design in 1947, followed by fine arts in 1952. Westermann stopped painting after graduation and began construction of highly personalized houses, memorials and sculptural pieces in wood, glass, industrial hardware and other materials. Notably, during this period he did not make preparatory studies for this work. Instead he composed in three dimensions. Westerman remarked later that his large constructions "... are not models or doll houses, but concrete formulations of human experience, suggesting both the futility and permanence of human endeavor." (See note.) In later years Westermann taught briefly at the San Francisco Art Institute (1971), and at the University of Colorado (1973). The Los Angeles County Museum of Art presented a retrospective of 47 objects and ten drawings in 1968. The Whitney Museum of American Art, New York, held a retrospective in 1978.

Westermann's overall techniques were impressive and quite meticulous, but the emotional effect of his work conveys a primitive or folk-art sensibility rather than one of a professional carpenter or artist. His technical display was only sufficient to convey his personal message. In addition to his structures, Westermann was an able printmaker and gifted draftsman. He incorporated complex and inventive drawings into his normal correspondence, wherein the prose was quite brief.

Westermann reflects his personal experiences in all of his works: the preposterous design of the palm tree, the comedic possibilities in a pratfall, the wonders and perils of bodies of water in any of their guises. *Untitled (Falling Man)* is a "presentation drawing," conceived as an autonomous work in the artist's typical linear pen strokes. It features a male character which he developed, perhaps an alter-ego of himself, a "Dick Tracy" figure, often with a "gambler's" moustache, and a suggestion of worldly wisdom that may include the capacity to carry out unusual wickedness. He utilized this character in his drawings and prints, but created other characters and acrobatic figures, developed in a sticklike form or in a fluid and inventive calligraphy. In this drawing the protagonist appears to be falling backward from the high cliff to a plain, or a body of water, and likely death. We can not be certain where the waterfall flows, but the figure seems to flail, straining to run back to the precipice, an unlikely possibility. The event occurs in an exotic landscape, with a mysterious bird nest, tall peaks and rolling mountains. Westermann's narrative is as inconclusive as are the readings of his three-dimensional works. They are all objects for contemplation.

Sources:

Adrian, Dennis. *Sight Out of Mind*. Ann Arbor, MI: UMI Press, 1985.

Haskell, Barbara. *H. C. Westermann*. New York: Whitney Museum of American Art, 1978.

Kozloff, Max. *H. C. Westermann*. Los Angeles: Los Angeles County Museum of Art, 1968.

Westermann, H. C. *Letters from H. C. Westermann*. New York: Timken Publishers, Inc., 1988. Letters selected and edited by Bill Barrett; biographic sketch by Joanne Beall Westermann.

Note:

In Dennis Adrian, *Sight Out of Mind*, n.p.

V. PAINTERLY ABSTRACTION

DOROTHY DEHNER

American, 1901-1994
Measure of Time (Virgin Island Series), 1948
ink and gouache on paper
17 ⅜ x 13 inches
Arkansas Arts Center Foundation Purchase, 1988.
88.59

Dorothy Dehner's father died in 1912 and her mother not long after, in 1916. She grew up with her mother's family, developing an interest in drama, dance and art, when she had traveled to Europe, where she enjoyed the theater and museums. At New York's Art Students League in the mid 1920s, Dehner fell in love—first with the drawing classes of Kimon Nicolaides and then with Kenneth Hayes Miller's painting classes. A year later, she met David Smith; they married in 1927, and soon after purchased a farm at Bolton's Landing, New York, where they spent summers.

During the later 1930s Dehner's and Smith's friends included such artists as Herman Cherry, John Graham, Adolph Gottlieb and Mark Rothko. Throughout the 1940s, she worked on drawings, exploiting the expressive potential of biomorphic imagery and abstract geometric forms. After her divorce from Smith in 1952 (the same year she gained her degree at Skidmore College), she concentrated on printmaking with Stanley Hayter at Atelier 17 and renewed her interest in sculpture. Just a year before her death, the Katonah Museum of Art in New York honored her with a retrospective exhibition.

It is not surprising that the definitive history of Abstract Expressionism has yet to be written. The rich mixture of fact, fashion and lasting value is perhaps too close to our time for clear understanding. Nevertheless, enduring qualities survive and inevitably emerge. It is in this context that we must put aside the dominance of the heralded masters of Abstract Expressionism—the likes of Jackson Pollock, Willem de Kooning, Smith and Rothko—and recognize important practitioners who were women, among them, Dehner.

The title of the drawing, *Measure of Time*, includes *Virgin Island Series*, a clear reference to the artist's eight-month visit to the Virgin Islands in 1931 and 1932. However, the meaning is less obvious. Those earlier works were a reworking of Cubist still-life subjects. This 1948 drawing may have recalled some long-unrecognized inspiration from that time, but in imagery, the work is clearly the product of a familiar late-1940s play with organic form and of an interest in, using Rothko's words, the "spirit of myth." The free-flowing composition combines male and female symbolism derived from experimentation with automatism—the linear or painterly stroke that derives more from unconscious forces than from any studied approach. It synthesizes references to cellular division, marine maps, drifted flora, Paleolithic bone sculptures and prehistoric pottery designs. Dehner's work, however, owes no apologies to related pre-Abstract Expressionist work. Its gentle color palette and sense of evolutionary forms give it a strong quality of highly personal drama. G.N. and M.P.

Sources:
Keane-White, Dorothy. *Dorothy Dehner, Sculpture and Works on Paper*. New York: Twining Gallery, and Allentown, PA: Muhlenberg College, 1988.
Marter, Joan M. *Dorothy Dehner: Sixty Years of Art*. Katonah, NY: Katonah Museum of Art, 1993.
Marter, Joan M. and Sandra Kraskin. *Dorothy Dehner: A Retrospective of Sculpture, Drawings and Paintings*. New York: Baruch College Gallery, 1991.

EMERSON WOELFFER

American, b. 1914
The Argument, 1949
tempera on paper
23 x 29 inches
Gift of Betty Parsons Foundation, 1985.
85.50.32

Another name intertwined in the complex history of Abstract Expressionism is Emerson Woelffer. Unlike many of that group who chose to remain in New York, Woelffer moved around the country. Recently his work has become associated more with California modernism, which includes Hans Burkhardt, Helen Lundeberg and Frank Lobdell, among others.

Born in 1914, Woelffer grew up in Chicago's Prohibition era of jazz, for which he had a fondness. He did not choose a vocation in life until 1935, when he had saved enough money from various jobs to enroll in the School of the Art Institute of Chicago. He constantly studied European journals, seeking to learn more about Picasso, the School of Paris, the German Expressionists and primitive art. Later, he served for the Works Project Administration as an instructor, painter and project assistant and as a topographic draftsman for the Geodesic Survey. In 1942, sculptor Laszlo Moholy-Nagy brought him to the Institute of Design, known as Chicago's "New Bauhaus." In 1949, Buckminster Fuller invited Woelffer and his wife, photographer Dina Andersen, to teach at Black Mountain College in North Carolina, where they befriended artist Robert Motherwell. Woelffer also counted Jackson Pollock and Lee Krasner among his friends. In 1950, he accepted a faculty appointment at the Colorado Springs Fine Art Center. In 1959, after years of traveling in Europe, he joined the faculty of the Chouinard Art Institute in Los Angeles. He remained until 1973, when it became the California Institute of Fine Arts, and then joined the faculty of the Otis Art Institute, Los Angeles, where he retired in 1992.

The Argument was painted at Black Mountain College. During that stay, Woelffer was working with abstract-constructivist teachers and showed a love of Picasso and the School of Paris but was sympathetic to the Surrealists, particularly Max Ernst, Joan Miró and Yves Tanguy. He came to accept the doctrine of automatism, improvising so swiftly and intensely that he could avoid all cautionary impulses from reason and bypass aesthetic or moral concerns that might censor the free expression of the unconscious. His gestural paintings in the later 1940s have their roots in figuration but show his commitment to spontaneous, painterly expression—an apt description of *The Argument*. We can see a row of figures in shallow space, male on the left and female on the right, with intertwined figures in the center. These figures correspond closely to a series of sculptures he formed in 1947, showing overtones of Picasso and the "jungle paintings" of Cuban-born Wifredo Lam. The strong contrasts in complementaries convey a primitive vigor, as do the expressive gestural blurring and over-painted corrections. G.N. and M.P.

Sources:

Ayres, Anne and Roy Dowell. *Emerson Woelffer: A Modernist Odyssey.* Los Angeles: Otis School of Art and Design, 1992.

Nordland, Gerald. *Emerson Woelffer: Profile of the Artist* (1947-1981). Fullerton, CA: California State University, 1982.

Wescher, Paul. *Emerson Woelffer: A Survey Exhibition* (1947-1974). Newport Beach, CA: Newport Harbor Art Museum, 1974.

ADOLPH GOTTLIEB

American, 1903-1974
Pictograph, 1948
gouache and crayon on paper
18 x 24 inches
The Stephens Inc. City Trust Grant, 1985.
85.76.1

One of the most familiar members of the vanguard New York School in the 1940s and 1950s was Adolph Gottlieb. His *Burst* series now stands beside Jackson Pollock's complex webs and Mark Rothko's energetic rectangles as inspired icons of Abstract Expressionism. His early classes at the Art Students League, New York, were with John Sloan and Robert Henri, painters of the Ashcan School whose reputations were being established in the early years of the twentieth century. After a brief trip to Paris, Berlin and Munich in the early 1920s, he returned to the United States and attended several schools, including Cooper Union, New York, and again the Art Students League. By 1935, he was already a part of the new generation of painters, having been a founding member of The Ten, an expressionist and abstract painting group. A prolific painter, he enjoyed numerous exhibitions during his lifetime, showing at Kootz Gallery, New York, during the most popular years of Abstract Expressionism. Before his death, he and his wife established the Adolph and Esther Gottlieb Foundation to provide financial assistance to deserving artists.

The artist's earliest works focused on figurative imagery and cityscapes, with a mood influenced by the Great Depression. And yet his interest in abstract values was apparent, probably influenced by his close friendship with Milton Avery. During his visit to Tucson, Arizona, in the late 1930s, his work began a metamorphosis toward more abstract and surreal qualities. What evolved was a compositional grid that emphasized surface patterning and a unique vocabulary of symbolic forms. Called pictographs, these works exploited the surrealist penchant for using the unconscious mind as a source of imagery. In addition, Gottlieb was certainly looking to Joan Miró, Pablo Picasso and Paul Klee, as well as to African and Northwest Coast American tribal arts for inspiration and sources of imagery that he could transform into his own.

This drawing from 1948 is a fully realized, mature work within Gottlieb's pictographic style. Easily recognized within the compartments are a figure and body parts eyes, hand and head and several abstract and hieroglyphic forms, one of which may be an umbilicus. Primitive art remains a central source of the work. It is well known that Gottlieb not only saw great ethnographic museums in Paris, Munich, Berlin, Vienna and Prague, but he also collected primitive art. He collected African art and later Oceanic and Native American art, often with the help of fellow artist and friend John Graham. Of this interest Gottlieb wrote in 1943:

> If we profess a kinship to the art of primitive men, it is because the feelings they expressed have a particular pertinence today. In times of violence, personal predilections for niceties of color and form seem irrelevant. A primitive expression reveals the constant awareness of powerful forces, the immediate presence of terror and fear, a recognition and acceptance of the brutality of the natural world as well as the external insecurity of life.(See note.) G. N. and M.P.

Sources:
Alloway, Lawrence and Mary Davis MacNaughton. *Adolph Gottlieb: A Retrospective.* New York: Arts Publisher and the Gottlieb Foundation, 1981.
Hirsch, Sanford. *The Pictographs of Adolph Gottlieb.* New York: Hudson Hills Press, 1994.
Rosenberg, Harold. *Adolph Gottlieb: Paintings 1959-1971.* London, Zurich. Marlborough Gallery, 1971-72.
Ross, Clifford, ed. *Abstract Expressionism: Creators and Critics.* New York: Harry N. Abrams, 1990.
Sandler, Irving. *Adolph Gottlieb: Paintings 1945-1974.* New York: Andre Emmerich, 1977.
Wilkin, Karen. *Adolph Gottlieb: Pictographs.* Edmonton, Alberta, Canada: The Edmonton Art Gallery, 1977-78.

Note:
In Clifford Ross, *Abstract Expressionism: Creators and Critics*, pp. 211-12.

ARSHILE GORKY

American, b. Armenia, 1905-1948
Untitled (Landscape) c. 1945
pencil and crayon on paper
6 x 9 ⅞ inches
The Arkansas Arts Center Foundation Purchase, 1988.
88.40

In the history of art, many writers place a heavy burden on the work of Arshile Gorky. His paintings are often considered a turning point, if not a midpoint, in the evolution of European Surrealism to American Abstract Expressionism. Regardless of the merits of the dialogue, we do know that his art, like his youth, was about the struggle to survive. Born Vosdanik Adoian in Khorkom, Armenia, in 1904, his life ran a difficult path. While his father emigrated to the United States in 1908 to avoid conscription in the Turkish army, the rest of the family suffered from the Turkish oppression brought against the Armenian minority. Eventually, after years of flight, he arrived in the United States in 1920, and moved to Watertown, Massachusetts, to stay with an older sister. It was during his attendance at the New School of Design in Boston that he adopted the name Arshile (from Achilles) Gorky (from Maxim Gorky, the Russian writer). By the mid 1930s, Gorky was firmly established as a major artist: He had attended the National Academy of Design, New York, and the New School of Design, taught at the Grand Central School of Art, New York, and exhibited extensively in New York and Philadelphia, including the Whitney Museum of American Art's *Abstract Painting in America* in 1935. Regrettably, his achievements were short-lived: He had a cancer operation in 1946, and an auto accident in 1948 that broke his neck and immobilized his painting arm. He took his own life a month later.

Gorky was a painter of poetic allusions, in that he combined his response to nature filtered through memory and the conventions of Parisian painting to reach abstraction. Beginning spontaneously, he evolved his themes with preparatory drawings and as distinct versions of paintings. He was the last major figure to join the Surrealist movement and is often considered to be the first Abstract Expressionist because of his painterly anticipation of the New York School. He had a powerful visual intelligence with great facility and the ability to draw upon subconscious emotional resources. He was gifted in his color sense and had a capacity to organize forms in space with rhythmic effect, creating structures with an electric line suggestive of sexually charged content. He was a charismatic teacher and speaker and a keen student of historic painting.

Gorky drew with every material: pencils and crayons, oil sticks, chalk, pen and ink, or with a sign-painter's liner brush, to which Willem de Kooning had introduced him. He had a hungry eye and a skillful hand. Some drawings were studies that he developed through numerous variations until he executed the painting(s). The modest scale of *Untitled (Landscape)* would indicated that it is an early exercise in the development of a motif. The two outer figures have plantlike attributes. Such figures tended to be transformed into personages, while the central element would evolve into a force yet unimagined, but all would be clarified in detail and embellished with rhythmic accent lines and added areas of color. As a composition coalesced, Gorky would tend to expand to 20-by-26-inch sheets and pursue complete variations with elaborations of each component and explorations of contrasts in dark and light and color, so that when he turned to canvas, he was as familiar with his themes as with the faces of his children. G.N. and M.P.

Sources:
Schwabacher, Ethel. *Arshile Gorky Memorial Exhibition*. New York: Whitney Museum of American Art, 1951.
Seitz, William Chapin. *Arshile Gorky: Paintings, Drawings, Studies*. New York: The Museum of Modern Art, 1962.
Spender, Matthew and Barbara Rose. *Arshile Gorky and the Genesis of Abstraction: Drawings from the Early 1930's*. New York: Stephen Mazoh & Co.: Distributed by the Universtiy of Washington Press, Seattle, 1994.
Waldman, Diane. *Arshile Gorky, 1904-1948: A Retrospective*. New York: Harry N. Abrams and Guggenheim Museum, 1981.

WILLEM DE KOONING

American, b. Holland, 1904-1997
Untitled, 1969
charcoal on paper
19 x 24 inches
The Museum Purchase Plan of the NEA and the Tabriz
Fund,1971.
71.9.b

Willem de Kooning was born in the Netherlands and began his art training at the Rotterdam Academy, where he studied from 1916 to 1924. Later in 1924, he went to Belgium, where he worked at a decorator firm and attended classes in Brussels and Antwerp. He sailed for New York in 1926. For part of the 1930s, he shared a studio with Arshile Gorky. The Federal Arts Project provided financial support during the years 1935-36 when de Kooning designed a mural (never executed) for the Williamsburg Federal Housing Project. In 1936, The Museum of Modern Art, New York, included his work in an exhibition of work by artists given federal support. Others in the show included Gorky, Stuart Davis and Ilya Bolotowsky. Shortly after, de Kooning worked with Fernand Léger on a mural for the French Lines' pier. The artist's first solo exhibition, through Charles Egan Gallery, New York, came in 1948. In the early 1950s, he was represented by Sidney Janis Gallery, New York, and he became known, along with Jackson Pollock, as a leading figure in the Abstract Expressionist movement. His 1953 exhibition at the Sidney Janis Gallery was both a success and a scandal. Recognized as a daring and powerful abstract painter for his black and white canvases, de Kooning's paintings depicted violently expressionist images of women. The artist has enjoyed exceptional museum shows, including *Willem de Kooning* at the Tate Gallery in London, the Stedelijk Museum in Amsterdam, and others; participation in a group show at the Metropolitan Museum of Art, New York (1969-70); a solo exhibition at The Museum of Modern Art, New York (1972); and countless other museum and gallery exhibitions.

Except for a series of early portraits of men from 1938 to 1944, there have been relatively few male subjects in de Kooning's work. This charcoal on paper is one of the exceptions. This work reflects the artist's vigorous and austere manner in working with charcoal, reminiscent of his black and white paintings of the late 1940s or a work such as *Excavation* from 1950. He established a composition, locked into the margins of the sheet with an ostensibly male-figure motif, giving the work an autonomous existence. In 1966, de Kooning prepared a number of spontaneous charcoal drawings for a project with Knoedler Gallery, New York (his dealer after he left Janis). Regarding these works, de Kooning stated, "… the pad I used was always held horizontally. The drawings often started by the feet … but more often by the center of the body, in the middle of the page." (See note.) This description begins to fit the Arts Center piece, which is a not-too-distant relative of the Knoedler pieces; but this later drawing is more aggressive. The negative spaces of the composition are as skillfully shaped and fully realized as are the positive elements of the male figure's head, torso, and arms: figure and ground are one. The charcoal drawing is both abstract and figurative, moving freely back and forth just as the artist had throughout his long and productive career. G.N. and B.Y.

Sources:

De Kooning, Willem. *Drawings.* New York: Knoedler, 1967.

Garrells, Gary and Robert Storr. *Willem de Kooning: The Late Paintings, The 1980's.* San Francisco: San Francisco Museum of Modern Art, 1995.

Hess, Thomas B. *Willem de Kooning.* New York: The Museum of Modern Art, 1968.

Willem de Kooning. Pittsburgh: Museum of Art, Carnegie Institute, 1979.

Larson, Susan and Peter Schjeldahl. *De Kooning: Drawings/Sculpture.* Minneapolis: Walker Art Center, 1974.

Rosenberg, Harold. *Willem de Kooning.* New York: Harry N. Abrams, 1973.

Note:

In *Drawings,* Knoedler, n.p.

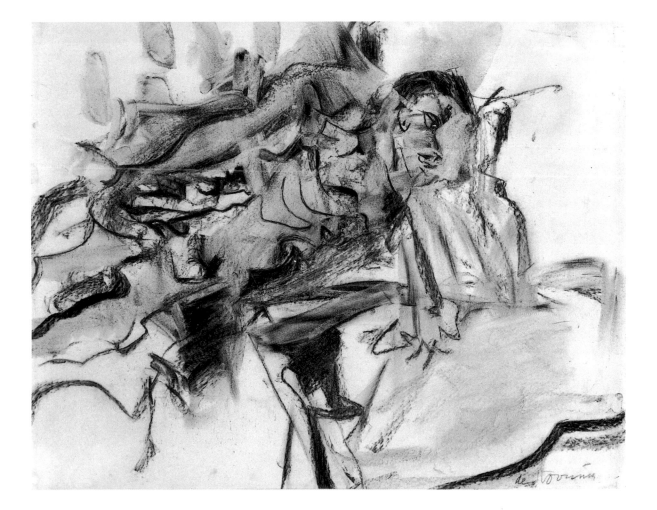

MORRIS LOUIS

American, 1912-1962
D-50, 1948
ink on paper
13 ½ x 17 ⅝ inches
Arkansas Arts Center Foundation Purchase, 1985.
85.17

Morris Louis is often associated with the Abstract Expressionists, though his mature work is consistently considered in a much more lyrical vein than those of the first pioneers. Born Morris Louis Bernstein in 1912, the artist chose Baltimore and Washington, D.C. as his home. He spent a short time in the late 1930s in New York, taking a new-techniques/new-materials course from David Siqueiros. (A fellow class student was Jackson Pollock.) Here he also met Arshile Gorky and Jack Tworkov. After moving back to Baltimore, he taught extensively. Later, with Kenneth Noland, he made a trip to New York and met the artist Franz Kline and the influential critic Clement Greenberg, and visited the studio of Helen Frankenthaler. There, Louis was impressed with her use of thinned oil paint on unprimed cotton duck. He believed she was a link between Pollock and the direction art was moving.

Louis returned from New York to his 12-by-14-foot dining-room studio and experimented wildly with stain and impasto, pouring wave after wave of acrylic color, working on the floor, with unstretched canvas loosely tacked to a manipulable stretcher to direct the poured paint. Self-critical, he kept only a small percentage of his output. Louis showed with *Emerging Talent* at the Kootz Gallery, New York, in 1954, the Washington Workshop in 1955 and Martha Jackson Gallery, New York, in 1957. Louis found himself with an international reputation.

After his death from cancer, a memorial exhibition was held at the Guggenheim Museum, New York, in 1963. In 1964 his work was selected to represent the United States in its pavilion at the Venice Biennale.

Drawing was an independent art for Louis, but *D-50* shows a less familiar side of the artist. It dates from a productive middle period of 1947 to 1953, a bridge between the formative years and his mature large-scale paintings. Louis drew when he did not have painting materials or time to work on a painting. He was familiar with the work of Pollock, Willem de Kooning and Robert Motherwell and exploited techniques of automatism and collage in guiding his improvisations. The exact nature of this imagery is unknown, but we can see an interest in delicate line, soft texture and gentle tones in this imaginary vision. Louis's relentless examination of form is fully revealed in this remarkable and complex pen drawing.

Sources:
Elderfield, John. *Morris Louis.* New York: The Museum of Modern Art, 1986.
Fried, Michael. *Morris Louis.* New York: Harry N. Abrams, 1970.
Headley, Diane Upright. *The Drawings of Morris Louis.* Washington, D.C.: The National Collection of Fine Arts, Smithsonian Institution, 1979.
Upright, Diane. *Morris Louis: The Complete Paintings.* New York: Harry N. Abrams, 1985.

JACKSON POLLOCK

American, 1912-1956
Untitled, c. 1939-40
pencil and pastel on brown paper
8 ½ x 6 inches
The Tabriz Fund, 1987.
87.46

Any discussion of the remarkable achievement of Abstract Expressionism must deal with the work of Jackson Pollock—not only the mature drip paintings for which he is so well known, but also the early work that helped Pollock and other artists escape from the tenets of regionalism and embrace the opportunities afforded by surrealist inspirations.

For those unfamiliar with Pollock, his formative years were quite remarkable. Born in Cody, Wyoming, in 1912, his interest in art came through his oldest brother Charles and classes at Manual Arts High School in Los Angeles, as well as school friends Philip Guston and Reuben Kadish. He moved to New York to work under Thomas Hart Benton at the Art Students League in 1930. His early influences were Albert Ryder, Jose Orozco, David Siqueiros, and Benton. He worked on the Federal Arts Project (easel division) from 1938 to 1942, a period in which he was introduced to Jungian therapy, and he explored the meanings of his own iconography with Dr. Joseph Henderson. He showed with French and American artists, including Willem de Kooning and Lee Krasner; Krasner became his wife in 1944. Robert Motherwell brought Pollock to the attention of Peggy Guggenheim, whose Art of This Century gallery, which opened in New York in 1943, became a rallying point for American and European avant-garde painters and sculptors. Pollock was also fortunate to be championed by Clement Greenberg, the influential writer and critic. Success came early, with acquisitions from The Museum of Modern Art and solo exhibitions in the 1940s and 1950s. He died in a car crash in The Springs, his Long Island home, in 1956.

In January 1939 Pollock began psychoanalytic therapeutic sessions. He was almost completely uncommunicative. At the doctor's request, Pollock brought drawings to the sessions and began to discuss the works, their symbols and meanings, and finally his emotional difficulties, with less reserve. The drawings were not specifically psychoanalytic in character, but merely a reflection of his work at that moment. Over the 18 months of meetings, he submitted 69 sheets of drawings, 13 of which were developed on both sides, and one gouache painting, to help facilitate the communication. The Arkansas Arts Center drawing is #14 from the Psychoanalytic Drawings monograph and has been sliced apart from #13, its original verso. The work is fragmented but shows a clear order in its separation of visual elements. Winglike shapes, a seashell form and a dismembered bird form are evident. Henderson found positive value in the ordering and suggested that dismemberment may symbolize a Jungian ritual of initiation, an ordeal or sacrifice through which the artist achieves maturity and earns recognition as a man.

G.N. and M.P.

Sources:
O'Connor, Francis V. *Jackson Pollock*. New York: The Museum of Modern Art, 1967.
———, and Eugene Thaw, eds. *Jackson Pollock: A Catalogue Raisonné of Paintings, Drawings, and Other Works*. New Haven: Yale University Press, 1978 (4 vols).
O'Hara, Frank. *Jackson Pollock*. New York: George Braziller, 1959.
Wysuph, C.L. *Jackson Pollock: Psychoanalytic Drawings*. New York: Horizon Press, 1970.

RAYMOND SAUNDERS

American, b. 1934
Untitled #158, 1987
pencil and watercolor on paper, mounted on drawing board
16 x 22 inches
The Museum Purchase Plan of the NEA and
Curtis and Jackye Finch, Jr., 1988.
88.25

Raymond Saunders is a painter, draftsman-watercolorist and collage maker who often approaches each medium separately. Saunders studied at the Pennsylvania Academy of the Fine Arts, the Barnes Foundation, Philadelphia, and the University of Pennsylvania; but it was at the Carnegie Institute, Pittsburgh, where he earned his BFA degree and the California College of Arts and Crafts, Oakland, where he received his MFA in 1961. He has been a professor of the latter since 1987. Saunders has had one-person shows at the San Francisco Museum of Modern Art (1971), the Pennsylvania Academy (1974), the Seattle Art Museum (1981), and the M.H. De Young Memorial Museum, San Francisco (1995), with many others in between.

Saunders's drawings are conceived as completely independent and expressive works of art, not as studies for paintings. He equates the drawing process with a "stream-of-consciousness" similar to that found in literature. Like the Surrealists of the 1930s and 1940s, he uses a form of psychic automatism, allowing varieties of images to emerge rapidly and freely on the paper and achieving a sense of spontaneity with asymmetrical compositions, casual doodles, scribbles, writings, handwritten phrases, numbers, little collages and scumbled erasures.

Untitled #158, consists of a watercolor sheet taped to a horizontal drawing which is rotated 90 degrees to be read as a vertical composition. The work is displayed as a drawing in progress. The pencil drawing of nude figures metamorphoses into a new image when juxtaposed horizontally to the splashy and spontaneous gesture of the overriding watercolor fragment that is attached. It could be said that Saunders's watercolors, drawings and collages are diaristic in that they reflect his quicksilver thoughts, his most direct and spontaneous intuitions. The artist does not second-guess his inspiration, but calls upon his automatic processes and reflexes for surprise.

Sources:
Feinberg, Joy. *Raymond Saunders: Recent Work*. Berkeley, CA: University Art Museum, 1976.
Garver, Thomas. *Flora / Contemporary Artists and the World of Flowers*. Wausau, WI: Leigh Yawkey Woodson Art Museum, 1995.
Mamet, David. *Notes for a Catalog for Ray Saunders*. San Francisco: Stephen Wirtz Gallery, 1985.
Raymond Saunders: Pieces. New York: Terry Dintenfass, 1973.

THEODOROS STAMOS

American, b. Greece, 1922-1997
Untitled, 1949
watercolor on paper
22 ¼ x 15 ½ inches
Gift of Aaron E. Cohen in memory of Tirca and Karlis Cohen, 1981.
81.71

Theodoros Stamos was born to first-generation Greek immigrants living in New York City. At the age of eight, he suffered a fall, rupturing his spleen, and in recovery began to draw. While in high school he earned a scholarship to the American Artists School, where he studied sculpture. From 1941 to 1947, he directed a frame shop where he met Arshile Gorky and Fernand Léger and framed works by Paul Klee. After he began to exhibit his own work in New York, Stamos came to know Mark Rothko, John Graham and Peggy Gugghenheim. After traveling to California and Europe, he met Mark Tobey, Constantin Brancusi, Picasso and Alberto Giacometti. In 1950 the Phillips Collection, Washington, D.C., presented an exhibition of his work. He taught at Black Mountain College, North Carolina, the Art Students League, and at Brandeis University, Massachusetts. In 1958 the Corcoran Gallery, Washington, D.C., hosted a retrospective.

The early paintings of Stamos evoke the secret life of nature in the fossil diagrams of plant and sea life. He utilized subdued colors, feathery surfaces and stony textures to suggest the archaic and timeless metaphors for the deepest patterns of life, birth and death, desire and terror, and the struggles of emotional life for all living creatures. He later connected his archaic imagery with Greek myths and the tales told him by his Greek parents. From the age of twenty, he collected translations of Oriental poetry and essays on Oriental art. In 1949 and

thereafter, Stamos's art became more calligraphic, gestural and colorful, and his canvases grew larger. Starting in 1970 Stamos spent part of each year on Lefkada, Greece, where the intense light of the island influenced the sparsely detailed but very strong color fields of *The Infinity Field* series of paintings.

The Arkansas Arts Center's drawing is a transitional work from the close of Stamos's earliest period, when he dealt with undersea life and the exploration of archaic nature. There is a wide range of color and a light tonality overall. The rectangular composition and color patches predict developments which fulfilled themselves in the 1950s. The dark framing of the bright central space is dissimilar to his earlier work. The black mound at lower center and the rhythmic vertical line arising from it would have been related, in 1945-48, to fossil records or the regenerative energy of plant life, but it has become a formal release, leading toward the aesthetic fields, Orientalist calligraphy and gestures of the *Tea House* compositions, and ultimately to the more expressionistic and painterly paintings of the late 1950s and early 1960s.

Sources:

Cavaliere, Barbara. "Theodoros Stamos in Perspective," *Arts*, 52 (December 1977): 104-15

Hobbs, Robert C. and Gail Levin. *Abstract Expressionism: The Formative Years*. New York: Whitney Museum of American Art, 1978.

Pomeroy, Ralph. *Stamos*. New York: Harry N. Abrams, n.d. (1970).

PHILIP GUSTON

American, b. Canada, 1913-1980
Untitled, 1958
gouache on paper
21 ½ x 28 ½ inches
Gift of Musa Guston, 1992.
92.41.2

Philip Guston was born in Montreal, Canada, to Russian parents who had emigrated from Odessa around 1900. The family then moved to Los Angeles in 1919, where Guston entered Manual Arts High School and became friends with Jackson Pollock. In 1930 he studied for several months at the Otis Art Institute, Los Angeles. Six years later he moved to New York and shortly thereafter began to work for the Works Project Aministration Federal Arts Project, New York, in the mural division. In 1938, Guston was included for his first of twelve successful showings at the *Annual Exhibition of Contemporary American Painting* at the Whitney Museum of American Art, New York. From 1941 to 1958, he spent much of his time as a university artist-in-residence or teacher at the following schools: the University of Iowa; Washington University, St. Louis; the University of Minnesota; and New York University. The University of Iowa held his first one-person exhibition in 1944, which was followed by a solo show at Midtown Galleries, New York, in 1945. His first retrospective was in 1959 at *V Bienal*, Museu de Arte Moderna, São Paulo, Brazil. A year later, one was held at the *XXX Biennale*, Venice. In 1962, the Guggenheim Museum in New York hosted another retrospective, which traveled to Los Angeles, London, Brussels and Amsterdam.

Guston was always torn between classical form and the sensuous handling of paint exemplified by the Renaissance Venetian painters. He executed his first abstract paintings around 1948 and reached an atmospheric painterly abstraction around 1950, which was then referred to as Abstract Impressionism. He proclaimed his new-found style with an exhibition *Paintings 1948-51, by Philip Guston*. Yet by the early sixties, he began to reject the freedom of abstraction and returned to the elements around him. At first this later style was called cartoonish—shocking many of Guston's regular viewers.

Untitled, a painting on paper, stems from a critical period when Guston was feeling his way toward the return of imagery to his work. The paintings and drawings involve a broader range of colors than did the atmospheric pieces from the early 1950s. While still committed to abstraction, he did not know precisely where he was going, but he may have been seeking a balance between content and the textured properties of colored pigment. Michael Shapiro commented on the transitional pieces:

> Guston's rejection of abstraction and his return to figuration marked a turning point for postwar American art. It seems to have been the honesty of a figurative artist who needed a representational vocabulary to express himself.... Guston's initial transformation from a representational artist in the 1940s to an abstract artist in the 1950s allows us to appreciate more fully the effort of will needed to effect this metamorphosis. (See note.)

Shapiro may be suggesting that Guston's pictures from the middle 1950s fall between two representational styles, with the later, cartoonish mode serving as the visual essence of Guston. Clearly Guston's abstraction resides within the environment of Burgoyne Diller, Willem de Kooning and Arshile Gorky, artists he had known since the 30s. The nonrepresentational era within Guston was relatively short, but crucial in its own right—the vibrant colors, loaded strokes and spirited composition reveal the hallmark of the artist, especially when compared to the later depictions. G.N. and B.Y

Sources:
Arneson, H. H. *Philip Guston*. New York: Guggenheim Museum, 1962.
Ashton, Dore. *Yes, but … (A Critical Study of Philip Guston)*. New York: The Viking Press, 1976.
Dabronski, Magdalene. *The Drawings of Philip Guston*. New York: The Museum of Modern Art, 1988.
Guston, Musa. *Night Studio: A Memoir of Philip Guston*. New York: Knopf, Inc., 1988.
Philip Guston. New York: George Braziller, 1980.
Shapiro, Michael. *Philip Guston: Working through the Forties*. Iowa City: The University of Iowa Museum of Art, 1997.

Note:
Michael Shapiro, *Philip Guston: Working Through the Forties*, p. 12.

HANS BURKHARDT

American, b. Switzerland, 1904-1994
Transition, 1959
pastel on paper
34 ½ x 26 ½ inches
The Tabriz Fund, 1988.
87.28

It is a coincidence that the title of the Arkansas Arts Center's work, *Transition*, is the very word that describes the early life of the artist himself. In fact, the concept of transition may be the descriptor at the soul of his work. Born in Basel, Switzerland, Hans Burkhardt was the second of three children. His father left the family for the United States, and shortly after, his mother died of tuberculosis. After early years in a public orphanage, young Hans emigrated to New York in 1924 to seek and live with his father. His early employment was in custom furniture, but his love of art led him to study at Cooper Union, New York, and eventually to the Grand Central School of Art. There, in 1927, he took life drawing and private lessons in painting with the remarkable Arshile Gorky.

It was in 1938 that Burkhardt decided to leave the artistic ferment of New York and venture to California. Though a bitter divorce with his wife was at hand, the reasons for his departure remain unclear. However, the desire to develop his own work outside the powerful influence of Gorky and away from the strictures of New York was a strong motivator. Today, as historians seek to reconnect artists to Abstract Expressionism, they find in Hans Burkhardt a sincere, hardworking artist. Here was a devoted practitioner, living and working outside the mainstream, who sidestepped regionalism, worked his way through Synthetic Cubism and found long-lasting power in the expressive possibilities of the figure, the still life and their abstractions.

In *Transition* we can find several indications of change from one stage to another. In most literal terms, the composition consists of three views of a nude model—recognizable on the left, emerging in the center and almost completely enveloped on the right. We can also see a metamorphosis from light to darkness or, by extension, from life to sleep and eventually death. Perhaps Burkhardt's early love of the work of the symbolist painters Ferdinand Holder (1852-1918) and Edvard Munch (1863-1944) forms a spiritual tie.

As Peter Frank noted in his essay on Burkhardt's drawings, his work was very much a unique development:
They [the pastels] display the embrace of conflicting Modernist tendencies that characterized the experimentation leading into Abstract Expressionism. They also show Burkhardt's own Abstract Expressionist "moment" and the ways in which the artist extended that moment through the rest of his life. Burkhardt's maintenance of Abstract Expressionist attitudes may appear eclectic on the surface, ranging as it does between degrees of figuration and abstraction and between moods of sobriety, even fury, and of contemplation and delight. But these shifts in form and sensation, unified through undergirding personal sensibility and pictorial cohesion, manifest precisely the expressive and intellectual license and breadth Abstract Expressionism always sought to command. (See note.) G.N. and M.P.

Sources:
Bordeaux, J.L. and Melinda Wortz. *Hans Burkhardt: Pastels*. Los Angeles: Jack Rutberg, 1984.
Frank, Peter. *Hans Burkhardt Drawings, 1932-1989*. Little Rock: Arkansas Arts Center, 1996.
Kuspit, Donald. *Catastrophe According To Hans Burkhardt*. Allentown, PA: Muhlenberg College, 1990.
Selz, Peter. *Hans Burkhardt: Desert Storms*. Los Angeles: Jack Rutberg Gallery, 1991.

Note:
Peter Frank, *Hans Burkhardt Drawings, 1932-1989*, pp. 15-16.

Mark Tobey

American, 1890-1976
Little World No. 40, 1961
tempera on brown paper
8 ⅛ x 5 ½ inches
The Museum Purchase Plan of the NEA and the
Tabriz Fund, 1974.
74.6

After a period of intermittent study at the School of the Art Institute of Chicago (1906-11), Mark Tobey moved to New York, where he worked as a fashion illustrator until 1922, when he took a position as an art teacher in Seattle. The following year he began to study Chinese calligraphy. From 1931 to 1938, Tobey resided in England as an artist-in-residence at Dartington Hall, Devonshire. The 1920s and 1930s also afforded him chances to travel within Asia. In 1940 he returned to Seattle for twenty years, followed by a move to Basel, Switzerland. Tobey was given solo exhibitions at the Seattle Art Museum; the Palace of the Legion of Honor, San Francisco; and the Art Institute of Chicago in the early 1950s. A retrospective of his work appeared at The Museum of Modern Art, New York, in 1962, in Amsterdam in 1966 and at the Museum of Fine Arts, Dallas in 1968.

Tobey became fascinated with the "entangled line" of Asian calligraphy and took a decade (1932-42) to transform his study of that discipline into a personal visual language. He made many depictions of aerial views of the Seattle Market and of other city environments where the vitality of the crowd and the energy of the neon and incandescent lights coalesced into a visual force related to his entanglements of "white writing." Tobey was slow to accept a totally abstract painting, making endless applications of his discoveries to figuration, informed by his religious belief in the oneness of religion, culture and mankind. He was eventually able to rationalize his inexhaustible inventions in abstraction as being consistent with his fundamental Baha'i belief and as an expression of aesthetic/spiritual unity. At the same time, Tobey did not accept the idea of his art as "Baha'i art." Uncomfortable with labels of any kind, he disapproved of the mechanical and celebrated the personal in every situation. He discovered a new form in his linear brushstrokes and found the line to be a spiritual path rather than a boundary of depiction. He acknowledged his drawing skills but could not applaud mere virtuosity or intellectuality in art. He extolled freedom and improvisation and was known to say of his "little wonders" that he did not know how they came about.

Little World No. 40 is drawn and painted in tempera on board. It is a contrapuntal composition, like a Bach fugue or a Vivaldi choral work, with independent voices joined in creating a complex unity. Diverse linear developments are fused into a new idea of form without a central focus. The separate and interrelated linear themes establish a vitality that echoes that of life by transmutation: stripped of the frantic competition, convulsive motion and seeking associations with modern life, and transforming experience into a meditative calm.

Sources:
Dahl, Arthur. *Mark Tobey: Art and Belief.* Oxford: George Ronald, 1984.
Mark Tobey (from the collection of Joyce and Arthur Dahl). Palo Alto: Stanford Art Gallery, Stanford University, 1967.
Mark Tobey. Seattle: Foster/White Gallery, 1973. (Catalog FW9, in color).
Mark Tobey Retrospective. Dallas: Museum of Fine Arts, 1968.
Roberts, Colette. *Mark Tobey.* New York: Grove Press, 1960.
Schimied, Wieland. *Tobey.* Stuttgart: Verlag Gerd Hatje, 1966.

LEE KRASNER

American, 1911-1984
Earth #1, 1969
gouache on paper
18 ¼ x 22 ½ inches
The Tabriz Fund, 1984.
84.17

Lenore (Lee) Krasner was one of the best educated and most knowledgeable members of the founding generation of Abstract Expressionist painters. She attended the Women's Art School, Cooper Union, New York (1926-29); the Art Students League, New York (1928); and the National Academy of Design, New York (1929-32). She worked on the Public Works of Art Project, earning the rank of supervisor in 1935 for the WPA mural division. From 1937 to 1943, she exhibited in New York at the Artist's Union and the American Abstract Artists Group. In 1945 she and Jackson Pollock where married and later that year they moved to East Hampton, Long Island. Krasner exhibited often, with highlights including a retrospective in 1965 at the Whitechapel Art Gallery, London (which toured to six other museums); solos at the University of Alabama Art Gallery, Tuscaloosa (1967); the Whitney Museum of American Art, New York (1973-74); and the Corcoran Gallery of Art, Washington, D.C. (1974).

Krasner and Pollock influenced each other's art. She was often overlooked because she was omitted from the famous Irascibles photograph for *Life* magazine and because she was Pollock's wife. It was only after Pollock's death that Krasner began to receive her deserved attention. Her strong drawing and painting skills were focused on expressionist paint handling and an overall imagery, which she had developed around 1946 but elaborated on a larger scale in her post-1956 work.

Krasner wrote Hebrew in early years but, through lack of practice, lost the ability. She continued to make calligraphic drawings that related to Hebrew but they were unreadable even though they "had the gesture." After a decade of producing very large paintings, she entered into a period in 1969 of working in gouache on heavily textured handmade paper into which the gouache penetrated. She called the four series of works *Earth*, *Water*, *Seeds* and *Hieroglyphs*. *Earth #I* is the first work from the series and was included in the Houston retrospective as figure 136. Barbara Rose writes in the catalogue:

> Together the titles sum up the content and imagery of her mature painting, indicating as well the means by which they were created: pigment (earth) dissolved in liquid (water) coaxed to flower from initial marks (seeds) that often grew into calligraphic figurations (hieroglyphs). (See note.)

Sources:
Albee, Edward and John Cheim. *Lee Krasner: Paintings from 1965 to 1970*. New York: Robert Miller Gallery, 1991.
Hobbs, Robert C. *Lee Krasner*. New York: Abbeville Press, 1993.
Rose, Barbara. *Lee Krasner: A Retrospective*. Houston: The Museum of Fine Arts, and New York: The Museum of Modern Art, 1983.
Tucker, Marcia. *Lee Krasner: Large Paintings*. New York: Whitney Museum of American Art, 1973.

Note:
Barbara Rose, *Lee Krasner: A Retrospective*, n.p.

HELEN FRANKENTHALER

American, b. 1928
Emerson Series I, 1965
acrylic paint on lithograph
20 x 25 inches
Bequest of Betty Parsons, 1985.
85.50.8

Helen Frankenthaler associated with the critic Clement Greenberg in the early 1950s, met Jackson Pollock and became familiar with the first-generation Abstract Expressionists. During her years at the Dalton School, New York, Frankenthaler studied with Rufino Tamayo, followed by instruction at the Art Students League, New York; and finally, she studied with Hans Hofmann in 1950. Frankenthaler has taught at numerous schools including: New York University, Yale University, New Haven, Connecticut; the Brooklyn Museum School and Swarthmore College, Swarthmore, Pennslyvania. One-person exhibitions include the Jewish Museum (1960), Swarthmore College (1974) and retrospectives at the Whitney Museum of American Art (1969), the Corcoran Gallery of Art, Washington, D.C. (1975), and the Modern Art Museum, Fort Worth, Texas (1989).

Frankenthaler elected to work on the floor, in the manner of Pollock, and evolved her "soak-stain" technique by thinning oil paint with turpentine and pouring it onto unprimed cotton canvas so that the paint bled into the fabric and became one with it. In 1962 she began to work with acrylic paints. In addition to painting, the artist draws, makes watercolors, and prints in different media.

In the early 1950s, Frankenthaler often found herself producing a cage-like rectangle in her paintings. Over the years, the cage has returned from time to time. She explains that "it is all in the wrist," meaning that it was a learned reflex from her training and practice. In such compositions the artist produced a black-and-white lithograph with a rectangle, realized in a spontaneous and rhythmic linear manner, which she later embellished with acrylic colors. This afforded her an opportunity to experiment with color variations. It recalls Picasso's experiment with arbitrarily adhering small pieces of paper to his etching sheets prior to making an edition in 1927.

Sources:
Carmean, E. A.,jr. *Helen Frankenthaler: A Painting Retrospective.* New York: Harry N. Abrams, 1989.
Elderfield, John. *Frankenthaler.* New York: Harry N. Abrams, 1989.
Goossen, E.C. *Helen Frankenthaler.* New York: Whitney Museum of American Art, 1969.
O'Hara, Frank. *Helen Frankenthaler.* New York: The Jewish Museum, 1960.
Wilkin, Karen. *Frankenthaler: Works on Paper.* New York: George Braziller, 1985.

Robert Motherwell

American, 1915-1991
Elegy Drawing No. 17, 1977
acrylic and ink on mylar
11 ½ x 22 ⅛ inches (sight)
The Museum Purchase Plan of the NEA and the Tabriz
Fund, 1978.
78.13.a

At the age of eleven, Robert Motherwell won a scholarship to the Otis Art Institute, Los Angeles. In 1932 he enrolled at Stanford University, California, and graduated in 1937. Motherwell later enrolled at other schools: California School of Fine Arts, San Francisco; Harvard University, Cambridge, Massachusetts; and Columbia University, New York. He was also a teacher and lecturer of considerable experience, including six years at Hunter College, New York, in the 1950s and a brief period at Columbia. In 1948 he was a cofounder of the brief-lived school Subjects of the Artist with William Baziotes, Barnett Newman and Mark Rothko. He also edited *The Documents of Modern Art*, an important text, and *The Dada Painters and Poets* (1951). In 1966 the artist was given a commission at the John F. Kennedy Federal Office Building, Boston. Similar commissions followed at Stanford University; the University of Iowa; and the National Gallery, Washington, D.C. Motherwell had numerous one-person shows in prominent museums, but in 1965-66, The Museum of Modern Art gave him a retrospective, as did the Phillips Collection, Washington, D.C.

In the late 1940s, while showing at Kootz Gallery in New York, Motherwell submitted a new body of work—the *Elegies,* the *Capriccios* and *Wall Paintings.* All of the early elegies were in black and white—funeral pictures, laments, dirges, and rigorously austere. Motherwell had been obsessed with the Spanish Civil War, a grave soci-

etal issue of the 1930s, which served as a prologue to World War II and centered the Western world on the spread of authoritarianism, Fascism, the decline of democracy, and war's terrible sacrifices, including the death of the great Spanish poet Garcia Lorca. The key *Elegy to the Spanish Republic* was subtitled "At Five in the Afternoon" after Lorca's poem, which referred to death at that hour in the bull ring.

Devoted as he was to "automatism," Motherwell placed great value on spontaneity and sought to capture his improvisational vision in its most transient manifestations, even when working in heroic scale. *Elegy Drawing No.17* has been related to *Elegy (#100)*, 1963-75, and to the *Reconciliation Elegy*, 1978, National Gallery of Art, Washington, D.C. (See note.) Another important element in Motherwell's inspiration relates to Piet Mondrian's rectilinear geometry, which served as a reciprocal force throughout Motherwell's work. The linking of oval elements on the right of the drawing in opposition to the large anchored form on the left is carried over from the 1963-75 *Elegy*, just as it was to the National Gallery of Art's 30-foot composition. This balancing of dark and light, of anchored weight and floating ovals, is significantly mediated by the sensitive hand recognized in the ground, in the related linear elements and in the emotional qualities of the composition's dark theme.

Sources:

Arnason, H. H. *Robert Motherwell.* New York: Harry N. Abrams (revised ed.), 1982, with an introduction by Dore Ashton and an interview by Barbaralee Diamondstein.

Ashton, Dore and Jack Flam. *Robert Motherwell.* Buffalo: Albright-Knox Art Gallery, and New York: Abbeville Press, 1983.

Carmean, E. A., jr., ed. *Robert Motherwell: Roconciliation Elegy.* Geneva: Skira, and New York: Rizzoli, 1980.

O'Hara, Frank. *Robert Motherwell.* New York: The Museum of Modern Art, 1965.

Note:

See E.A. Carmean, jr., ed., *Robert Motherwell: Reconciliation Elegy,* for a discussion of this series.

Richard Stankiewicz

American, 1922-1983
Untitled #7, c. 1960
ink on paper
22 x 8 ⅛ inches
Arkansas Arts Center Foundation Purchase, 1988.
88.13

Richard Stankiewicz was born in Philadelphia but moved to Detroit after his father died in a railroad accident. He graduated from Cass Technical High School, in 1940, where he studied art, music and mechanical drawing. From 1941 to 1947, he served in the U.S. Navy in the Pacific. While in Seattle he met Mark Tobey, Morris Graves and their circle. In 1948 he moved to New York to attend the Hans Hofmann School of Fine Art. Then, in 1950 he moved to Paris and studied briefly with Fernand Léger and Ossip Zadkine. He returned to New York in 1951 and helped run the Hansa Gallery, an early co-op. In 1962 Stankiewicz moved to rural Massachusetts. A retrospective of the artist's work was presented at the University Art Gallery, Albany, in 1979, which traveled to the Clark Art Institute, Williamstown, Massachusetts; The Johnson Museum, Cornell University, Ithaca, New York; and the Museum of Fine Arts, Springfield, Massachusetts.

Stankiewicz began as a painter and developed an interest in collage from the Cubist movement and Hans Hofmann. Aware of Duchamp's "found object" works, he began to work with discarded and rusted iron and steel elements and integrated them into new unities, which often suggested anthropomorphic figures. He relied upon his engineering knowledge and machine-shop skills to organize his new aesthetic ideas. His works were sometimes humorous, often critical of the mechanical age. He felt an ambition to transform ordinary things—"apparently dead stuff"—into a vital art. He would perceive an aesthetic property in a discarded item, separate it and later synthesize it into a new context.

The artist showed the influence of Minimalism in the mid-1960s and slowed his sculptural pace. Working in Australia in 1969, he produced sixteen sculptures in steel at Transfield Foundry, Sydney, and found fresh inspiration, working thereafter in milled steel rather than discarded iron elements. His years of working with Dadaist shock and Surrealist surprise gave way to formalism as he confronted more basic sculptural concerns, composing with lean and stylized sobriety, discipline and economy of means in the exploration of sculptural space.

The sculptor's remarkable drawings were never exhibited in his lifetime, but were found in his home and studio after his death. Emmie Donadio writes that the drawings "resemble ink blot tests or experiments in improvisation … as if he were experimenting with Miró's recipe for composition by hallucination, training his vision to find significance in accidental appearances."(See note.) One senses that the artist has allowed the ink to run before his brush, to stain and saturate the paper fibers, using the absorbent capacity of the paper to play a part in the work. *Untitled #7* appears to have been assembled from separate calligraphic gestures which have been unified into a new and unexpected silhouette, a process related closely to his sculptural technique of welded assemblage and yet strangely consonant with the ink-on-paper drawings of Franz Kline and Robert Motherwell.

Sources:
Donadio, Emmie. *Richard Stankiewicz: Sculpture in Steel.* Middlebury, VT: Middlebury College, 1994.
Miller, Dorothy C. *Sixteen Americans.* New York: The Museum of Modern Art, 1959.
Richard Stankiewicz, Thirty Years of Sculpture 1952-82. New York: Zabriskie, 1984.

Note:
In Emmie Donadio, *Richard Stankiewicz: Sculpture in Steel,* n.p.

DAVID SMITH

American, 1906-1965
Untitled, 1954
black egg ink on paper
7 x 10 ½ inches
Arkansas Arts Center Foundation Purchase, 1995.
95.59.1

David Smith was a tireless and devoted worker who produced a magnificent body of work in iron and steel and a surprisingly large quantity of paintings and drawings, which were seldom, if ever, exhibited in his lifetime. Before attending the Art Students League, New York (1926-31), Smith studied at Notre Dame University, South Bend, Indiana; Ohio University, Athens, and George Washington University, St. Louis. At the Art Students League League, two of his teachers were Kimon Nicolaides and Jan Matulka. Yet his knowledge of metal fabrication came from his early experiences as a welder at the Studebaker auto plant in South Bend. Smith is generally recognized as the outstanding sculptor of his generation in America and one of the most innovative artists in international modernism. He was acclaimed in his lifetime by such diverse critics as Clement Greenberg, Thomas B. Hess and Hilton Kramer, but sold only a few works during his 35 years as a professional artist. Smith was given his first solo museum show at The Museum of Modern Art, New York (1959). It was not until 1979, fourteen years after his death, that the Whitney Museum of American Art, New York, organized the first serious study of his drawings.

Smith denied that he made drawings that were in any way preparatory for sculptures. He professed to be a direct metal sculptor. However, he did make sketchbook drawings—notes made on the train to New York, which might be developed at a later time. He also made finished presentation drawings about sculptural ideas he hoped to find time to create. Smith's presentation drawings are usually worked on high quality rag papers in pencil, pen and ink, various egg inks, pastel, tempera, oil and occasionally spray paint, with some combinations. It was not unusual for him to produce a dozen or more complex drawings in a day. He made meticulous notes (usually on the verso of these sheets), describing the inks, paints and colors used and the paper support.

The Arkansas Arts Center's characteristic drawing sets out five distinct sculptural ideas across the sheet, with no relationship between the individual elements other than their approximate heights. These are not working schematics in reference to front, back and side views, but silhouetted improvisations on a family of separate concepts, wherein the artist has taken pleasure in the play of the brush and the qualities of the expensive ink and its reception into fine paper.

Sources:

Cone, Jane H. *David Smith 1906-1965.* Cambridge: Fogg Art Museum, Harvard University, 1966 (with four Smith texts, bibliography, and an interview with Katharine Kuh).

Gray, Cleve, ed. *David Smith by David Smith.* New York: Holt, Rinehart & Winston, 1972.

Cummings, Paul. *David Smith: The Drawings.* New York: Whitney Museum of American Art, 1979.

Fry, Edward F. and Miranda McClintic. *David Smith: Painter Sculptor Draftsman.* New York: Braziller, and Washington, D.C.: Hirshhorn Museum and Sculpture Garden, 1982.

David Smith/Nudes: Drawings and Paintings from 1927-1964. New York: Knoedler & Co., 1990.

Nordland, Gerald. *David Smith: Workbook Drawings for Sculpture, 1954-1964.* Milwaukee: Milwaukee Art Museum, 1983.

SEYMOUR LIPTON

American, 1903-1986
Untitled Drawing (#8), n.d.
oil crayon on paper
11 x 8 ½ inches

Untitled Drawing(#12), 1960
oil crayon on paper
11 x 8 ½ inches

Untitled Drawing (#14), 1963
oil crayon on paper
8 ½ x 11 inches (illustrated)

Gift of Alan and Michael Lipton, Ridgewood, New Jersey, 1991.
91.58.1-50

Seymour Lipton was born in New York City and attended Brooklyn Polytechnic Institute and the College of the City of New York (1921-23), before entering Columbia University, New York, receiving his DDS degree in 1927. In fact, Lipton practiced dentistry for many years while concentrating on sculpture. His first exhibition was held at ACA Gallery, New York (1938). After other group shows and inclusion in the 1940 Worlds Fair, he taught sculpture at Cooper Union, New York. Group exhibitions beginning in the late 1940s included those at the Whitney Museum of American Art, New York, the Art Institute of Chicago and The Museum of Modern Art, New York. Solo exhibitions followed at the American Pavilion of the Venice Biennale (1958); the Milwaukee Art Center (1969); the Massachussetts Institute of Technology, Boston (1971); and the Virginia Museum of Art (1973). A retrospective by the National Collection of Fine Arts, Washington, D.C., was circulated by the Smithsonian Institution in 1979.

Lipton began his welded-metal constructive sculptural technique in lead around 1944 to 1946; continuing the development, he moved from lead to steel and to combinations of wood and metals by 1947. He evolved a technique of brazing brass rod over sheet steel with an oxyacetylene torch, achieving his mature manner around 1949.

Lipton was self-trained. He developed his vision and his skills from looking at the art of the past and confronting the emerging art of his own time, with all of its philosophical and technical complexity. He always preferred to work directly—to carve in wood and plaster, to hammer, shape and rearrange lead, steel and other sheet metals, cutting and welding steel and brazing brass and nickel onto welded steel and monel sculptures, establishing richly modulated surfaces. His forms are derived from nature—the cell, the seed, the flower, undersea life and the sexual interaction of species.

The *Lipton Drawing Suite* is a group of fifty studies for metal sculpture, which the artist made to preserve ideas for new work between the 1960s and the 1980s. In the sculpture, Lipton creates positive and negative forms and volumetric spaces, often reminiscent of wombs, helmets and caves. These mysterious vessel-like shapes are built of strong formal elements, which appear to be derived from nature. The drawings are not elegant, but swiftly and unpretentiously direct translations of ideas for future development. *Untitled Drawing #8* is a standing figure with legs, head and a dark shadow in the torso. *Untitled Drawing #12* is a horizontal piece involving two counter-thrusting elements pushing through structured apertures. *Untitled Drawing #14* appears related to a sculpture (*Empty Room*, 1964) developed in monel metal with a brazed nickel-silver overlay.

Sources:
Elsen, Albert. *Seymour Lipton.* New York: Harry N. Abrams, 1974.
Miller, Dorothy C. *12 Americans.* New York: The Museum of Modern Art, 1956.
Rand, Harry. *Seymour Lipton: Aspects of Sculpture.* Washington D.C.: National Collection of Fine Arts, Smithsonian Institution, 1979.
Seymour Lipton: Major Late Sculpture. New York: Babcock Galleries, 1991.

Jack Tworkov

American, b. Poland, 1900-1982
Untitled, 1962
Oil on paper
22 x 20 inches
The Tabriz Fund, 1994
95.9.2

Jack Tworkov was born in Bial, Poland, in 1900. He emigrated to the U.S. when he was thirteen. He studied English at Columbia University, New York, later electing to become an artist, first in Provincetown, Massachusetts, and then in New York at the National Academy of Design and the Art Students League. His sister also became a painter, taking the name Biala. Tworkov was employed on the WPA Federal Art Project (1935-41), and steadfastly avoided social realism, Marxism, and the decorative mannerisms of the School of Paris. Always of a meditative bent, he became infatuated with the paintings of Cézanne and turned to abstraction in the mid 1940's. He was soon recognized by his peers as a member of the Abstract Expressionist circle and began exhibiting with the Charles Egan Gallery, New York (1947-56). Tworkov had an adjoining studio with Willem de Kooning (1948-53), and he was as charmed by his old friend's intelligence as by his draftsmanship and his painting.

The Stable Gallery, New York, invited Tworkov to show in 1957, and he later exhibited with other established New York galleries including Leo Castelli, French & Company and finally Nancy Hoffmann. He held solo shows at the Baltimore Museum of Art (1948), and a mid-career survey at the Whitney Museum of American Art, New York, in 1964, which toured to five museums from 1964 to 1965. Tworkov taught at Yale University, New Haven, Connecticut, for one year before he became Chairman of its Art Program (1963-69).

In the later 1960's Tworkov made a shift within abstract painting away from emotional and gestural work and toward what he was to call a "diagonal grid," which he examined systematically with his paint stroke, in a field of carefully managed achromatic color—grays, muted browns, violets or forest greens. "By limiting my color interests I was able to concentrate on form." (See note 1.) He found merit in the limitations and the variations he could find within his new geometric problem. "I arrived at an elementary system of measurements implicit in the geometry of the rectangle, which became the basis for simple images…. I wanted the spontaneous brushing to give a beat to the painting somewhat analogous to the beat in music. I arrived at a painting style where planning does not exclude intuitive and sometimes random play." (See note 2.)

The Arkansas Arts Center's work on paper of 1962 is reflective of the artist's aesthetic process in the period 1960 to 1964, when he achieved a high level of maturity, consistency and recognition for both drawing and painting. This work is close to his painting process at that time. He widened and feathered his brushstroke, out of concern for his total effect, where foreground, image, surface and background achieve a plastic unity and each stroke serves as constructive unit in the improvisation of the work and as a factor in the counterpoint of color, form and movement. Each work is a sum of its layered corrections and destruction, wherein he shows his openness to revelation and surprise. His advice was to "… work close to one's own feelings, and risk the contradictions of all aesthetic dicta and all professions to find necessity deep in one's life, which at bottom happens to be everybody else's life too." (See note 3.) He found that the weight of his strokes, the contrast between lightness and heaviness, and the rythmic density in discrete sections presented him with new ideas in both drawing and painting. He came to see an endless range of possibilities, variations and challenging promises in the marriage of system and intuition.

Sources:

Bryant, Edward. *Jack Tworkov.* New York: Whitney Museum of American Art, 1964.

Kroeter, Steven W. "An Interview with Jack Tworkov," *Art in America,* November 1982, pp. 82-87.

Tworkov, Jack. "Statement," *It is,* 2, 1958 (New York), p. 15.

———. "Notes on My Painting," *Art in America,* September 1973, pp. 66-69.

Notes:

1. Jack Tworkov, "Statement." *It is,* p.15.

2. Ibid.

3. Ibid.

VI. GEOMETRIC ABSTRACTION

BURGOYNE DILLER

American, 1906-1965
Third Theme, 1948
crayon and pencil on paper
12 ½ x 10 ¾ inches
Arkansas Arts Center Foundation Purchase, 1988.
88.6

Burgoyne Diller was raised in Battle Creek, Michigan, and attended Michigan State University. After graduation he moved to New York to attend the Art Students League (1928-30), to study with Van Schlegell and work with Jan Matulka. While working in the League's bookstore, he became a friend of Hans Hofmann, who would later write the foreword for Diller's solo show at the Contemporary Arts Gallery in 1933. Diller earned an appointment as managing supervisor of the mural division of the WPA Federal Art Project, and commissions were given to Ilya Bolotowsky, Stuart Davis, Willem de Kooning, Fernand Léger, Arshile Gorky and others. After the WPA closed, Diller taught at Brooklyn College and the Pratt Institute, both from 1945 to 1964. He enjoyed a two-person exhibition with José de Rivera, in 1945, at Harvard University, Cambridge, Massachusetts. His first retrospective came in 1966 at the New Jersey State Museum, Trenton. Five years later, the Walker Arts Center, Minneapolis, hosted a circulating retrospective.

Diller is generally considered the leading American-born exponent of Neo-Plastic painting, a style characterized by flat, supportive shapes—narrow vertical rectangles, diamonds, tondos and ellipses; the use of secondary colors; reversing the white ground and the black proportional grid; and seeking an interaction between colors within the field. While Diller admired the work and philosophy of Piet Mondrian and Theo

Van Doesburg, his work had its own personal development. Diller was not prolific, but in addition to painting, which was for him an arduous and lengthy process, he produced a limited number of relief constructions and freestanding sculptures and a large body of works on paper, all relating to themes the artist established in the 1930s and developed thereafter.

Third Theme, reflecting "elements submerged in activity," is from the last of Diller's thematic works. It is the most complex and "orchestral" of his approaches. In truth, the classification is somewhat misleading in that each "theme" represents an extreme aspect of manners which feed upon and interpenetrate each other. Diller occasionally began a painting from a drawing. Drawing represented a spontaneous manner of expression and a way to preserve current ideas for later analysis and potential uses. Therefore the drawings stood primarily as independent works of art, intuitive developments of the ideas that he could not find the time to realize in more ambitious forms.

Sources:
Diller, Burgoyne. *Burgoyne Diller: Drawings 1945 to 1964.* New York: André Emmerich Gallery, 1984.
Haskell, Barbara. *Burgoyne Diller.* New York: Whitney Museum of American Art, 1990.
Larson, Philip. *Burgoyne Diller: Paintings Sculptures Drawings.* Minneapolis: Walker Art Center, 1971.
Livingston, Jane. *Burgoyne Diller.* Los Angeles: Los Angeles County Museum of Art, 1968.
Nordland, Gerald. *Burgoyne Diller: The Early Geometric Work.* San Francisco: Harcourt's Modern and Contemporary Art, 1991.

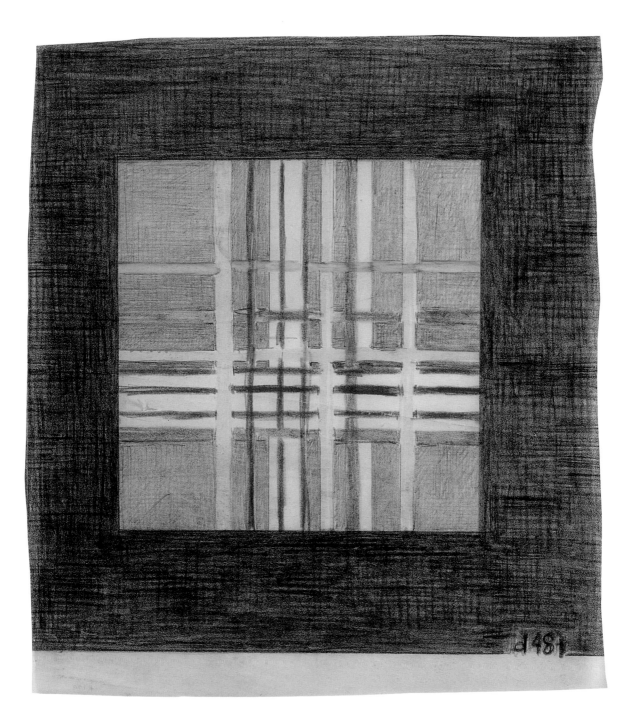

ILYA BOLOTOWSKY

American, b. Russia, 1907-1981
Blue Ellipse, 1977
acrylic on paper
27 ½ x 19 ½ inches
Museum Purchase Plan of the NEA and the Tabriz Fund,
1978.
78.13.h

Ilya Bolotowsky was Russian by birth and moved with his family to Turkey, where he studied at the College of St. Joseph, Istanbul (1921-23). Following this he came to New York, where he studied at the National Academy of Design (1924-30). From 1930 to 1932, he traveled in Europe including France, Italy, Germany, Denmark and Austria. Upon his return to the U.S. he discovered the work of Piet Mondrian, in 1933, in the A.E. Gallatin Collection at New York University. Under the supervision of Burgoyne Diller, Bolotowsky became a member of the mural division of the Public Works of Art Project. He was also a founding member of the American Abstract Artists group and exhibited regularly with it. He taught and exhibited extensively, including positions at Black Mountain College, North Carolina; the University of Wyoming, Laramie, and the University of Wisconsin, Whitewater. Retrospectives have been held at the State University of New York, Stony Brook (1968); the University of New Mexico, Albuquerque (1970), which was circulated to other venues; Reed College, Portland, Oregon; and the Gugghenheim Museum, New York (1974).

In 1933 Bolotowsky encountered the austere work of Piet Mondrian and then the biomorphic abstraction of Joan Miró. He tried to join these elements in his work, but ultimately committed himself to variations on Mondrian's Neo-Plasticism. Like Mondrian, Bolotowsky omitted the diagonal line from his oeuvre, but he differed from his predecessor in that he found great satisfaction in rendering the ellipse and tondo.

In *Blue Ellipse* the artist used red and yellow sparingly. Black emerges as an important element of structure, while white no longer serves as the field but as a linear spatial element. The pleasure derived from Bolotowsky's art lies in its simplicity and order. He has written, "Nowadays when paintings torture the retina, when music gradually destroys the eardrum, there must, all the more, be a need for an art that searches for new ways to achieve harmony and equilibrium … as Mondrian said for an art that strives for the timelessness of the Platonic ideas." (See note.)

Ssources:

Agee, William C., Milton Avery, Henry Geldzahler, et al. *Ilya Bolotowsky: Washburn Gallery*. New York: Washburn Gallery, 1983.
Homage to Bolotowsky, 1935-1981. Stony Brook, New York: The Fine Arts Center Gallery, State University of New York at Stony Brook, 1985.
Breeskin, Adelyn D. *Ilya Bolotowsky*. Washington, D.C.: Smithsonian Institution, 1974.
Ellis, Robert M. *Ilya Bolotowsky: Paintings & Columns*. Albuquerque: The University of New Mexico, 1970.
Svendsen, Louise Averell. *Ilya Bolotowsky*. New York: Guggenheim Foundation, 1974.

Note:
In Adelyn D. Breeskin, *Ilya Bolotowsky*, p. 2.

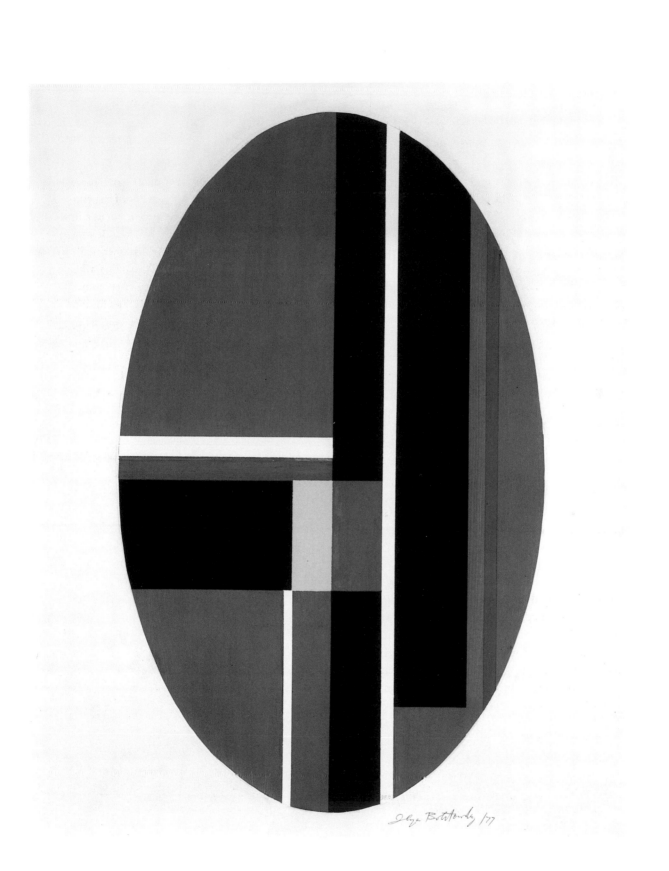

Ilya Bolotowsky '77

AL HELD

American, b. 1928
Untitled #7, c. 1965
ink on paper
22 ¼ x 34 ¾ inches
Acquired from Roy Anderson, 1988.
88.12

Following service in the Navy (1945-47), Al Held enrolled at New York's Art Students League in 1948, studying drawing with Kimon Nicolaides and painting with Harry Sternberg. From 1950 to 1953, he was in Paris at the Académie de la Grande Chaumière, studying drawing and painting with Ossip Zadkine. In Paris, he encountered a generation of young Americans including Sam Francis, Kenneth Noland and Jules Olitski. From 1962 to 1980, Held was an Associate Professor at Yale University, New Haven, Connecticut. In 1964, he joined André Emmerich Gallery, New York. In 1966 a solo exhibition was held at the Stedelijk Museum, Amsterdam, while his first U.S. museum show was presented by the San Francisco Museum of Modern Art (1968), which traveled to the Corcoran Gallery of Art, Washington, D.C. A retrospective was hosted by the Whitney Museum of American Art in 1974.

Scale is important in all of Held's paintings. In general his works transcend the quality of largeness to suggest a bellying forth from the canvas plane to occupy space between the canvas and the observer. In works like *The Big N* and *The Yellow X* (both of 1965), he created forms that occupy the entire painting space, with colored tabs that define the shapes. These were exclusively geometric, flat, abstract forms, with a pragmatic sense of objectivity and visual matter-of-factness, unlike decorative abstract painting of the prior generation.

Since that period, Held has worked to develop linear geometric constructive shapes, first in black and white, and then with color, defining linear structures of a wholly invented nonreferential abstraction.

The ink drawing *Untitled #7* is from the artist's middle period, approximately 1959 to 1967, when he sought a flat-patterned imagery derived from simple forms such as squares, circles and triangles, with a clear recognizability and no decorative or sensuous appeal. The drawing has been made with a housepainter's brush with ink, boldly setting out two forms—a square and a circle overlapped—occupying the entire sheet and suggesting an extension beyond the picture space at the right margin. This dominating, aggressive form relates to a series of two-part paintings—*I-Beam*, 1961-62, *Genesis*, 1963, and *Circle and Triangle*, 1964. While the drawing lacks the sinuous movement of the great form at the center and right of *Genesis*, there is a similarity of design in relating to and emphasizing the edges of the support. Held does not make drawing studies specifically for development in his paintings, but he makes notes which he uses in the early stages of larger works. These initial configurations disappear during the course of the painting in favor of new images, or they may remain to be transformed into more personal forms in the process.

Sources:
Armstrong, Richard. *Al Held*. New York: Rizzoli, 1991.
Green, Eleanor. *Al Held*. San Francisco: San Francisco Museum of Modern Art, 1968.
Tucker, Marcia. *Al Held*. New York: Whitney Museum of American Art, 1974.

SOL LEWITT

American, b. 1928
Untitled, 1969
ink on paper
14 ½ x 20 ½ inches
The Tabriz Fund, 1992.
92.30

Sol Lewitt is a pioneer in the minimal and conceptual art movements of the 1960s. Lewitt received his BFA degree (1949), from Syracuse University, spent two years in the U.S. Army and relocated to New York in 1953, attending Cartoonists and Illustrators School. He worked at painting and commercial design (1954-60), including a stint with the architect I. M. Pei. Lewitt has also taught at The Museum of Modern Art School, New York (1964-67), and the Cooper Union, New York, also in 1967. Solo exhibitions have been extensive, and a retrospective of his drawings organized by the San Francisco Museum of Modern Art, circulated from 1974 to 1976. The Museum of Modern Art also hosted a circulating retrospective in 1978.

Lewitt's work has tended to be in sculpture, wall reliefs or geometric modular units of hollow white cubes. In addition, Lewitt conceived "wall drawings," based on rigorous directions or rules that might be executed by assistants. In recent wall drawings, color has become more dominant, but the same rigorous application of conceptual rules applies. The work is only what it is, and it could be remade by another team of equally competent followers of the artist's directions as to the linear and coloristic standards of measurement. In this way the work is "demystified," and its preciousness as art is removed.

Untitled, 1969, is an example of the working drawings developed by the artist for the production of three-dimensional objects. The skill involved is that of the draftsman, engineer, architect or designer who describes precisely the size, proportions and weights of the work to be fabricated by a corporate service. There is no hint of emotion or feeling in the lines or shapes, which are as objective as an engineering exercise. This is an art of cool, distanced, intellectual discipline. It is intended to serve as a reaction to, and an extreme alternative to, the emotional, handmade and personal work of the Abstract Expressionists.

Sources:

Lippard, Lucy, Bernice Rose and Robert Rosenblum. *Sol Lewitt.* New York: The Museum of Modern Art, 1978.

McShine, Kynaston. *Primary Structures.* New York: Jewish Museum, 1966.

Sol Lewitt—Structures 1962-93. Oxford, England: Museum of Modern Art, 1993.

Sol Lewitt: 25 Years of Wall Drawings, 1968-93. Seattle: University of Washington Press, 1993.

S.L. 1969

HENRY PEARSON

American, b. 1914
Five and Five-Eighths Inch Drawing, 1961
ink on paper
10 x 10 inches (sheet size)
Gift of the artist in memory of his parents,
Louis and Estelle Pearson, 1994
93.53.4

Henry Pearson was born in North Carolina and attended the University of North Carolina, Chapel Hill, where he received his BA degree in 1935, and then Yale University, New Haven, Connecticut, where he took his MFA in stage design in 1938. During the war, Pearson worked on huge aerial maps of Japan, which introduced him to contour mapping. After the war, he signed up for four additional years of service, requesting duty in Japan. He was the first Western artist to exhibit in the Mizusaki Gallery, Tokyo. On returning to New York, he read Kuniyoshi's praise of the Art Students League and decided to enroll, working first with Reginald Marsh and then Will Barnet (1953-56). In 1975 he was included in the Art Students League Centennial Exhibition. A Pearson retrospective was organized by the Columbia Museum of Art, South Carolina, 1988. Pearson also taught for fifteen years at the Pennsylvania Academy of the Fine Arts, Philadelphia.

Throughout his career, Pearson has focused on abstraction. He has worked in a Neo-Plastic manner that some critics relate to the work of Piet Mondrian and Charmion von Wiegand. He questioned the need to adhere to the rigid vertical and horizontal discipline and began to round the corners of his work, which led him to reevaluate his contour-map-inspired linear developments in drawing and painting.

Five and Five-Eighths Inch Drawing is one of ten he created in the same format and developed in series, working with crow quill pen and ink. Pearson's linear mazes differ from the work of other optical painters and designers such as Bridget Riley in that they are not based on a repetition of a geometric interval or a stencil form. Instead they present a compulsively developed discipline of freehand seeing and decision making, whether in drawing scale or in that of painting. The artist started simultaneously at the outside of the drawing and at the inside with three or four lines alternating, intending that the inner ones would hold to a constant rhythm while the outer lines would wave and ripple. How the two systems would be joined was left to chance and improvised at the last. The serene outer ring at "north" and "west" and the constant inner circle tend to stabilize the composition, while the activity that billows and ripples through the "south" and "east" carries the drama of the work.

Sources:

Barnet, Will. *Henry C. Pearson*. Duluth: University of Minnesota, 1965.

Heaney, Seamus. *Poems and a Memoir*. Introduction by Thomas Flanagan, original relief engravings by Henry Pearson. New York: Limited Editions Club, 1982.

Lippard, Lucy R. "Notes on Henry Pearson," *Henry C. Pearson*. Duluth: University of Minnesota, 1965.

Parris, Nina. *Henry Pearson*. Columbia, SC: Columbia Museum of Art, 1988.

PEARSON 1961

RICHARD POUSETTE-DART

American, 1916-1992
Quartet #13, c. 1950
mixed media on paper
22 ½ x 30 ⅞ inches
The Arkansas Arts Center Foundation Collection,
The Tabriz Fund, 1994.
94.36

The inspiration to become an artist came early in Richard Pousette-Dart's life, for his mother was a poet and his father was a painter and writer of a series of books on American painters, including Childe Hassam, Robert Henri and James Abbott McNeill Whistler. Born in St. Paul, Minnesota, in 1916, Pousette-Dart began painting at the age of eight. However, like many gifted artists of his generation, formal schooling did not serve him well. He attended Bard College, Annandale-on-Hudson, New York, but left quickly, preferring to paint by night and work by day at secretarial chores. Yet he gained prominence early in his career, for his work was shown in the seminal exhibition *Abstract Painting and Sculpture in America* in 1944 at The Museum of Modern Art, New York. He showed at Peggy Guggenheim's Art of this Century gallery, New York in 1947 and exhibited at the Betty Parsons Gallery, New York, from 1948 to 1967.

Pousette-Dart was generally considered an independent outsider, much like William Baziotes, even though he exhibited in influential galleries. He was one of the first (in 1942) to exploit the expressive potential of very large canvases. His imagery tends to be complex, comprising congested verticals and horizontals and intersecting circles and signs in a many-layered rendering of shallow abstract space. Like Baziotes, he endowed his work with a spiritual, often mystical, quality.

Quartet #13 probably dates from around 1950, when the artist was in his early thirties. Four figures are represented on a shallow stage, with vertical and semicircular shapes and semigeometric markings. The title describes the four figures, or is a musical allusion that makes reference to the contrapuntal arrangement of shapes. When speaking of these counterpoints, Pousette-Dart uses the term "tuning," a reference to the process of making fine adjustments in the process of painting in order to bring the whole into harmony. G.N. and M.P.

Sources:
Fry, Edward. *Richard Pousette-Dart: Recent Paintings*. New York: ACA Galleries, 1991.
Gordon, John. *Richard Pousette-Dart*. New York: Whitney Museum of American Art, 1963.
Hobbs, Robert and Gail Levin. *Abstract Expressionism, The Formative Years*. New York: Whitney Museum of American Art, 1978.
Hobbs, Robert and Joanne Kuebler. *Richard Pousette-Dart*. Indianapolis: Indianapolis Museum of Art, 1992.
Richard Pousette-Dart: Drawings. Chicago: Arts Club of Chicago, and New York: Andrew Crispo Gallery, 1978.

JOEL SHAPIRO

American, b. 1941
Untitled, 1979
charcoal on paper
20 x 27 ⅝ inches
The Tabriz Fund, 1986.
86.18.1

Joel Shapiro studied at New York University, New York, receiving a BA degree in 1964 and an MA in 1969. He served in the Peace Corps (1965-67), and has taught at Princeton University, Princeton, New Jersey (1974-76), and the School of Visual Arts, New York (1977-82). Important solo exhibitions in institutional settings include the Museum of Contemporary Art, Chicago (1976); the Albright-Knox Art Gallery, Buffalo (1977); the Arkon Art Institute, Ohio (1979); Brown University, Providence, Rhode Island (1980); the University of North Carolina (1981); and venues in Europe.

Shapiro began his productive career in the period 1969-74, the heyday of conceptual and minimal art, and he acknowledges the impact of artists such as Carl Andre and Donald Judd. Shapiro's art has passed through an evolution from hand-formed clay balls, to tiny sculptures of houses, bridges, and chairs often displayed directly on the floor of exhibition spaces in the minimal tradition, and then blocky figurative pieces without a pedestal. He has worked in wood, cast iron, bronze, rarely with color. He does not sketch, but he makes drawings and prints, and he conceives of them as autonomous and independent works.

The artist has a variety of ways of working in drawing materials—early works demonstrate a painterly manner of developing overall surfaces. In his classic drawing period—1975 to 1980—he focused on charcoal, leaning heavily on the stick for a broad and aggressive band rather than a simple line. The bands function as positive elements and as enclosures for positive spaces, and often suggest a floor plan. When he makes a correction, smudging out a band, the original line remains as a ghost of the earlier concept and the two levels resonate together in the final work. Shapiro constantly questions and recalculates the relationship of figure to ground. His bands extend and enclose space, with the emphasis away from the center and toward the edges of the sheet, with the focus on the whole rather than on any particular element within, just as he works in his sculptures. Erasures, smudges, band changes and finger prints reflect his drawing process, his hesitancies and his physical pressure on the materials. He refrains from "cleaning them up" and thereby risking the loss of the documentary directness of process.

Sources:

Krauss, Rosalind. *Joel Shapiro*. Chicago: Museum of Contemporary Art, 1976.

Ormond, Mark. *Joel Shapiro: Selected Drawings 1968-1990*. Miami, FL: Center for the Fine Arts, 1991.

Phelan, Ellen. *Joel Shapiro: Painted Wood Sculpture and Drawings*. New York: Pace Gallery, 1995.

Smith, Roberta. *Joel Shapiro*. New York: Whitney Museum of American Art, 1982.

RODNEY CARSWELL

American, b. 1946
Untitled (AP89-1), 1989
acrylic on paper
22 ½ x 22 inches
Arkansas Arts Center Foundation Purchase, 1989.
89.57

Rodney Carswell earned a BFA degree from the University of New Mexico, Albuquerque (1968), and an MFA from the University of Colorado, Boulder, in 1972. He has been afforded several museum exhibitions including the Museum of Art, University of Oklahoma, Norman (1988); the Art Museum of Miami University, Ohio (1989); and The Renaissance Society at the University of Chicago (1993).

Rodney Carswell made an early commitment to abstract painting. His early work was executed in rhoplex on unstretched canvas, which led him to seek a more structured presentation that lifted the painted surface outward from the exhibition wall. He built simple, open and unpainted wooden scaffoldings upon which his painted surfaces were set out, which became featured elements in a three-dimensional structure. At approximately the same time, Carswell began working with encaustic—oil color in wax—in multiple layers, which produced a surface of tangible thickness related to the dimensionality of his raw-wood outrigger scaffoldings. Geometry dominates Carswell's images, with abutting rectangles, crosses and circles that are sometimes tilted, penetrated and even reversed. Color is restricted to muted reds, blues, a range of grays, occasional oranges or burgundies and a stripe of white, worked in monochrome units, with contrasting geometric forms asymmetrically placed.

In the drawing *Untitled* (AP89-1), the artist makes reference to the gestalt of abutting forms in his constructed painting method. The square shape and the two related adjoining rectangles have been developed by the removal of the square "bite" from the upper-right-hand corner of the work's paper support. The color conforms to the artist's customary grayed hues, and the geometric form of a cross is introduced in such a way as to float out of the primary square up into the gray rectangle abutting the square's upper margin. The off-center thrust of the colorless cross (upward and on the left) is effectively balanced by the weight of the red rectangle on the right. The artist's many-layered painting process is revealed through the rainbow of color strokes to be read at the paper's margins. That which first seemed entirely disciplined and ascetic proves to be sensuous in material and engaging in color.

Sources:

Kirshner, J.R. Surfaces: *Two Decades in Chicago Painting, Seventies and Eighties.* Chicago: Terra Museum of American Art, 1987.

Pagel, David. *Rodney Carswell: Selected Work: 1975-1993.* Chicago: The Renaissance Society at The University of Chicago, 1993.

Spector, Buzz. *New Work: Rodney Carswell.* Norman: University of Oklahoma, 1988.

SEAN SCULLY

American, b. Ireland, 1946
Untitled, 1984
charcoal and chalk on paper
30 ¼ x 13 ¼ inches
The Tabriz Fund, 1994.

Sean Scully was born in Ireland, but in 1949 the family moved to London. He attended the Croyden College of Art, London (1965-68), the Newcastle University (1968-71), and Harvard University, Cambridge, Massachusetts (1972-73), where he earned his MA degree. From 1977 to 1983, Scully taught at Princeton University, Princeton, New Jersey. He has exhibited in galleries and museums throughout the United States and Europe including Germany, England and Spain.

Scully perceives abstract painting as the great art form of the 20th century. As a student he recognized Mark Rothko and Jackson Pollock's impact on art and the plastic clarity of Mondrian. He also admired the work of Robert Ryman and Brice Marden. He had a bent toward the grid, and evolved through polychromed grids to striped panels, which developed into multiple-panel paintings with stripes of different widths and rhythms, juxtaposed at 90 degrees. He began painting in acrylics but switched to oils in 1979, and later adopted large Italian housepainter's brushes. For a time, he used tape to form his stripes, but he now works directly in multiple layers with undefinable and changing colors that reveal their sensuous underpainting.

The drawing *Untitled* shares the sensuous handmade application found in his multipanel oil paintings. Even in his most colorful works, Scully utilizes black as the alternate stripe, as in his breakthrough painting *Heart*

of Darkness, 1982, where black and white, black and red, black and yellow, set the triptych. In *Untitled,* five broad horizontal stripes alternate in the larger visual element, and ten vertical black and dark brown stripes abut the larger element at a 90-degree angle, visually suggesting two independent panels.

Sources:

Caldwell, John, David Carrier and Amy Lighthill. *Sean Scully*. Pittsburgh: Carnegie Institute Museum of Art, 1985.

Poirier, Maurice. *Sean Scully*. New York: Hudson Hills Press, 1990.

Ratcliff, Carter, Danto Coleman and Steven Henry Madolf. *Sean Scully, the Catherine Paintings*. Fort Worth, TX: The Modern Art Museum of Fort Worth, 1993.

Scully, Sean and Joseph Mascheck. *Sean Scully: Paintings*. New York: David McKee, 1985.

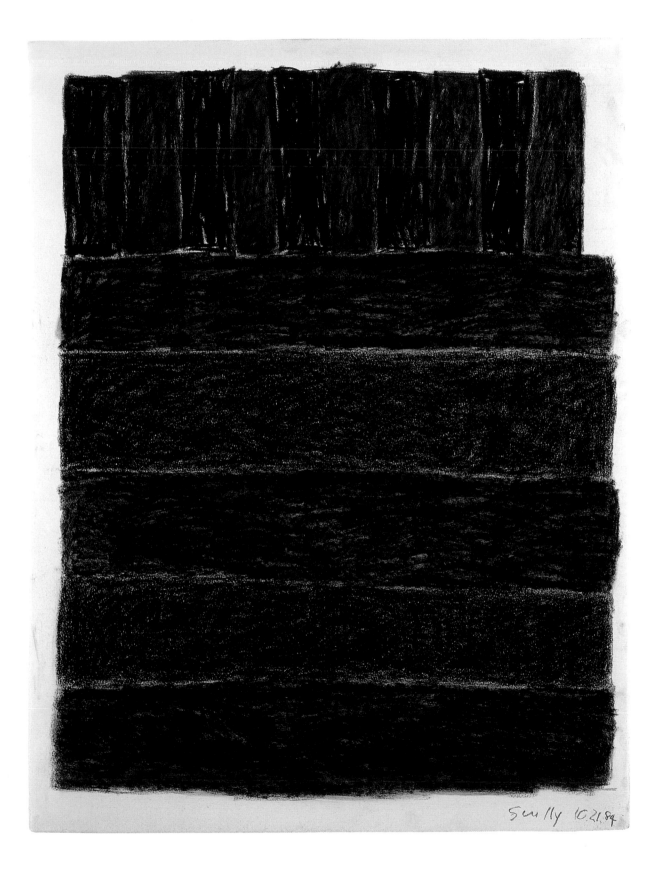

Scully 10.21.84

ELIZABETH MURRAY

American, b. 1940
Untitled, 1984
charcoal and colored chalks on paper
37 ¼ x 38 inches
The Tabriz Fund, 1991
91.49

Born in Chicago, Elizabeth Murray attended the School of the Art Institute of Chicago (1958-62), receiving a BFA degree. Later she received an MFA from Mills College, Oakland, California. In 1967, Murray moved to New York City, where she met Joel Shapiro. She has taught intermittently at Wayne State University, Detroit; the School of the Art Institute of Chicago; and Bard College, Annandale-on-Hudson, New York. She was included in exhibitions at the Whitney Museum of American Art, including several Biennials in the 1970s and 1980s. Other exhibitions are, *Elizabeth Murray Drawings: 1980-86,* Carnegie Mellon University Art Gallery, Pittsburgh; *Drawings, Pastels and Charcoals* at the University of California, Berkeley, 1987; and *Elizabeth Murray: Paintings and Drawings*, organized by the Dallas Museum of Art (1987).

Murray began her career as an abstract painter but evolved a personal vocabulary of biomorphic and geometric shapes, with many large irregularly shaped parts brought together in loose conjunction, expansive in size and complex in their interactions and three-dimensionality. Often her forms are eccentrically shaped panels which nestle together in relief. The actual paint body may contradict the volumes created by the relief structure. Murray introduces hints of figuration, landscape, sky or plant forms and fragments of recognizable household objects combined in a rowdy structure of multiplicity that somehow achieves its own unity. She is also interested in the literal spaces left by her eccentric panels and apertures and sometimes paints *trompe l'oeil* negative spaces into her works.

Murray regards drawing as an end in itself—a process conducive to invention and spontaneity. Her drawings concentrate on a single configuration expanded to the margins of the sheet, which is usually shaped by a selective tearing-in process into a configuration of sheets tailored to fit the image. She allows the image to emerge slowly and to undergo a metamorphosis that springs from an instinctual level of consciousness. Her erasures are integral to the making and may even result in the complete obliteration of the image. This results in a continual overlayering of imagery and a rubbing out, with half-ghosts always enduring. It is not unusual for ideas and images developed in the drawings to be developed later in her large painted constructions.

Source:
Armstrong, Richard and Richard Marshall. *Five Painters in New York. New York*: Whitney Museum of American Art, 1984.
Graze, Sue, Kathy Halbreich and Roberta Smith. *Elizabeth Murray: Paintings and Drawings.* New York: Harry N. Abrams, and Dallas: Dallas Museum of Art, 1987.
King, Elaine. *Elizabeth Murray: Drawings 1980-1986*. Pittsburgh: Carnegie Mellon University Art Gallery, 1986.

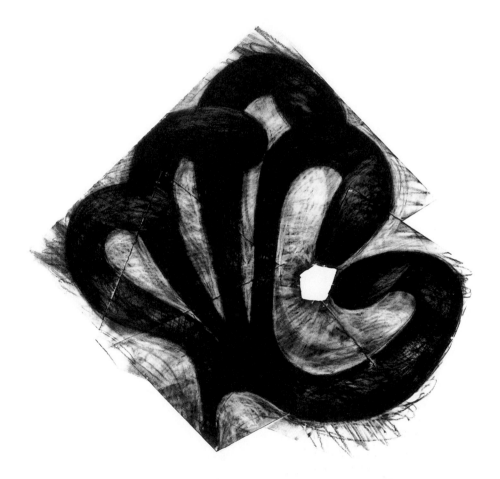

Morton Livingston Schamberg

American, 1881-1918
Untitled Composition, 1916
pastel and pencil on paper
9 ¾ x 6 ⅜ inches
The Arkansas Arts Center Foundation Collection:
The Mrs. Frank Tillar Fund, 1996.
96.3

A Philadelphia native, Morton Schamberg graduated with a degree in architecture from the University of Pennsylvania, Philadelphia, in 1903. During his architectural study he began to paint, and he enrolled at the Pennsylvania Academy of the Fine Arts (1903-06), where he studied with William Merritt Chase and became a classmate of Charles Sheeler. He was invited to show in the Armory Show of 1913. Later, while visiting galleries in New York City, he encountered Walter and Louise Arensberg and their New York salon, which embraced a distinguished group of intellectuals including Marcel Duchamp, Francis Picabia, Albert Gleizes, Man Ray, Charles Demuth, William Carlos Williams, Katherine Dreier, Arthur Dove and numerous others.

Schamberg's two best-known paintings show machines (1916), one in the Société Anonyme Collection, Yale University, New Haven, Connecticut, and one in the Arensberg Collection, Philadelphia Museum of Art. Both are rendered in a cool, architectural draftsman's technique, without evident strokes. The machines imply movement, but are at rest. The centered forms are balanced by asymmetric thrusts and strong color. Schamberg has not had the independent fame of so many of his contemporaries, but he is often included in major exhibitions of the Dada artists.

An important discovery of thirty pastels by Schamberg was made in the early 1980s. All of these small works take as their subject the textile and printing machines associated with his family's hosiery company. These works were not exhibited in the artist's lifetime, and since they were found in sketchbooks, they are remarkably fresh. These pastels appear to have been made independently of the static oil-on-canvas works of 1916 and are calculated to suggest that the machines are in full motion. Sheeler recalled that Schamberg talked constantly about pictures he was going to paint in which mechanical objects were to be a major subject, and described them in detail down to the last line and nuance of color. The pastels are not studies, but complete and independent works of art.

In contrast to the machine images of Duchamp and Picabia, which reflect metallic parts and surfaces with ironic and often erotic overtones, Schamberg depicts his images with lyrical delicacy in powdery pigment. *Untitled Composition* is skillful but veiled, the color lyrical and nuanced, though unmachinelike. The machine elements are set out in detail, with drive wheel, power belts and pulleys related tensely in their movements and organized to fill the picture space compositionally. The selected forms are detached, only part of a larger machine, but clearly related to an industrial unit engaged in a continuous process of production. This is not the jagged and angular organization of Futurism, with horsemen, racing motor cars or armored trains, but a tender, even feminine appreciation of the wonder and laborsaving capacities of industrial activity.

Sources:
Agee, William C. *Morton Livingston Schamberg (1881-1918)*. New York: Salander-O'Reilly Galleries, 1982.
————. *Morton Livingston Schamberg (1881-1918)*: *The Machine Pastels*. New York: Salander-O'Reilly Galleries, 1986.
Wolf, Ben. *Morton Livingston Schamberg*. Philadelphia: University of Pennsylvania Press, 1963.

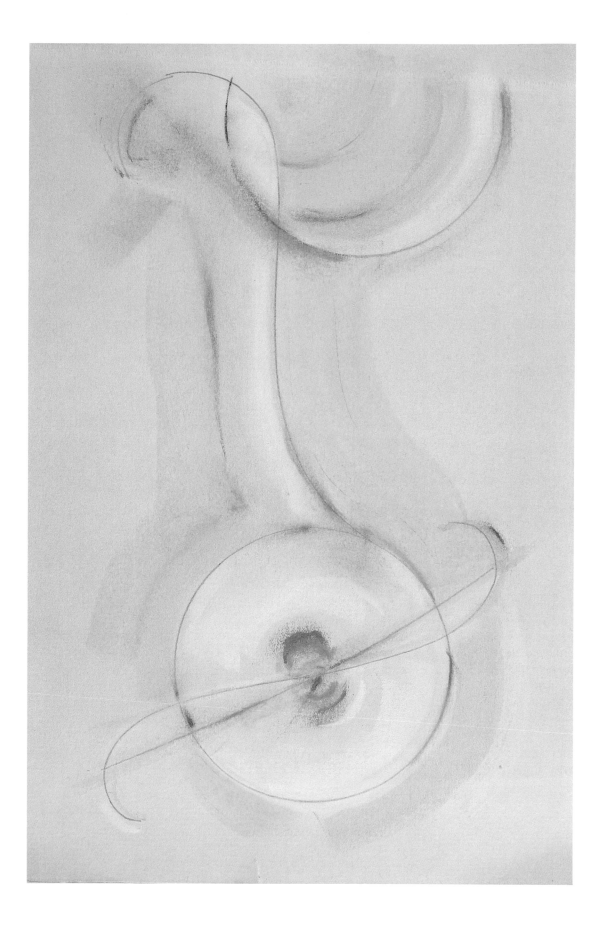

THEODORE ROSZAK

American, b. Poland, 1907-1981
Mechanical Heart, c. 1932
watercolor and ink on paper
12 ½ x 9 ½ inches
Arkansas Arts Center Foundation Purchase, 1988.
88.58

Theodore Roszak was born in Poland and moved to the U.S. in 1909. He attended Columbia University, New York, the National Academy of Design, New York, and the School of the Art Institute of Chicago; the latter institution gave the artist traveling fellowships to visit the East Coast (1928-29). Roszak also taught at the Art Institute from 1927 to 1929. From 1937 to 1939, he worked on the WPA Federal Art Project. Later he taught at Sarah Lawrence College (1941-56). He exhibited frequently, including Whitney Museum of Art, New York, Annuals and also the Pierre Matisse Gallery, New York, from 1951 to 1962. A retrospective was presented by the Walker Art Center, Minneapolis (1956-1957), which traveled to the Whitney, the Los Angeles County Museum of Art, the San Francisco Museum of Art, and the Seattle Art Museum.

Roszak worked in a variety of media but is best known as a sculptor. He began in the 1930s with a bent toward machine-shop technology, experimenting with European Constructivist notions. These ideas evolved in the 1940s into expressive organic bronze sculptural forms entirely his own.

In the 1930s, drawing was Roszak's central means of expression. It was his way of conceptualizing his ideas, later developed in plaster, wood or metal. The heart serves as a metaphor for feeling, sensitivity and compassion at the same time it is a powerful and long-lived power pump. Roszak approached his subject from both points of view, wishing to encompass the former through his respect for the medical wonders of the latter. The watercolor *Mechanical Heart* purports to be a cross-sectional view of the device, presented atop a cylindrical pedestal; it incorporates medical references, mechanical drawing, engineering references, Cubism and playful fantasy.

Sources:
Arneson, H.H. *Theodore Roszak*. Minneapolis: Walker Art Center, 1956.
Dreishpoon, Douglas. *Theodore Roszak: Constructivist Works, 1931-1947*. New York: Hirschl & Adler Galleries, 1992.
Miller, Dorothy C. *Fourteen Americans*. New York: The Museum of Modern Art, 1946.
Theodore Roszak: Sculpture and Drawings, 1942-1963. New York: Hirschl & Adler Galleries, 1994.

Hans Hofmann

American, b. Germany, 1880-1966
Study for Fruit Bowl, 1950
ink and oil on paper
17 x 14 inches
Arkansas Arts Center Foundation Purchase, 1988.
88.39

Hans Hofmann was born in Weissenburg, Bavaria, and then moved to Munich as a child. By age sixteen, he had left home to become assistant to the director of public works in Bavaria. Later, he moved to Paris (1910-14), and studied for one year at the Académie de la Grande Chaumière. In 1915 he returned to Munich where he opened an art school. In 1932 he taught at the Arts Students League, New York, and closed his Munich School, only to open his own school in New York in 1933 and a summer program in Provincetown, Massachusetts (1935), both of which continued until 1958. From 1947 to 1966, he was associated with Kootz Gallery, New York. A retrospective of his work was held at the Addison Gallery of American Art, Andover, Massachusetts (1948), with others at New York's Whitney Museum of American Art and The Museum of Modern Art, New York (1963).

During his study in Paris, Hofmann had direct contact with the avant-garde art movements of the early twentieth century—Cubism, Fauvism, Futurism and German Expressionism. He brought this firsthand experience and knowledge with him to America, where he became an influential teacher who had a profound impact on artists of the second-generation New York School, including Helen Frankenthaler, Jane Freilicher, Michael Goldberg and Larry Rivers. In his painting and teaching, Hofmann emphasized the creation of suggested

space through the optical push and pull of color and form. Hofmann's paintings are constructed with bright contrasting abstract shapes. The surface is decidedly painterly with thick tactile impastos.

Study for Fruit Bowl was the second in a group of exercises in oil, which were depicted in the article "Hans Hofmann Paints a Picture" by Elaine de Kooning for *Art News,* February 1950. The white bowl, the surrounding space, and the planar elements of the paper, fruit and pitcher are depicted with spontaneous freedom. The artist was clearly looking for a two-dimensional interpretation of a three-dimensional subject which had a plastic verve in keeping with his self-image of creativity.

Sources:

Bannard, Walter Darby. *Hans Hofmann: A Retrospective Exhibition*. Washington, D.C.: Hirshhorn Museum and Sculpture Garden, and Houston: Museum of Fine Arts, 1976.

Goodman, Cynthia. *Hans Hofmann*. Berkeley: University of California Press, and New York: Abbeville Press, 1986.

Greenberg, Clement. *Hofmann*. Paris: Editions Georges Fall, 1961.

Hofmann, Hans. *Search for the Real and Other Essays*. Eds: Sara Weeks and Bartlett Harding Hayes. Cambridge: MIT. Press, 1948 (rev. ed., 1967).

Hunter, Sam. *Hans Hofmann*. New York: Harry N. Abrams, 1963.

Seitz, William C. *Hans Hofmann*. New York: The Museum of Modern Art, 1963.

Wight, Frederick S. *Hans Hofmann*. Berkeley: University of California Press, 1957.

MICHAEL GOLDBERG

American, b. 1924
Untitled, 1952
oil and pencil on paper
18 x 12 inches
Stephens Inc. City Trust Grant, 1985.
85.76.16

Michael Goldberg, a native of New York City, studied with Hans Hofmann (1940-42), then served in the U.S. Army; enrolled at the Art Students League, New York (1946-47), and continued to study with Hans Hofmann (1948-50). He lived and painted in Greenwich Village in the early fifties, where he met Willem de Kooning, Franz Kline and Joan Mitchell. He was exhibited among the *Four Younger American Painters* at Sidney Janis Gallery, New York (1956). He was also in the *Young Americans* at New York's Whitney Museum of American Art (1957), and in numerous group exhibitions. He was given a solo exhibition at the Cleveland Museum of Art (1981); the Virginia Commonwealth University, Richmond (1983); and the Sheldon Memorial Gallery, Lincoln, Nebraska, in 1984.

Goldberg exhibited unusual skill as an oil painter in the early 1950s and demonstrated dynamic gestures, broad strokes, slabs of color, strong contrasts and surging broken color. Goldberg experimented with media, always demonstrating a mastery of material and an aesthetic edge in whatever approach he undertook. In 1989 he returned to a vigorous paint handling, but with a new layered, striped and multifaceted painterly touch.

The Arts Center's drawing was executed in 1952, at the early peak of Abstract Expressionist achievement, just one year prior to the showing of de Kooning's *Women* paintings. In contrast to Goldberg's highly gestural and heavily pigmented canvases of 1952-55, this work is lightly and yet fully developed, lyrical, with empty space and washes of blue, mauve, ochre and black. The influence of Hofmann's teaching may be indicated in the suggestion of a still-life subject and the simple boldness of the organization. The color selections, however, are more personal, reminiscent of such second-generation Abstract Expressionists as Sam Francis and especially Helen Frankenthaler, who reflected a similar wariness of the primary colors and an impulse to lighter washes.

Sources:
Conversations between Michael Goldberg and Lucio Pozzi. Livorno: Galleria Peccolo, 1988.
Kuspit, Donald. *Michael Goldberg: Paintings of the 1950's.* New York: Vanderwoude-Tananbaum, 1990.

CLAES OLDENBURG

American, b. Sweden, 1929
Colossal Structure in the Form of a Clothespin, 1972-74
pencil on paper
40 x 30 inches
The Museum Purchase Plan of the NEA and the
Barrett Hamilton Acquisition Fund, 1981.
81.14

Claes Oldenburg was born in Stockholm, Sweden, but raised in Norway before emigrating with his family to the U.S. where they settled in Chicago. He attended Yale University, New Haven, Connecticut, majoring in English and art. Shortly thereafter, he attended the School of the Art Institute of Chicago (1953-54). He moved to New York in 1956. Today, Oldenburg is best known for his colossal works of art, including a giant *Clothespin* in Philadelphia; the *Bat Column* in Chicago; and a *Giant Eraser*, National Gallery of Art, Washington, D.C. In addition to sculpture, Oldenburg has worked in happenings, film, poster design, prints and multiples. Retrospectives of his work were held at the Pasadena Art Museum (1971), the Walker Art Center, Minneapolis (1975), and the Museum of Contemporary Art, Chicago (1977), all of which toured. The Guggenheim Museum, New York, and National Gallery of Art, Washington, D.C., presented a retrospective in 1995.

Oldenburg's early work was sculptural, inspired by New York's Lower East Side, tribal art, outsider art and the work of Jean Dubuffet. The work was formed in "street materials"—castoff junk, scrap wood, cardboard, newspapers soaked in paste—producing rude totems. He soon turned to work in plaster, shaping toy "ray guns," butcher shop steaks and chops, bakery goods in glass cases, and men's and women's clothes, all splashily painted in bright color. He made drawings of works he admired, and projected variations to be executed in "found materials." With growing recognition, the artist expanded his scale to produce relief "paintings" on plaster-soaked muslin, of flags, 7-Up signs, clothes, cash registers, and three-dimensional pie slices, sandwiches and roasts. The next step was to produce common objects in muslin, filled with foam rubber: ten-foot ice cream cones lying on the floor, giant chocolate cake slices, and seven-foot "floor-burgers." The enlarged objects led him to emphasize the contrast between traditional sculptural materials and his new soft forms.

Determinedly Freudian in his view of the city and modern life, Oldenburg freely confesses that his imagery is inspired by sexual awareness. His ray guns, baked potatoes, 7-Up signs and depictions of clothing and Chicago fire hydrants had erotic overtones. The concept of making colossal objects drawn from daily life led him to conceive of sculptural monuments on an incongruous scale, which would totally change the viewer's consciousness of the object.

In the period of his soft sculpture, the artist utilized wooden clothespins to hold edges together after stuffing and prior to sewing. He enjoyed the pin form and studied it for its possibilities. On a 1967 flight to Chicago, thinking of the enlargement of common objects, he juxtaposed a clothespin to a postcard of the Chicago Tribune tower. He then made drawings for an ironic work titled *Late Submission to the Chicago Tribune Architectural Competition of 1922: Clothespin,* in which his drawings set out a building in the form of a clothespin, replacing the Gothic Tribune Tower. He provided a cover drawing for *Artforum* magazine in 1968, and authorized an edition of cor-ten steel clothespin sculptures, fabricated by Lippincott in 1972. A 40-foot-high version was commissioned by the City of Philadelphia, 1974, and installed near City Hall (1977). The artist has said that the two independent forms of the clothespin, joined by the metal spring, are analogous to the male and female forms in Brancusi's *The Kiss,* 1908 (Arensberg Collection, Philadelphia Museum). The Arts Center's drawing is the original proposal drawing for the airport monument for Dallas and Fort Worth, intended to signal the joining of two cities, and although the monument was never commissioned, it would have mimicked the shape of the airport flight tower. This "presentation drawing" is of architectural "finish," in contrast to the flowing and spontaneous freehand of the artist's personal notation.

Sources:

Baro, Gene. *Claes Oldenburg: Drawings and Prints.* New York: Chelsea House, 1969.

Celant, Germano, Koepplin, and Mark Rosenthal, et al. *Claes Oldenburg: An Anthology.* New York: Guggenheim Museum, and Washington, D.C.: National Gallery of Art, 1995.

Friedman, Martin. *Oldenburg: Six Themes.* Minneapolis: Walker Art Center, 1975.

Haskell, Barbara. *Claes Oldenburg: Object into Monument.* Pasadena: Pasadena Art Museum, 1971.

Oldenburg, Claes. *Proposals for Monuments and Buildings 1965-69.* Chicago: Big Table Publishing Co., 1969.

Rose, Barbara. *Claes Oldenburg.* New York: The Museum of Modern Art, 1970.

WAYNE THIEBAUD

American, b. 1920
3 Bar-B-Que Beef, 1970
crayon and watercolor on paper
12 ⅜ x 22 ½ inches
The Tabriz Fund, 1984.
84.5

After high school, in 1938, Wayne Thiebaud worked for Sears Roebuck as a show card illustrator. He also attended Frank Wiggins Trade School in Los Angeles to learn commercial art, lettering and cartooning. After time in the Air Force (1942-45), he committed to being a painter. He studied art at San Jose State University (1949-50). He received his BA degree from California State University, Sacramento, in 1953. The Crocker Art Gallery, also in Sacramento, gave the artist his first solo exhibition, in 1950. A year later, Thiebaud began to teach at Sacramento City College, where he stayed on staff until 1960. In 1956-57, he took his academic leave in New York City to work in the field of art direction for advertising agencies. While there he met Willem de Kooning, Franz Kline, Barnett Newman and Philip Pearlstein. In 1960, he took a new position at the University of California, Davis, where he has remained. Museum exhibitions have come frequently. Stanford University, the Phoenix Art Museum, the Walker Art Center in Minneapolis, and the San Francisco Museum of Modern Art have all hosted his work.

Thiebaud was initially linked to the emergence of Pop Art because of his use of common objects and untraditional art imagery from daily life—cakes and pies and delicatessen's and cosmetic displays. Thiebaud, however, was expressing a plastic equivalency between his rendering of icing, meringue, bowls of soup, and delicatessen items and the tradition of still-life painting.

As Thiebaud expanded his subject matter into figures, portraits and landscape (always relating to his sense of contemporary truth), his independence from the New York movement became clear. His formalist view of figure painting and his long development of dramatic San Francisco cityscapes have clarified his position as an easel painter of distinction.

3 Bar-B-Que Beef sets out three comestibles in a row, consistent with earlier exercises, depicting three pies, three candy rolls or three jars of cold cream, from the artist's classic early period. This drawing is one of several preparatory drawings for an original silkscreen print, executed and published in 1970 in an edition of 50 impressions. A raking light from the left causes shadows between the sandwiches and appears to define the texture of the buns, which have been heightened by crayon and watercolor.

Sources:

Bahet, Kathleen. *Wayne Thiebaud Still Lifes and Landscapes.* New York: Associated American Artists, 1993.

Cooper, Gene. *Wayne Thiebaud Survey 1947-1976.* Phoenix: Phoenix Art Museum, 1976.

Coplans, John. *Wayne Thiebaud.* Pasadena: Pasadena Art Museum, 1968.

Glenn, Constance, ed. *Wayne Thiebaud: Private Drawings.* New York: Harry N. Abrams, 1987.

Tsujimoto, Karen. *Wayne Thiebaud.* Seattle: University of Washington Press, 1985.

NEIL WELLIVER

American, b. 1929
Study No. 2 for Trout and Reflections, 1982
watercolor and pencil on paper
22 ¾ x 30 ⅛ inches
The Memorial Acquisition Fund, 1983.
83.25

Neil Welliver was born in Millville, Pennsylvania. He took his BFA degree in 1953 from the Philadelphia Museum College of Art. He taught at Cooper Union in New York (1952-57), while completing his work at Philadelphia and pursuing graduate work at Yale's School of Art, New Haven, Connecticut, where he received his MFA in 1955. He taught at Yale (1955-65), and at the University of Pennsylvania, Philadelphia, from 1966. The artist's exhibition history is highlighted by a major retrospective, *Neil Welliver: Paintings 1966-80,* organized by the Currier Gallery of Art, Manchester, New Hampshire, which traveled to the Des Moines Art Center, Iowa; the Columbus Museum of Art, Ohio; and the Museum of Fine Arts, Virginia, among others.

Throughout Neil Welliver's career, he has pursued an objective painting manner, focusing on close observation, painstaking drawing and a skillful fluidity in paint handling. His large naturescape canvases are often compared to the works of American painters Frederic Church and John Kensett in their representation of an idealized nature. Yet Maurice Grosser explains that Welliver has the painstaking craftsmanship of the old masters combined with the "plein air practices of Impressionism." (See note.)

Study No. 2 for Trout and Reflections expands to fill the drawing sheet with a tracery of pencil lines, which shade and shape the two fish and the plane upon which they are displayed. The pale pencil lines imply that the brilliant light on the subject has bleached the color and pattern of the fish, except in the developed watercolor areas.

Sources:
Ashbery, John and Frank H. Goodyear. *Welliver.* New York: Rizzoli, 1985.
Grosser, Maurice. *Neil Welliver: Recent Paintings.* New York: Marlborough Gallery, Inc., 1985.

Note:
Maurice Grosser, *Neil Welliver: Recent Paintings,* p. 3.

CAROLYN BRADY

American, b. 1937
Lunch I, 1988
sepia wash on paper
22 ½ x 29 ⅝ inches
Purchased with a gift from Virginia Bailey, 1990.
90.5

Carolyn Brady, an Oklahoma native, attended Oklahoma State University (1955-58), and took her BFA and MFA degrees from the University of Oklahoma, Norman, in 1959 and 1961 respectively. She moved to New York and lived there from 1961 to 1967. Brady was afforded a major exhibition at the Fine Arts Center, University of Rhode Island, Kingston, Rhode Island (1977).

Brady earned her living in New York as a textile designer in the Jack Prince Studio, where she met Audrey Flack, Joseph Raffael, Paul Thek and a number of other young artists. She was influenced by photorealist Joe Raffael's work and adopted this style of painting in the early 1960s.

Lunch I is a companion to another work, *Lunch II,* 1988, both of which are reproduced in color in the artist's monograph of 1991. In what appears to be a photorealist work involved with transparency and reflections, we find a highly conceptual work concerned with location, point of view, and aesthetic and social considerations. The two lunch images are linked not only by their titles, but by the identical still-life materials and through examination in differing lights and angles of orientation. (This is similar to another pair of works: *Red Table from the North* and *Red Table from the South,* 1976.) In such conceptual pairings, Brady conveys her awareness that knowledge and meaning are always shifting and asserts the need to recognize and tolerate a multiplicity of viewpoints.

Source:
McManus, Irene. *The Watercolors of Carolyn Brady.* New York: Hudson Hills Press, 1991.

DAVID PARRISH

American, b. 1940
Black Cat, 1985
graphite on paper
16 ¾ x 22 inches
Arkansas Arts Center Foundation Purchase, 1985.
85.35

David Parrish, a native of Birmingham, Alabama, is included in the broad spectrum of photorealism. Having earned a BFA degree at the University of Alabama in 1961, Parrish made an unsuccessful attempt to become a magazine illustrator in New York City. A year later, he moved to Huntsville, Alabama, where he worked for a decade as an artist in the aerospace industry. As early as 1964, it was evident that he was clearly destined to enjoy a career as a painter.

Around 1970, Parrish began to concentrate on photorealistic images derived from the power, color and sparkle of the motorcycle. His early works were poster portraits of the machine, often depicting rows of their repeated forms receding into space. He refined his technique, achieving smooth, unmodulated surfaces through the use of fine sable brushes and the application of thinly applied coats of oil paint. In 1974-80 his work become more complex. He moved the machine and viewer closer together by focusing on the parts rather than the whole: his subject became the reflections and distortions seen in the engine, body, fenders and windscreen.

Parrish exploits the art of photography as a point of departure. Using 35mm film, he takes slides of motorcycles from various angles and with a multitude of details. He reviews his slides the way another artist might examine a sketchbook, looking for the right combination of visual information. Then the draftsman and colorist takes over, intensifying the shapes and colors to suit compositional needs, to break up the surface or to stress the multiple layers of space. The result is a bravura display of surface and depth, intriguingly abstract yet recognizable upon close inspection. New subject matter has added richness and variety to his work: gas stations, store window arrangements, kitsch accumulations and images of pop icons have found their way onto his canvases, all competing to serve as metaphors for modern life.

Parrish returned to drawing in the early 1980s. The drawings are not made as studies for canvases but tend to be postscripts and independent works. In *Black Cat,* we can sense a kind of lexicon of formal analysis. By reducing the color to graphite tones, Parrish can focus on relationships. All of the fundamentals are here—line, shape, form, value, space. He establishes a subtle competition between each, as though each element were fighting the others for attention. That they are fireworks is happenstance: they offer a means to an end.

G.N. and M.P.

Sources:

Kahan, Mitchell Douglas. *David Parrish: An Exhibition.* Montgomery, AL: Montgomery Museum of Fine Arts, 1981.

Meisel, Louis K. *Photorealism.* New York: Harry N. Abrams, 1980.

David Parrish, Porcelain Still Life. New York: Louis K. Meisel Gallery, 1990.

"Black Cat" David Parrish '95